THE LANDSCAPE OF
SCOTLAND

SAMPSON LLOYD

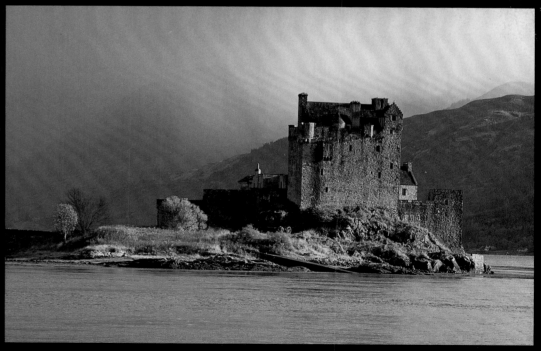

THE LANDSCAPE OF
SCOTLAND

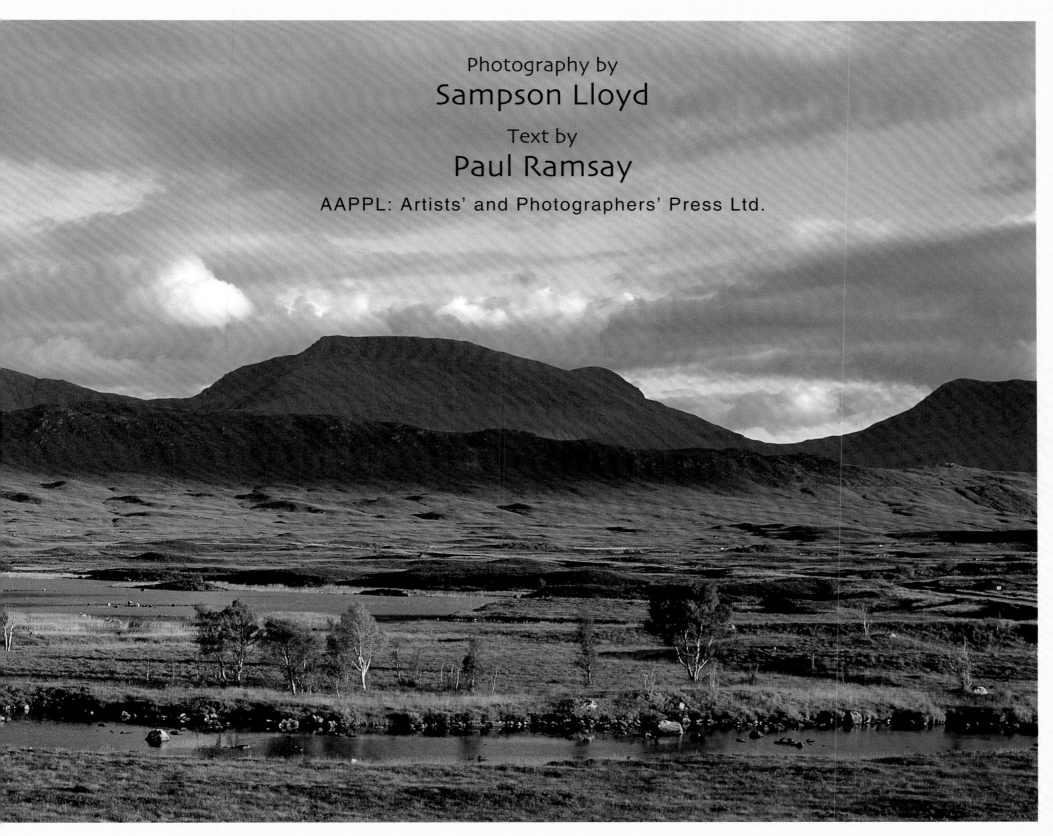

Photography by
Sampson Lloyd

Text by
Paul Ramsay

AAPPL: Artists' and Photographers' Press Ltd.

THE LANDSCAPE OF SCOTLAND

Published in Great Britain, USA and Germany by
AAPPL Artists' and Photographers' Press Ltd
10 Hillside
London SW19 4NH
UK
info@aappl.com
www.aappl.com

Sales and Distribution
UK and export: Windsor Books Intl.
windsorbooks@compuserve.com

USA and Canada: Sterling Publishing Inc., NY
sales@sterlingpub.com

German-language: Vollmer Communications
wv@vollmer-communications.com

A catalogue record for this book is available from the British Library.

ISBN 1-904332-02-1 (hardback edition)
1-904332-03-X (German language hardback edition)

Editors: Sarah Hoggett, Stefan Nekuda
Art Director and Designer: Stefan Nekuda
stefan.nekuda@chello.at

Reproduction and printing by: Imago Publishing
info@imago.co.uk

Half title page: Eilean Donan Castle
Title page: Rannoch Moor

Contents

6 The Landscape of the Gael

8 The Trossachs, Atholl and Breadalbane

26 Lorne, Mid-Argyll and Appin

46 Lochaber

64 The Great Glen, Glen Affric and Strathglass

78 Morvern to Moidart and Arisaig

92 Kintail to Loch Broom

114 Sutherland

140 The Cairngorms, Strathspey and Badenoch

156 Photographer's Note

160 Acknowledgements

The Landscape of the Gael

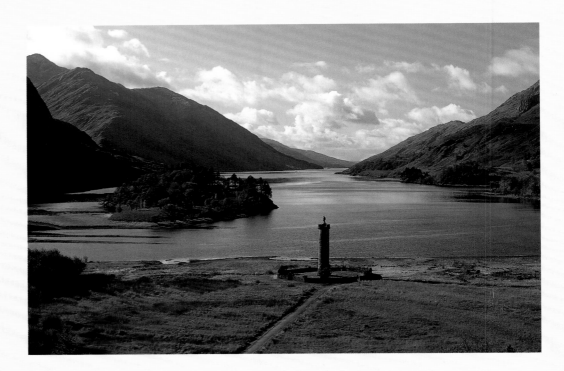

Knowing something of the derivation of place names can tell us about the previous history of an area. *Baile-* names, for example, indicate a farming township, and names with *ach-* (from *achadh*, meaning field) as prefixes often show where a secondary farming settlement developed when the population had outstripped the resources of the original township. The Christian past is recalled in the many *cill-* (meaning chapel) names.

A glance over a map will show many references to different types of woodland, often where there are no woods now. The words *darach* or *doire* indicate the presence of oak trees; *giubhsach* means pine word; *feàrna* is the world for the alder tree; and *call* or *calltuinn* means hazel.

The names of water courses indicate the size of the stream (*uisge*, a large river like the Spey; *abhainn*, a middle-sized river; *allt*, a stream or burn; *sruth*, a rushing rivulet), while the second part of the name may be simply descriptive, or have an ancient Pictish, pre-Indo-European element whose meaning has been lost. Hills were given names that reflected certain physical characteristics: broad slopes, rocky sides, pointed peaks, or a likeness to the breasts of women. Sometimes they commemorated an event in history or myth. The Sgùrr nam Spainnteach in Kintail is a reminder of the Spanish troops who fought alongside the Jacobite Highlanders in the Glenshiel Rising of 1719. The Sgor nam Fiannaidh in Glencoe gets its name from association with the Fenian band of the hero tales. And yet the Gaels' interaction with their land goes much deeper than this. For the Gaels, the components of the landscape themselves had symbolic importance. This went to the roots of Gaelic consciousness itself.

The letters of the Gaelic alphabet are each represented by trees or bushes. Thus *ailm*, the Gaelic for elm, stands for the letter A, B is represented by *beithe*, Gaelic for birch – and so on through the eighteen letters of the alphabet. The Celtic calendar was also based on the trees of the alphabet. Each month was represented by a symbolic tree or bush. Birch was seen as the tree of beginning, which makes sense to any forester because it is such a splendid colonizing species. Hazel was the tree of an autumn month because its nuts ripen then. These two examples hint at the way in which the world view of the Gaels was bound up with their experience of (and reliance on) the land in which they lived.

Although we may think that the mention of plants and trees simply serves to set things in a physical context, but we have to beware. Our own culture has lost the understanding of the frame of reference that gives certain allusions a particular significance.

(above) **The Glen Finnan Monument, Loch Shiel**

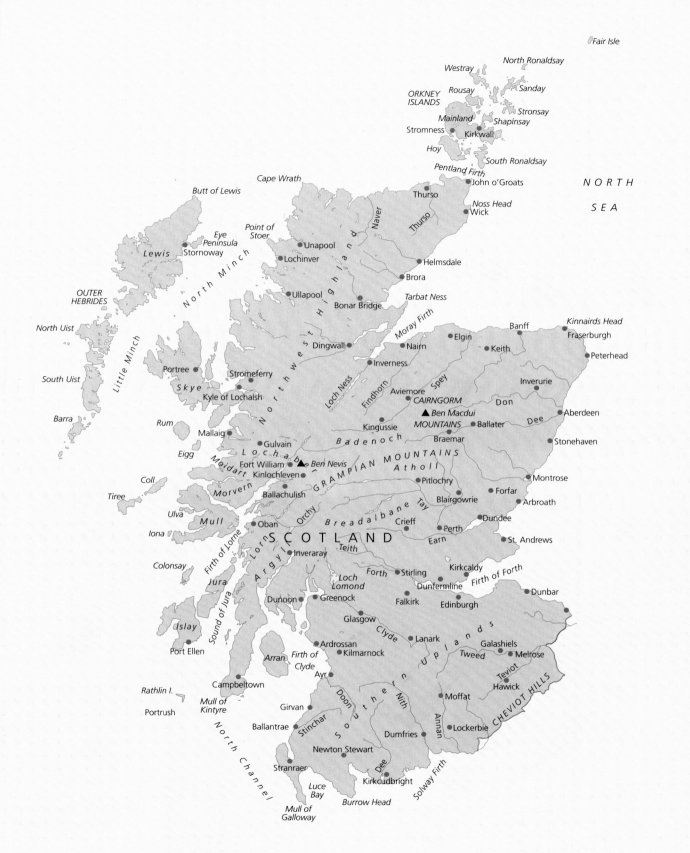

Fair Isle

NORTH
SEA

SHETLAND
ISLANDS

Herma Ness
Unst
Yell
Fetlar
St. Magnus Bay
Papa Stour
Whalsay
Mainland
Foula
Lerwick

ORKNEY
ISLANDS

Westray
North Ronaldsay
Rousay
Sanday
Stronsay
Mainland
Shapinsay
Stromness
Kirkwall
Hoy
South Ronaldsay
Pentland Firth
John o'Groats

Cape Wrath
Butt of Lewis
Thurso
Noss Head
Wick

Eye
Peninsula
Point of
Stoer
Unapool
Helmsdale
Lewis
Stornoway
Lochinver
Brora

North Minch
Naver
Thurso
Northwest Highland

OUTER
HEBRIDES
Ullapool
Bonar Bridge
Tarbat Ness

North Uist
Dingwall
Moray Firth
Banff
Kinnairds Head

Little Minch
Portree
Nairn
Elgin
Keith
Fraserburgh
South Uist
Inverness
Peterhead

Stromeferry
Loch Ness
Findhorn
Spey
Inverurie
Skye
Aviemore
CAIRNGORM
Don
Barra
Kyle of Lochalsh
Ben Macdui
Aberdeen
Rum
Kingussie
MOUNTAINS
Ballater
Mallaig
Badenoch
Braemar
Dee
Stonehaven
Eigg
Gulvain
Lochaber
Fort William
Ben Nevis
GRAMPIAN MOUNTAINS
Atholl
Kinlochleven
Montrose
Coll
Morvern
Ballachulish
Pitlochry
Forfar
Tiree
Orchy
Blairgowrie
Arbroath
Ulva
Mull
Oban
Breadalbane
Tay
Crieff
Dundee
Iona
Lorn
SCOTLAND
Perth
St. Andrews
Firth of Lorne
Earn
Inveraray
Teith
Colonsay
Argyll
Forth
Stirling
Kirkcaldy
Firth of Forth
Jura
Loch
Lomond
Dunfermline
Sound of Jura
Dunoon
Falkirk
Edinburgh
Dunbar
Greenock
Islay
Glasgow
Clyde
Lanark
Port Ellen
Ardrossan
Galashiels
Arran
Kilmarnock
Tweed
Melrose
Firth of
Clyde
Ayr
Southern Uplands
Teviot
Rathlin I.
Campbeltown
Hawick
CHEVIOT HILLS
Portrush
Mull of
Kintyre
Girvan
Doon
Moffat
Nith
Stinchar
Lockerbie
Ballantrae
Annan
Stranraer
Newton Stewart
Dumfries
North Channel
Dee
Kirkcudbright
Solway Firth
Luce
Bay
Burrow Head
Mull of
Galloway

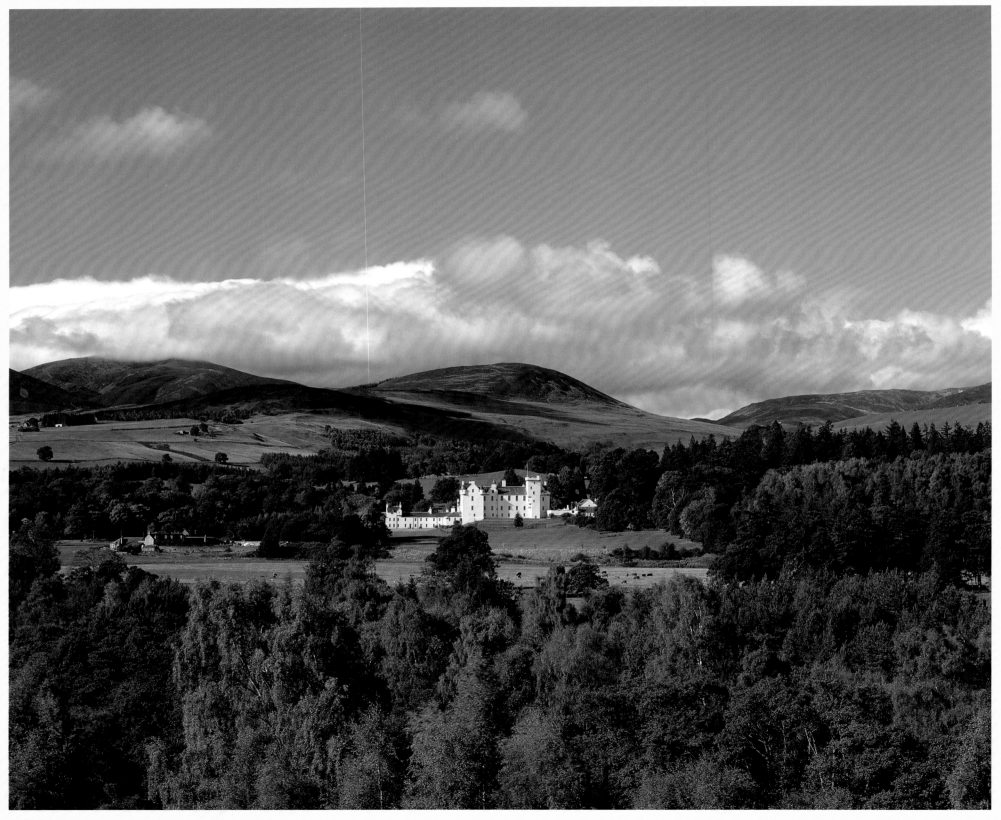

The Trossachs, Atholl and Breadalbane

The Trossachs (which means the 'bristly country' in Gaelic) are the region between Loch Venachar, to the northwest of Stirling, and Loch Lomond. The scenery of the area has attracted visitors since the eighteenth century. Sir Walter Scott is largely responsible for this; in the year following publication of his narrative poem 'The Lady of the Lake', the number of carriages along the shores of Loch Katrine is said to have increased from 55 to 270, and the flood of tourists has continued unabated ever since.

Loch Lomond itself is the largest area of fresh water in the British Isles. A line of islands at the south end of the loch – from Inchmurrin, through Creich, Torrinch and Inniscailloch – marks the Highland boundary fault, the dividing line between the Highlands and the Lowlands. The native oak woods that surround it were part of the vast oak forest that, 7,000 years ago, stretched from the south-west of England through to Sutherland. On the east side of Loch Lomond is Inversnaid and the drove road that leads past Loch Katrine. This is the country of the famous (or infamous) Rob Roy MacGregor. From Breadalbane through much of Atholl and into parts of Glen Shee, bands of limestone and other base-rich rocks have given rise to some fertile soils. These rocks are a major factor in the development of the unusual Arctic/Alpine flora of Ben Lawers and the hills of Breadalbane. The good soils of the district are a reason why farmers from Neolithic times on, have favoured the area. Even today, Atholl and Breadalbane are primarily stock-rearing country.

(left) **Blair Castle**

(above) **Tayside**

From Raiders to Drovers

Cattle have been central to Celtic society since the Bronze Age. If the harvest failed, cattle were a source of income with which to buy food for the winter. They were also the prey of raiders from other parts of the country where the harvest had not been successful. Cattle raiding was not thought of as theft by the Highlanders, but as a legitimate activity, so long as it was carried out between clans rather than within them. It was something in which all the clans indulged at one time or another, but it was a particular necessity for groups like the MacGregors, the MacDonells of Keppoch, and the MacDonalds of Glencoe, people with little or no arable ground of their own, or uncertain security of tenure, or both.

By the seventeenth century, cattle export had become a major part of the Highland economy. In the eighteenth century, when the cattle export trade was at its height, drovers would appear each autumn to buy cattle, even in the most remote districts. Many of the old drove roads still survive in the Trossachs – a reminder of a way of life that has now disappeared. However, the drover's life was not an easy one. He might need to take the cattle he had bought, usually on someone else's behalf, over a great distance through the Highlands. It would be essential to pay protection money to the clans through whose land he was travelling, or to men like Rob Roy, who arranged safe passage in exchange for payment.

Rob Roy

Rob Roy MacGregor of Inversnaid is one of the most controversial figures of Highland history. Some see him as a Gaelic Robin Hood, and others as no more than a clever, common thief and a brigand of no fixed loyalties. He was born in February 1671 at Glengyle, the third son of Donald MacGregor of Glengyle, from whom he inherited Inversnaid. His mother was a Campbell of Glenlyon. The family connection with the Campbells was important to Rob Roy and meant that he was able to look to his kinsman, the Earl of Breadalbane, chief of the powerful Campbells of Glenorchy, for support in times of difficulty.

Living in the disturbed times of the late seventeenth and early eighteenth centuries, and coming from a clan that was still subject to the ban on its existence imposed by James VI, Rob Roy lived the composite existence of de facto chief, farmer and cattle drover, protection racketeer, Highland Jacobite, soldier, and, some think, double agent. He spent much of his life as an outlaw of one sort or another. In 1713, wrongly accused of stealing £1000 from the Duke of Montrose, he was forced to take to the hills. In 1716 he carried out his most famous raid when he kidnapped the Duke of Montrose's factor, Graham of Killearn. Pursuit became hot, and in the next three years Rob Roy was captured three times – although he managed to escape each time. In 1717, having been active in the Jacobite Rising of 1715, he was listed in the Act of Attainder for treason.

In 1720 he settled in Balquhidder and was pardoned in 1725 through the good offices of General Wade, possibly in recognition of services rendered. He died peacefully in his bed in 1734 and is buried in the churchyard at Balquhidder. Even during his own lifetime he inspired a number of writers, but it was Sir Walter Scott's novel of 1818 that truly ensured his immortality.

Glen Falloch

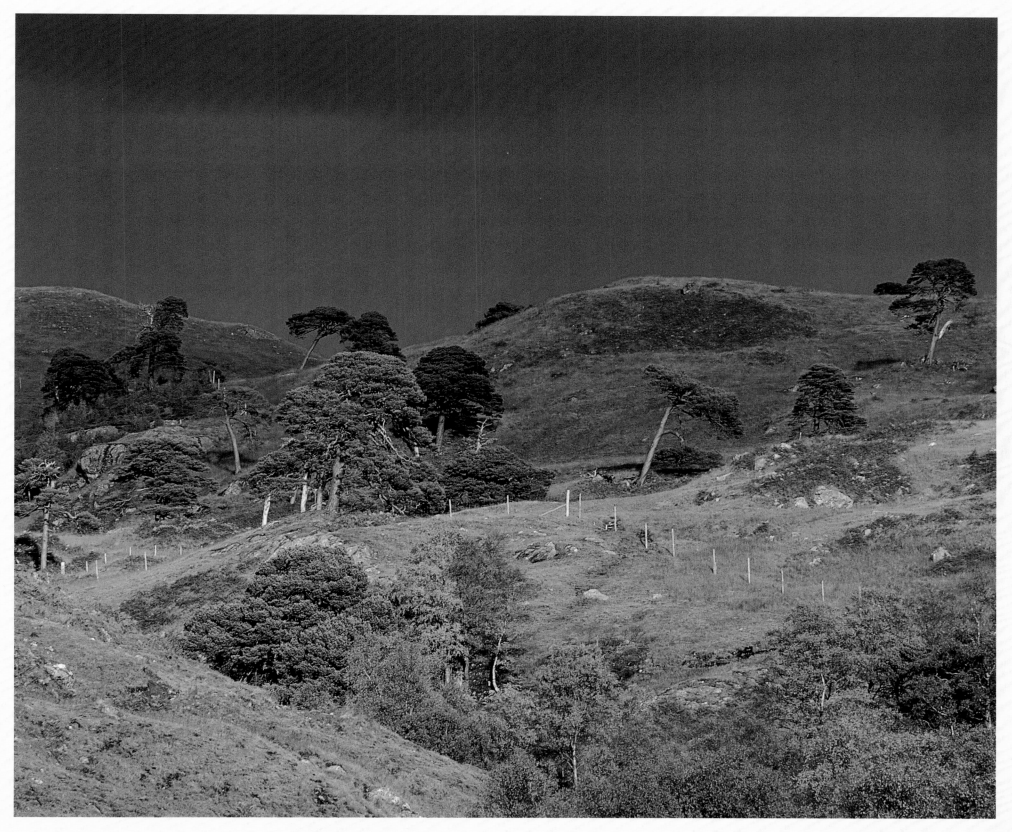

Shielings

If you study almost any map of the Highlands, you are sure to notice names with the prefixes *airigh* in the west and *ruigh* in the east. Often these prefixes have been corrupted, so you find that *airigh* becomes *ari* and *ruigh* becomes *ri*. These are Gaelic words for 'shieling', which means a summer grazing. The ruined remains of shieling huts are to be found all over the Highlands and are a reminder of the system of transhumance that prevailed here. The huts were occupied through the summer months by people who herded the cattle, sheep and goats on the high grazings.

The end of transhumance in the Highlands happened gradually, sometimes with the lower shielings becoming permanent settlements at times of population growth. Otherwise the system came to an end when the summer grazing was detached from a family's farm as a result of a landowner accepting a lowland grazier's bid for the area of the former summer pasture, or the conversion of the ground into deer forest. These things happened increasingly throughout the eighteenth and nineteenth centuries, but remnants of the old practice survived in the Outer Isles into the twentieth century.

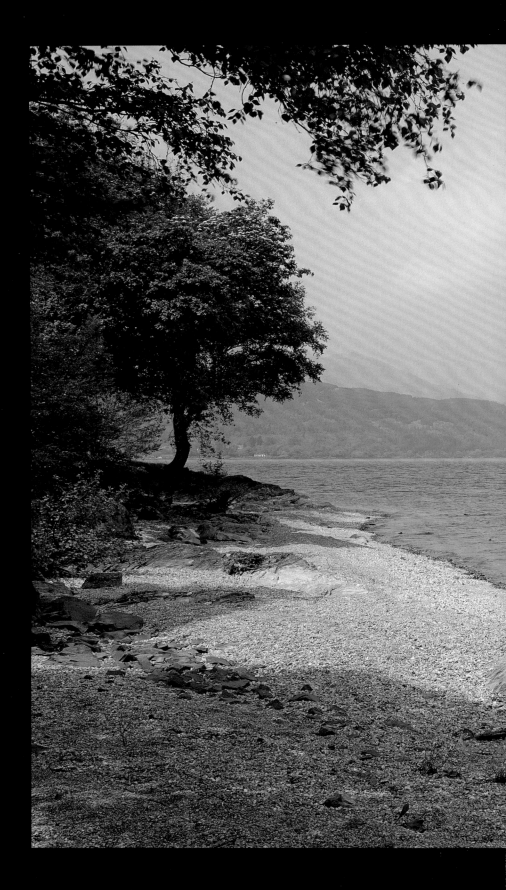

(next page) **Loch Tummel**

Loch Lomond

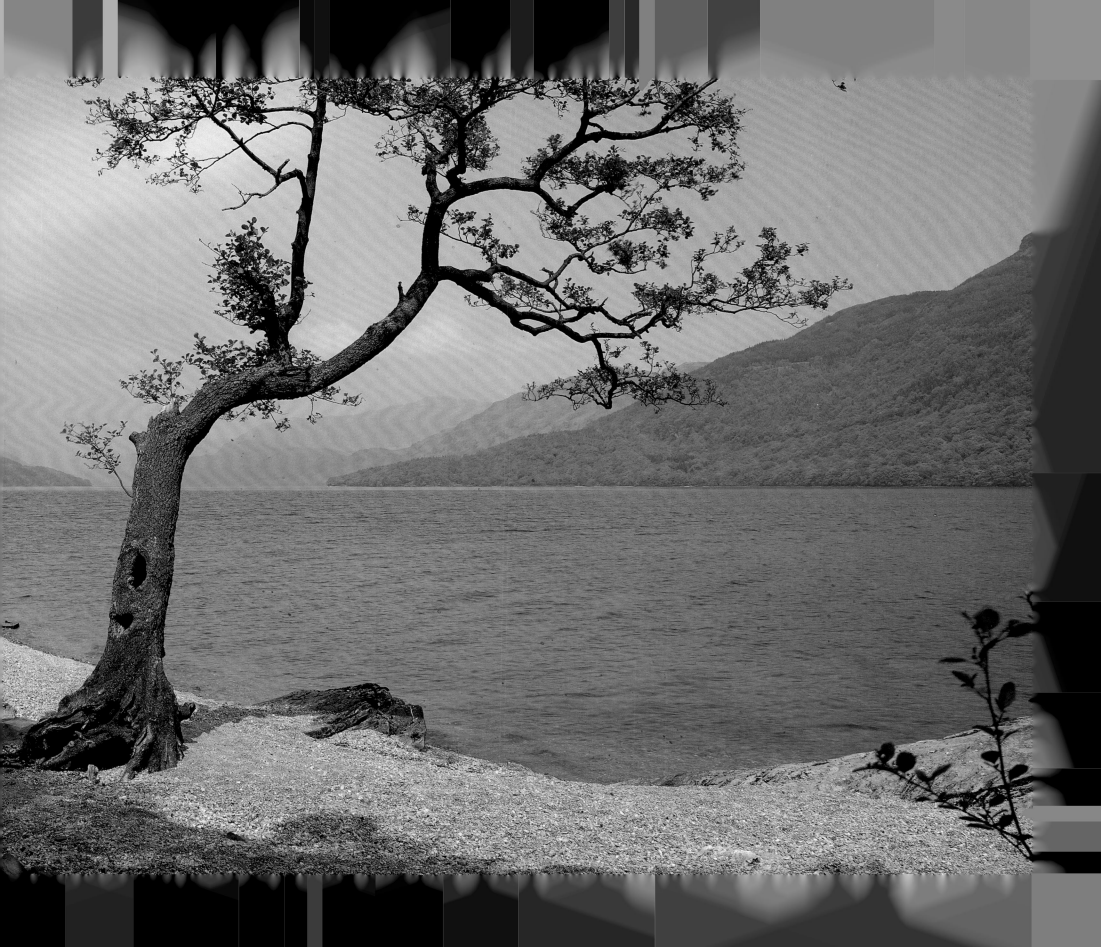

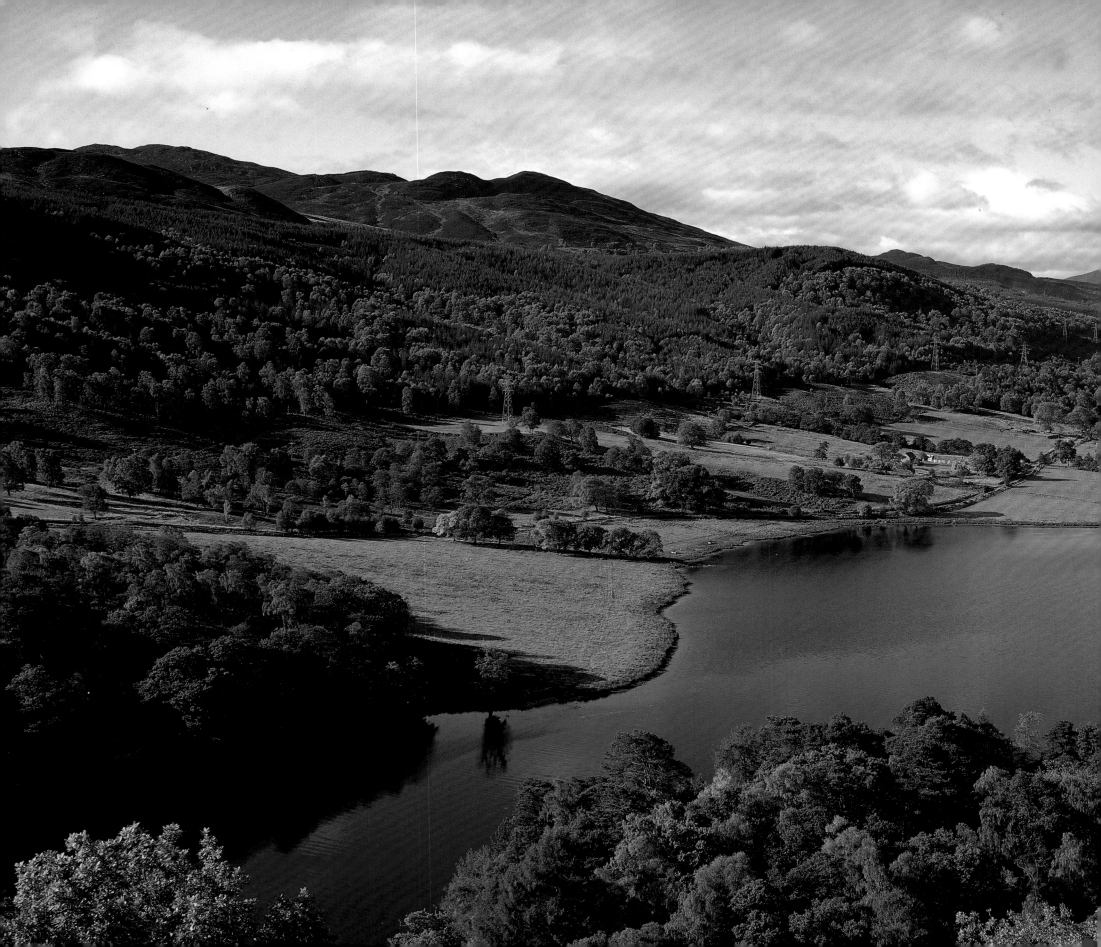

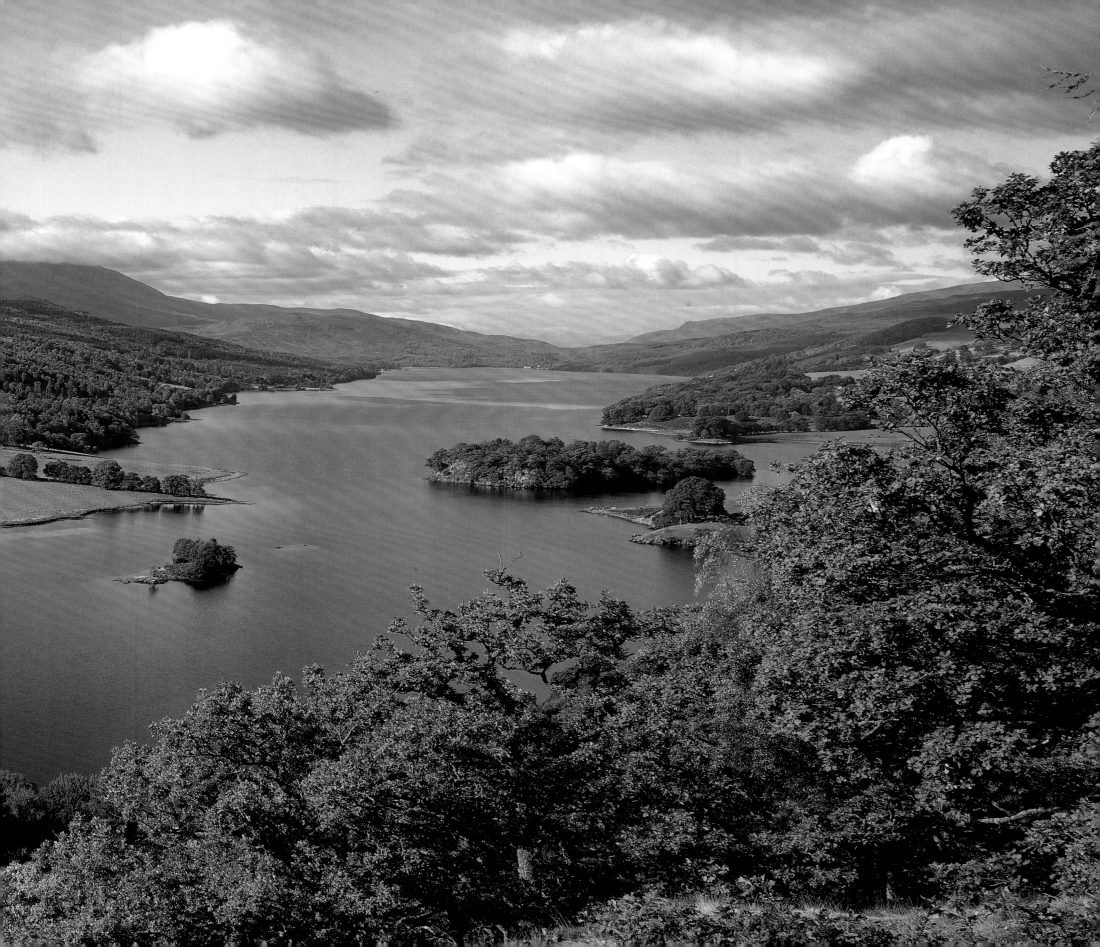

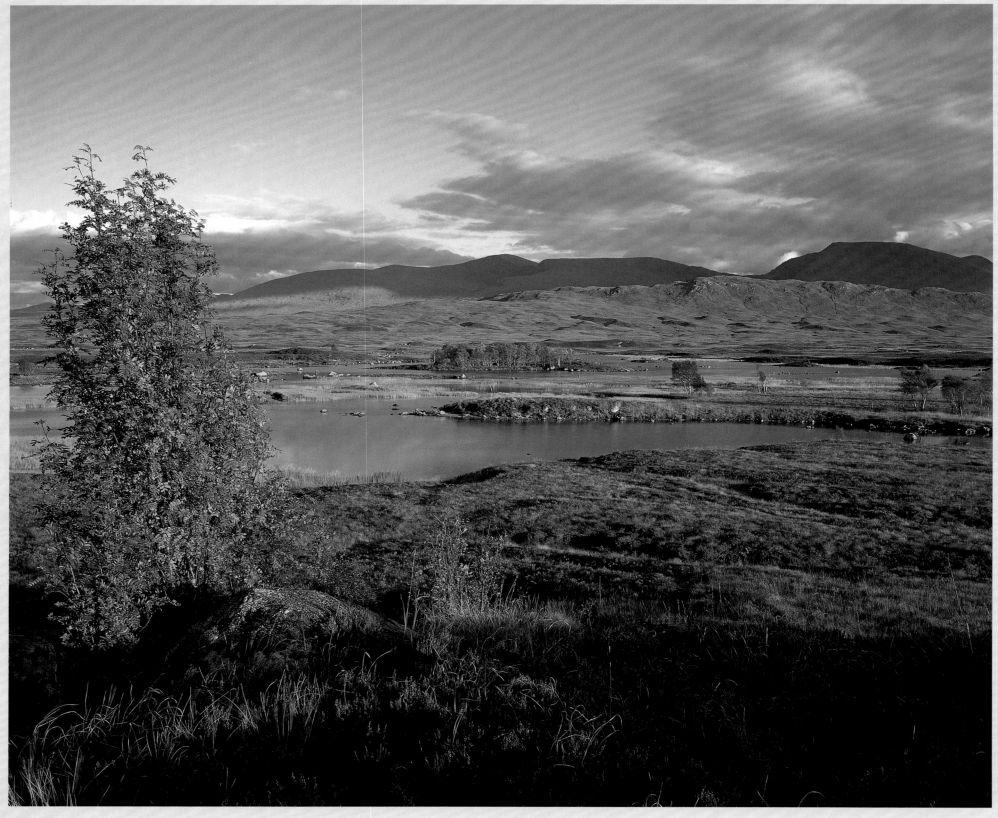

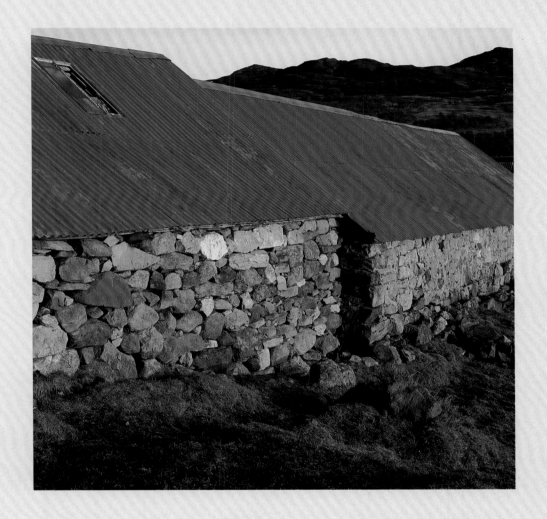

(left) Rannoch Moor

(above) A farm building beside Loch Tummel

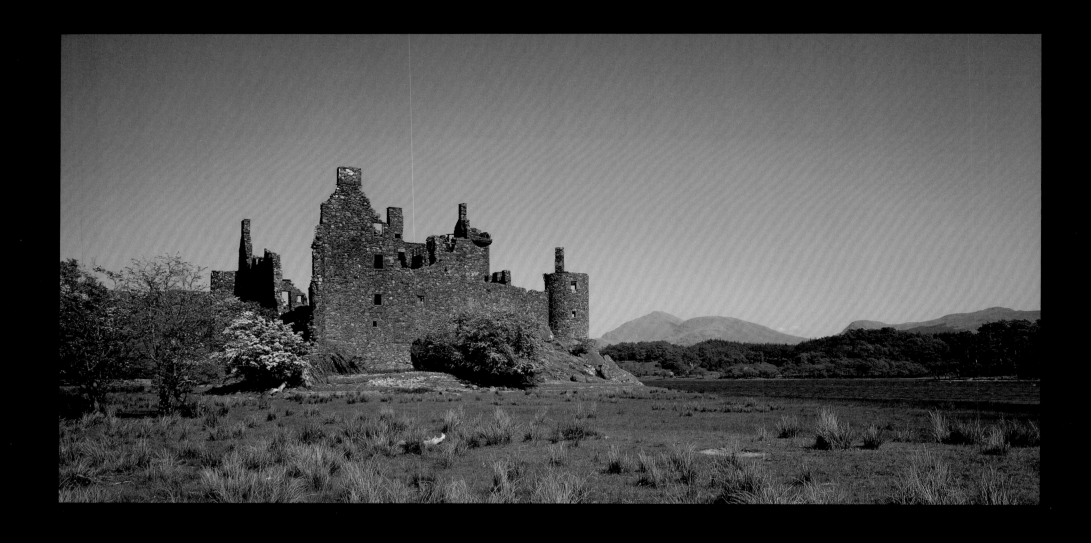

(above) Kilchurn Castle

(right) The ancient Black Wood of Rannoch

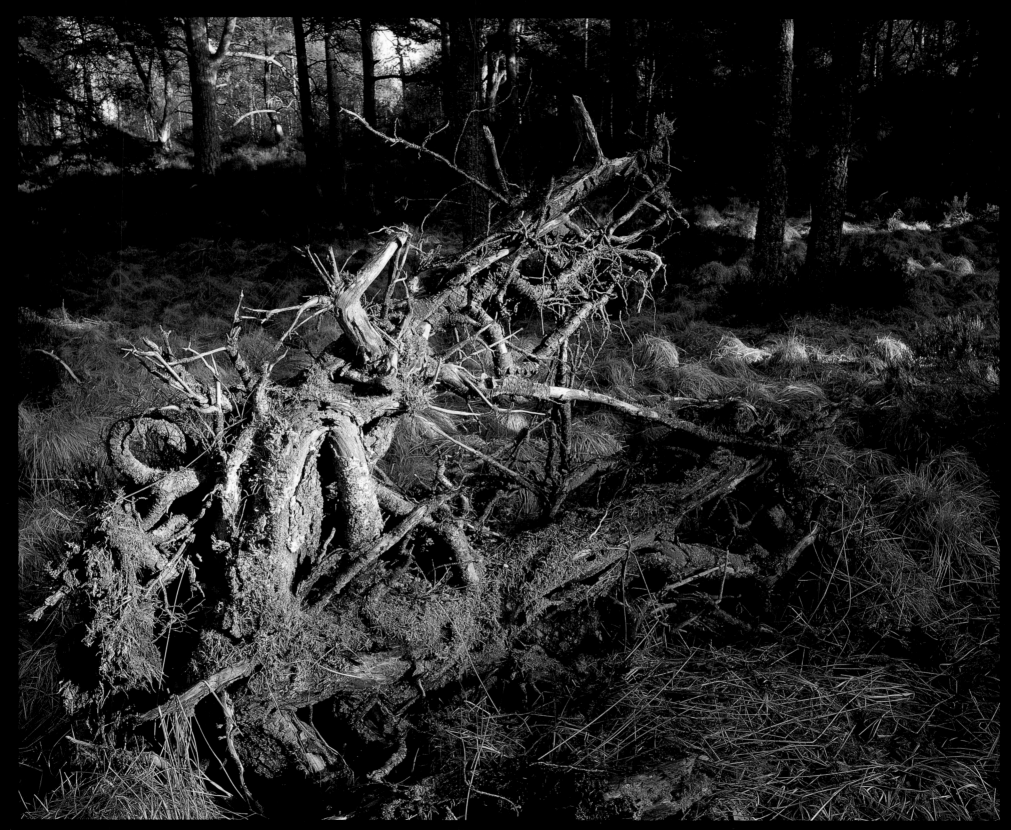

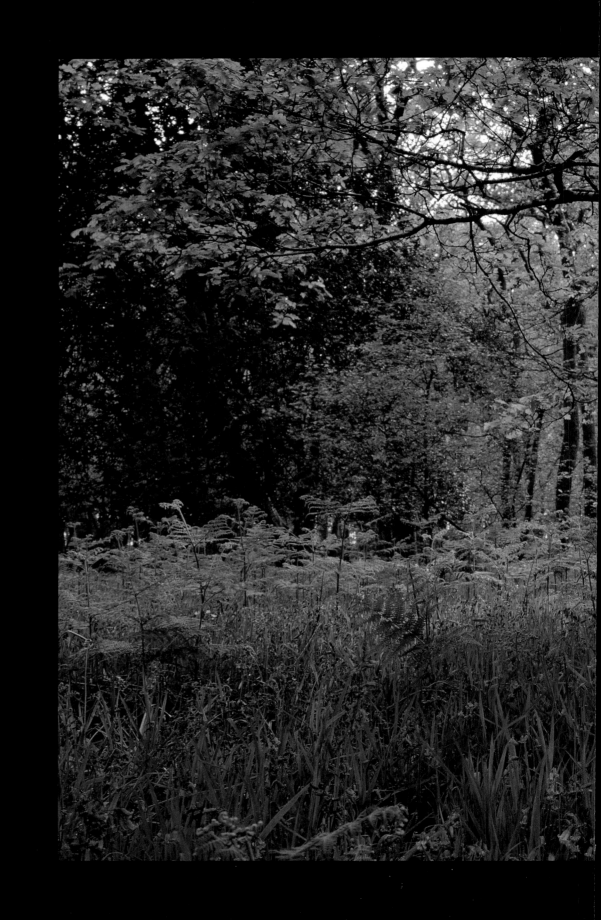

Bluebells in oakwoods near Rowardennan

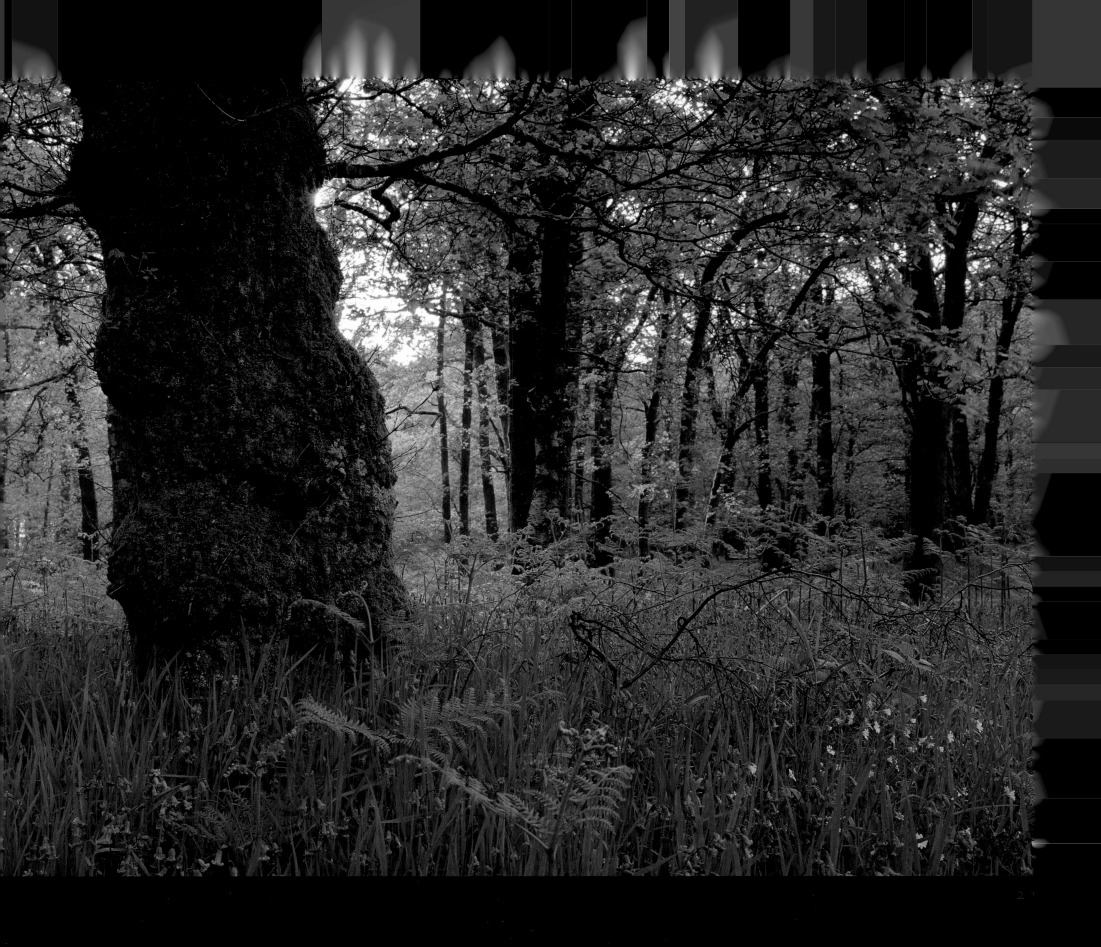

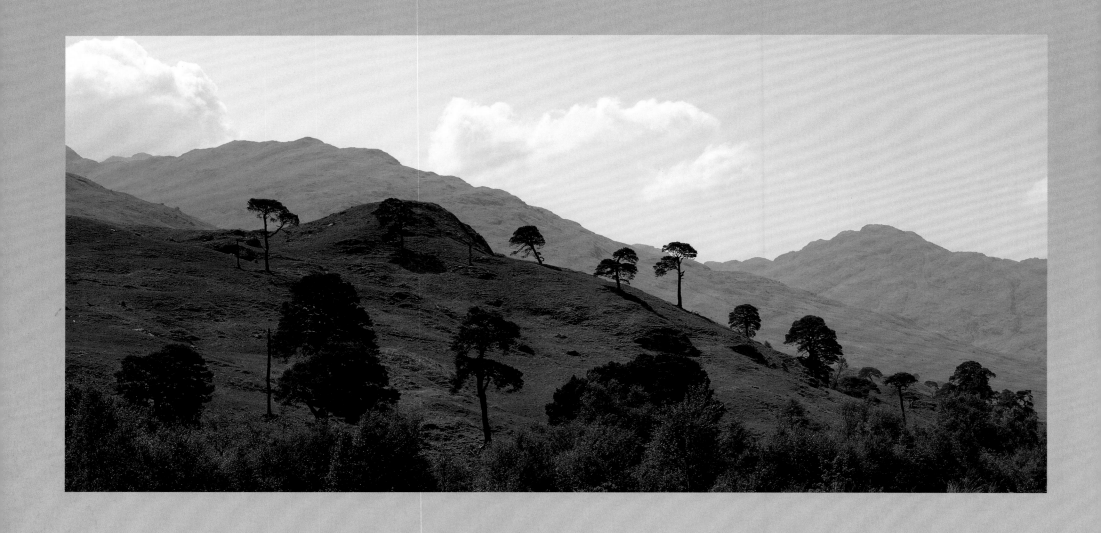

(above) Ancient pines near Crianlarich

(right) Kinloch Rannoch

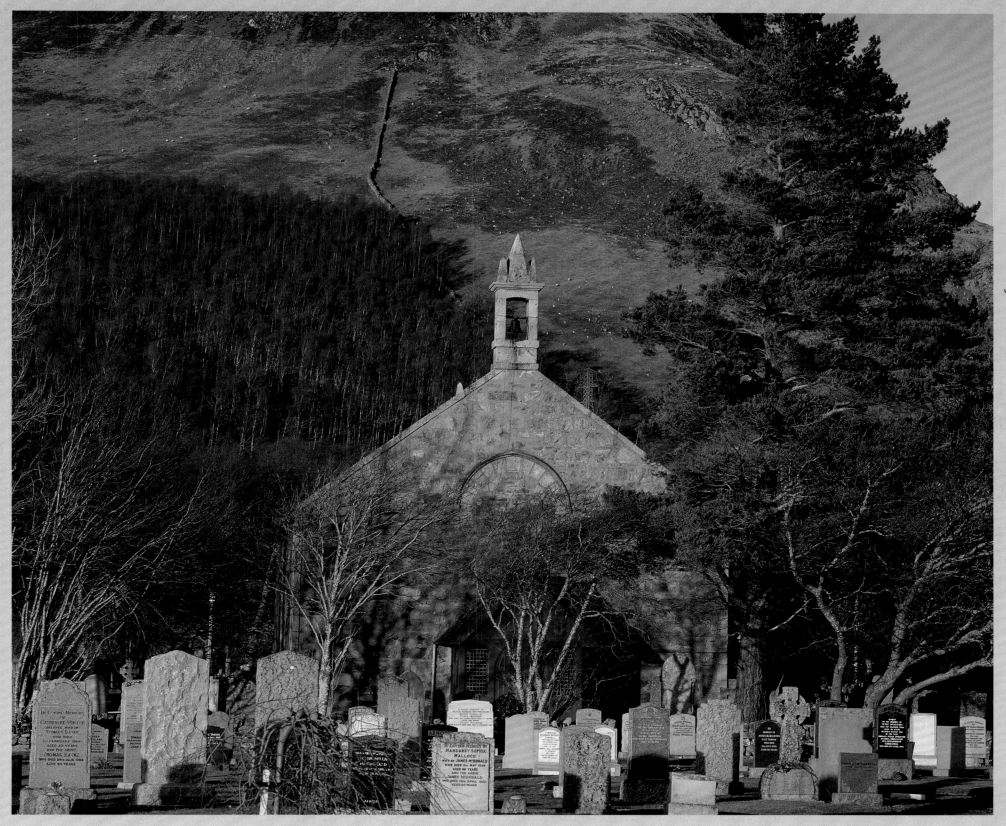

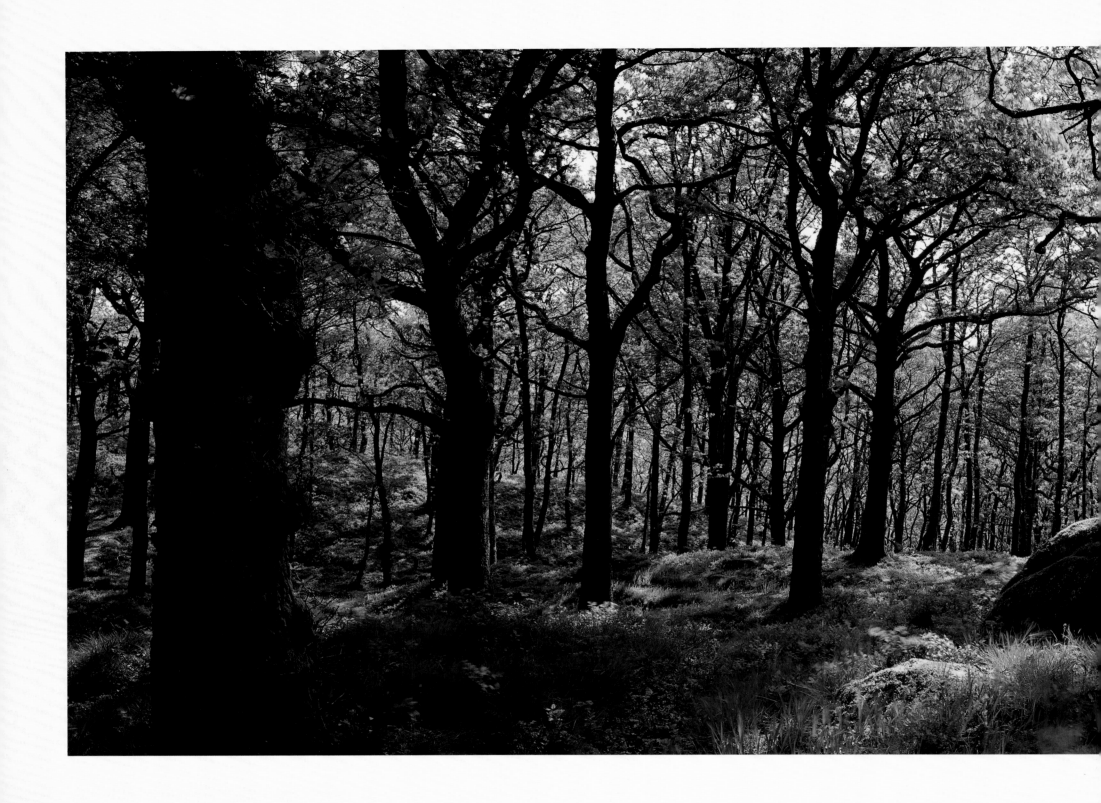

The Oakwoods of Achray above Aberfoyle

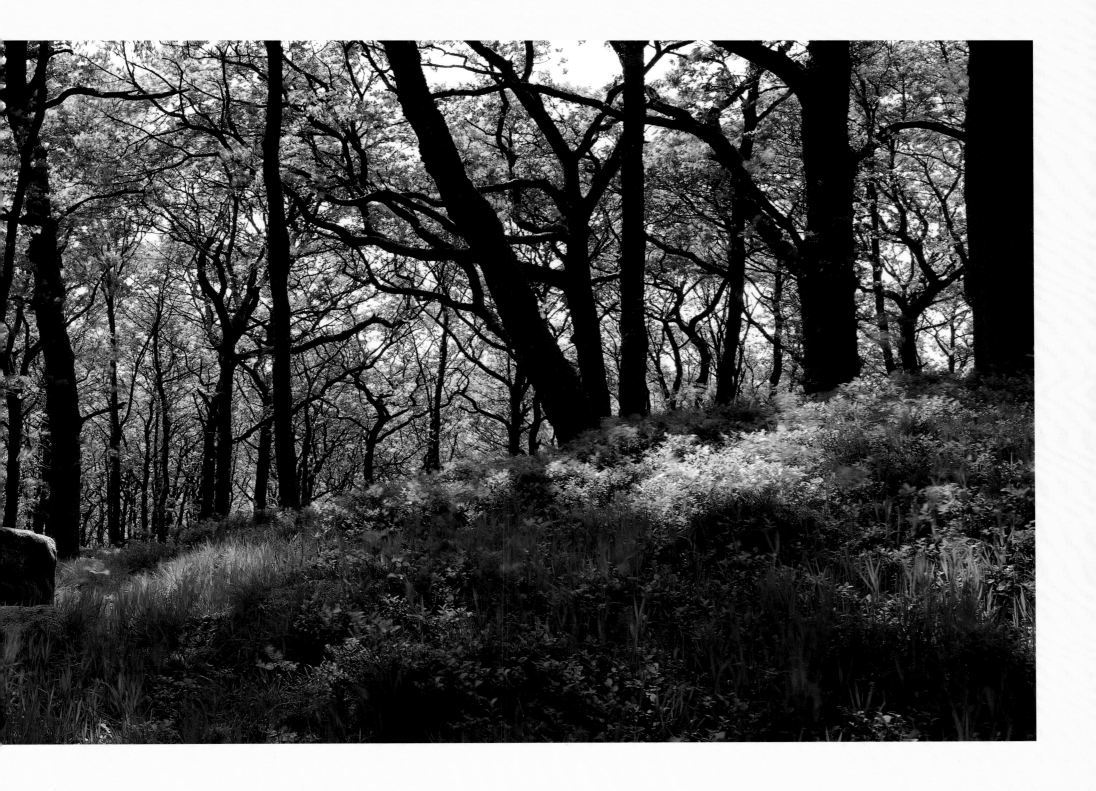

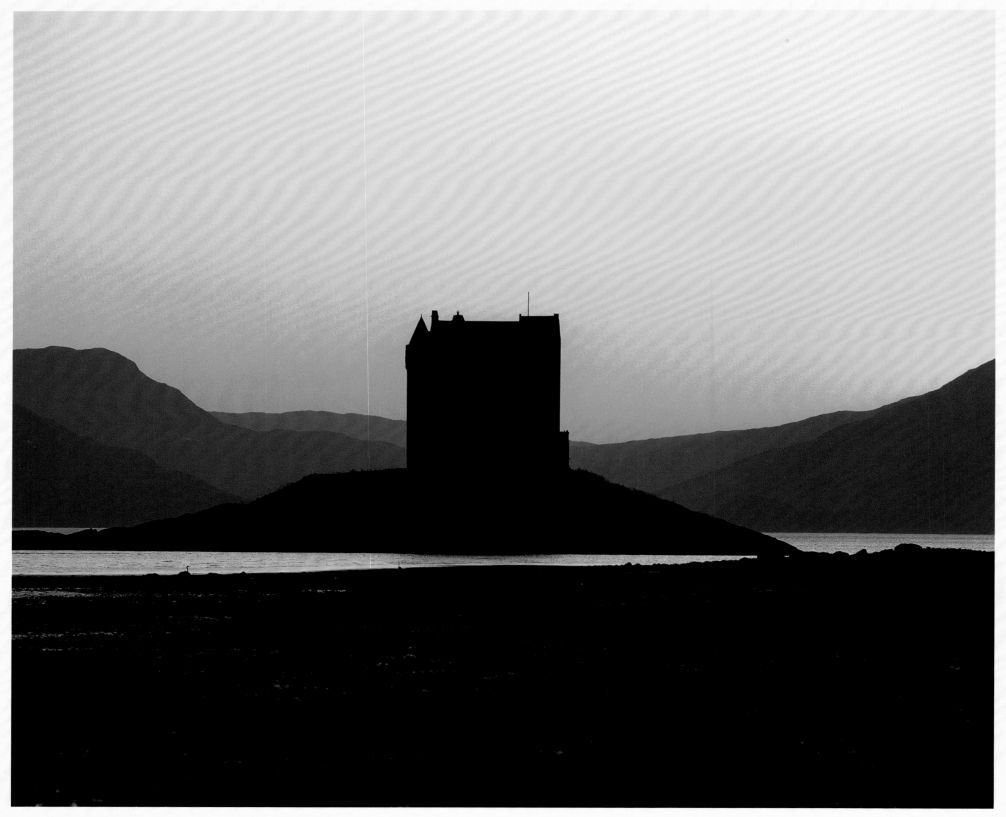

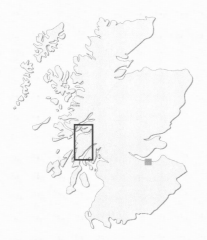

Lorne, Mid-Argyll and Appin

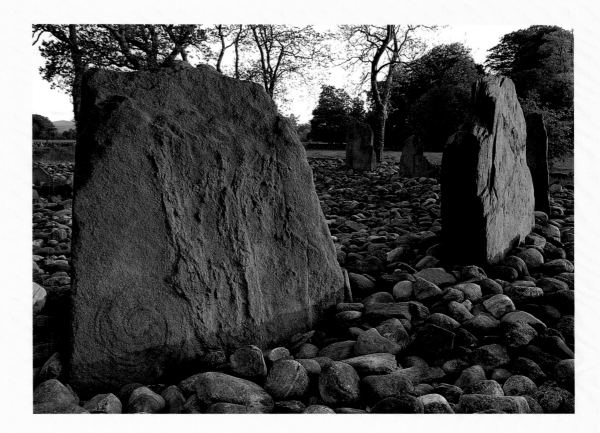

Humans had settled in Argyll long before the Gaels from Ulster made it their home. Some of the earliest evidence of human occupation in Scotland (from Mesolithic times – 10–7,000 years ago) has been found in the bay of Oban and on the shores of the islands of Jura and Oronsay. More importantly for this history of modern Scotland, however, it was from Argyll that the Gaels expanded to found the Kingdom of Alba (and so Scotland) under Kenneth MacAlpin in AD 843. It was from this area, too, that much of the conversion to Christianity of Scotland north of the Forth took place, powered by the spiritual energy that emanated from the Abbey of Iona.

Although the whole of Argyll is not much more than 240 kilometres (150 miles) from north to south, countless narrow inlets mean that the jagged coastline, from Cowal in the south, by Kintyre through Knapdale, up Lorne to Appin, and on to those conquests of the Campbells, Morvern and Ardnamurchan, stretches a staggering 1,600 kilometres (1,000 miles). Out to the west lies a string of islands, large and small, including Jura (Island of Deer); to the north of Jura is the infamous Strait of Corrievreckan, thought in the past to be a witch's cauldron because of its ferocious whirlpools. Inland, lochs and narrow passes cut through the hills.

Loch Awe, with its foot near Kilmartin (famous for its prehistoric standing stones and burial cairns) and its head guarded by the ruins of Kilchurn Castle, leads through to Breadalbane, on whose hills roamed the poet Donnchadh Ban Macintyre. Between Loch Awe and Loch Etive, on the lower slopes of Ben Cruachan, is the Pass of Brander, where Robert the Bruce put the MacDougalls to flight – a pass so steep and narrow that legend says it was once held against an army by an old woman wielding a scythe.

(left) Castle Stalker

(above) **The stone circles of Templewood**

Appin, famous for its associations with the Stewart clan, carries with it an aura of romantic tragedy: near the bridge at Ballachulish stands a monument to James Stewart of Acharn (James of the Glen), wrongly hanged in 1752 for the murder of Colin Campbell, a government officer, during the Highland clearances – an incident made famous by Robert Louis Stevenson in his novel, *Kidnapped*.

Going east from Ballachulish along the side of Loch Leven, one passes Eilean Munde, burial ground of the MacDonalds of Glencoe. Then Glencoe itself, site of one of the most infamous acts of betrayal in Scottish history, rises ahead. A wild, narrow valley that seems, even in the height of summer, to be full of gloom and foreboding, Glencoe is bounded by high volcanic peaks that are among Britain's most taxing mountaineering challenges: the Sgùrr na Ciche or Pap of Glencoe, Bidean nam Bian (at 1,141 metres/3,743 feet, the highest point in Argyll) and its foothills, the Three Sisters of Glen Coe: Beinn Fhada, Gearr Aonach and Aonach Dubh.

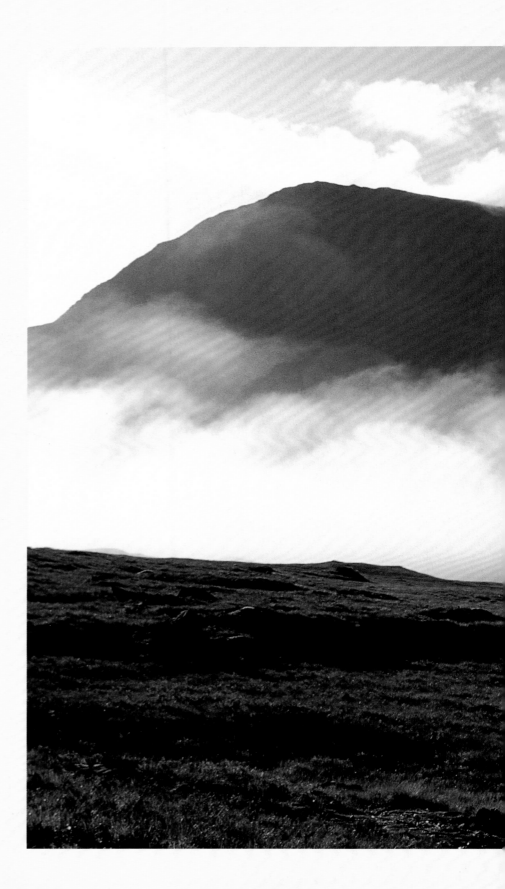

Glencoe

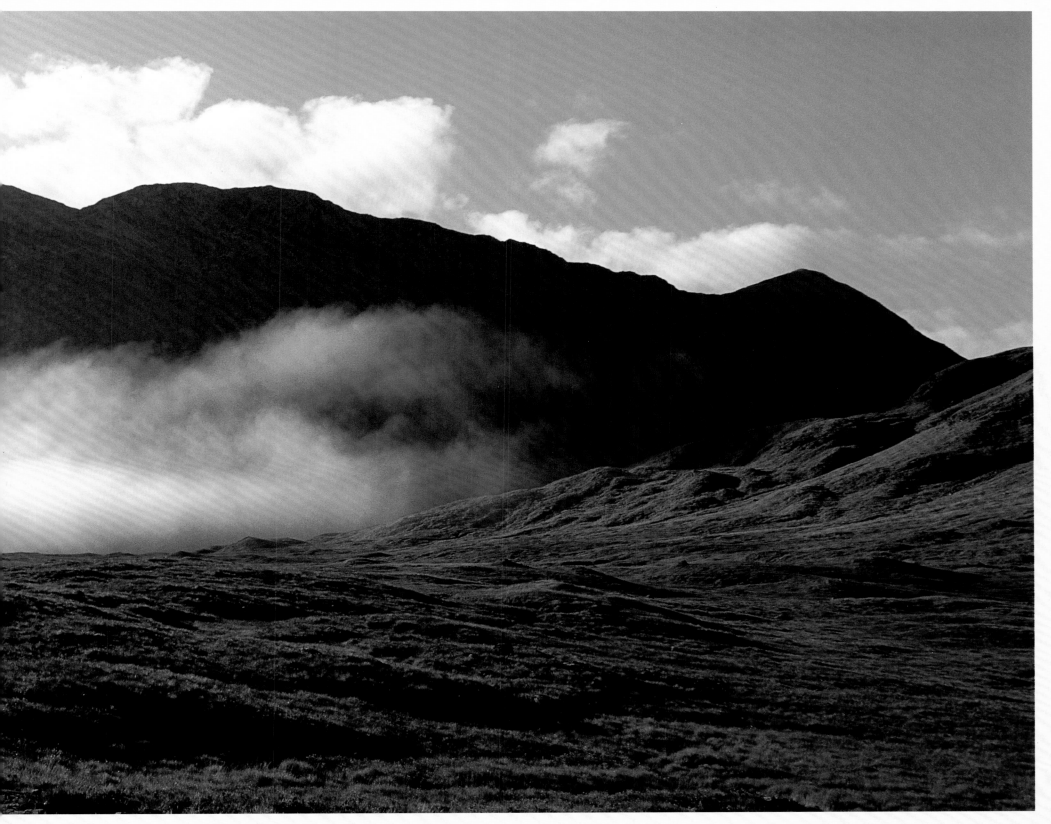

The massacre of Glencoe

Determined to exert his authority over the Scots, on 29 August 1691, William III of Orange issued a royal proclamation requiring the clans to take an oath of allegiance by 1 January 1692. Alasdair, elderly chief of the MacDonalds of Glencoe, went to Fort William to swear his oath of allegiance, when he should have gone to Inverary to swear it before the Sheriff of Argyll, Campbell of Ardkinglass. There followed a long journey in treacherous weather conditions before Alasdair arrived at Inverary on 2 January – only to find that Campbell of Ardkinglass was at home on the other side of Loch Fyne, celebrating the New Year. The Sheriff returned to Inverary on 5 January and accepted MacDonald's oath, but had to say that as it was late the oath was technically invalid. The old chief wept when he heard this, for he knew that he had played into the hands of his enemies.

On 1 February, troops arrived in Glencoe and were billeted among the MacDonalds. This was a standard way of collecting tax arrears in kind and so aroused no suspicion. On the night of 12 February, however, orders were given to massacre all MacDonalds under the age of 70. At five o'clock on the morning of 13 February, the killing began. About a dozen people were murdered, including the old chief and his family, and more than twenty others died of exposure out on the hillside as they tried to flee the glen.

Despite an official inquiry, those responsible were not brought to justice. The massacre was a small one in the history of human barbarity, and in mid-seventeenth-century Scotland it would hardly have rated a footnote in the annals. However the State-sanctioned conspiracy that brought it about, and the heinous nature of 'murder under trust', make it particularly disgraceful. The Jacobites were later able to make much of this example of perfidious behaviour by the new king towards his people.

Glencoe

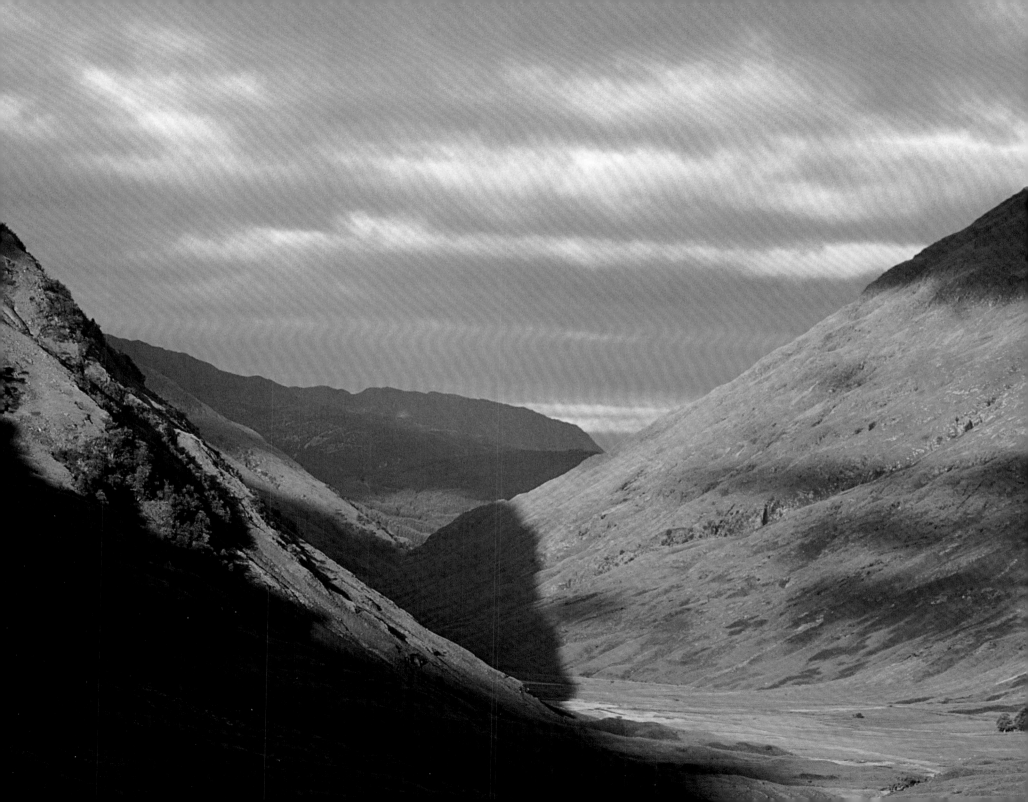

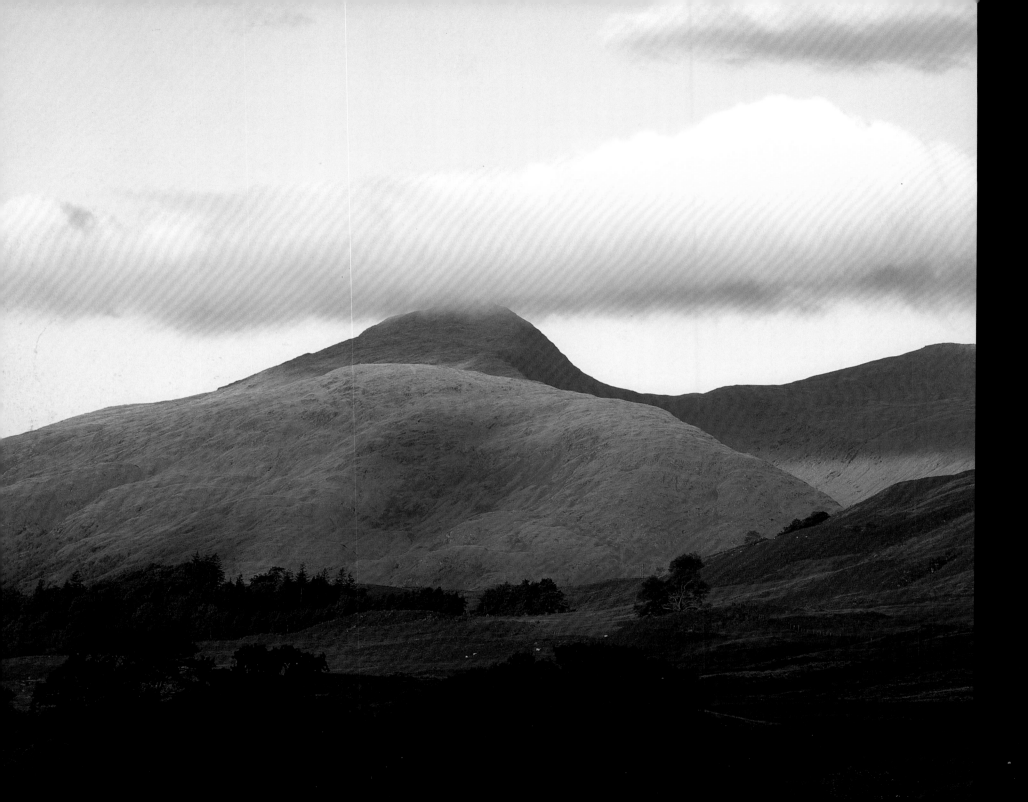

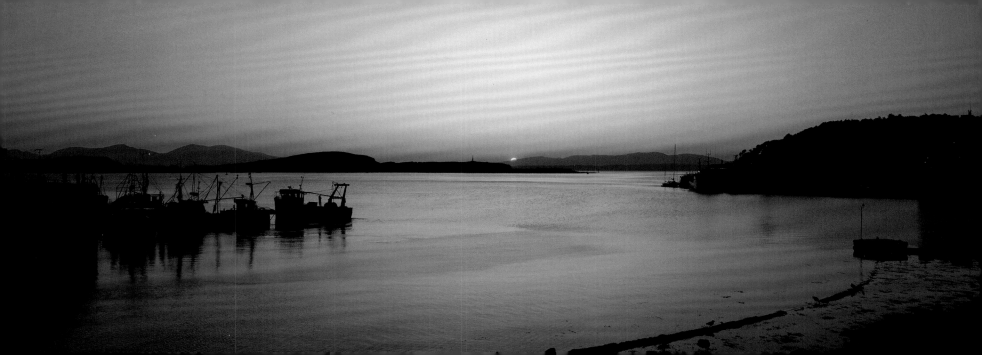

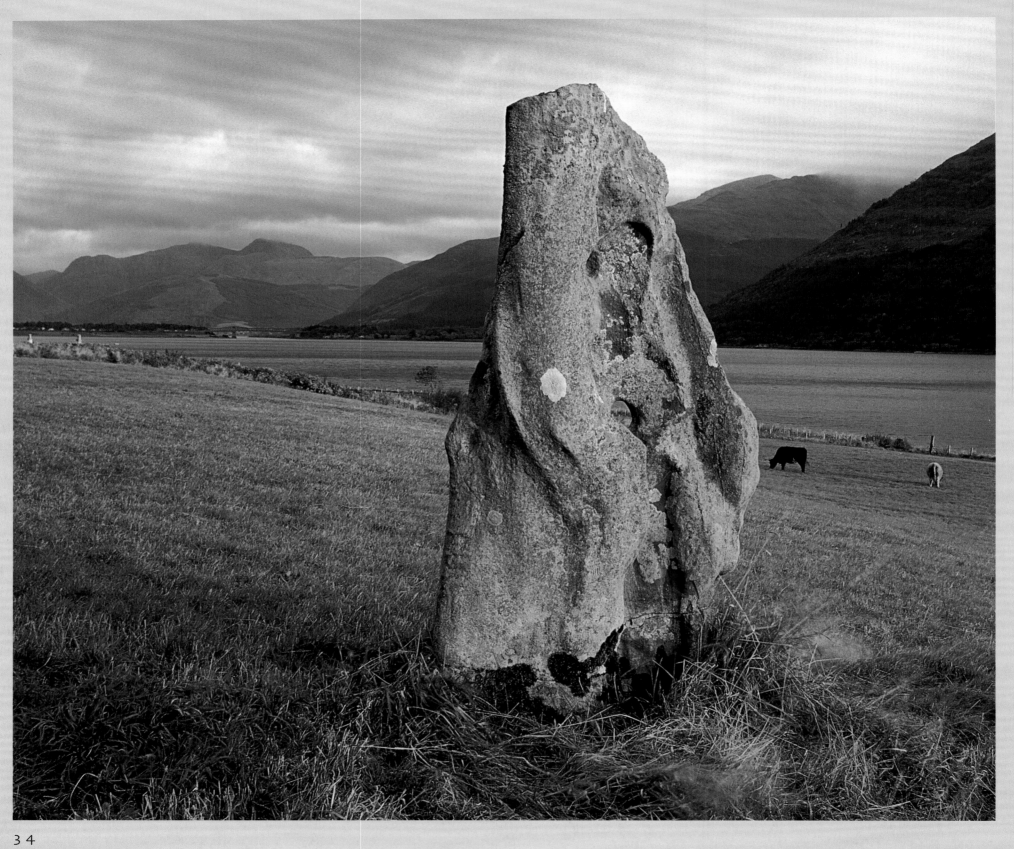

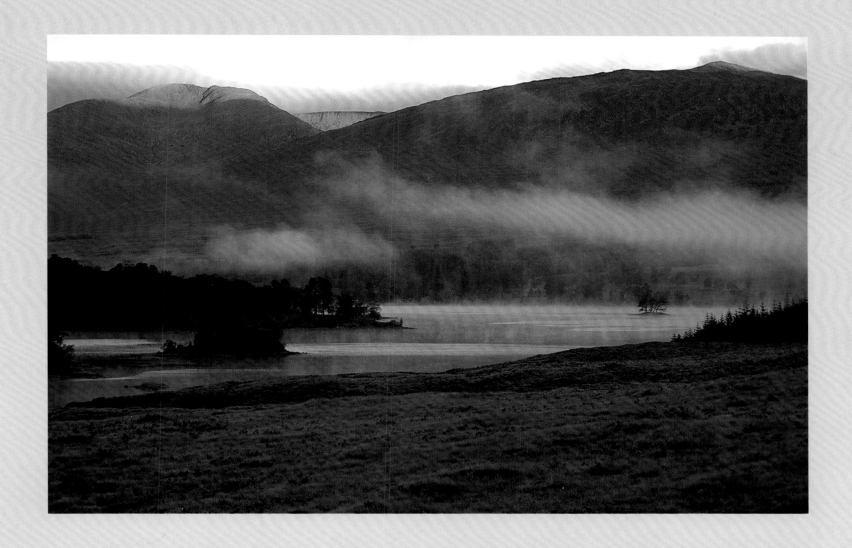

(left) Standing stone, Loch Linnhe

(above) Loch Tulla

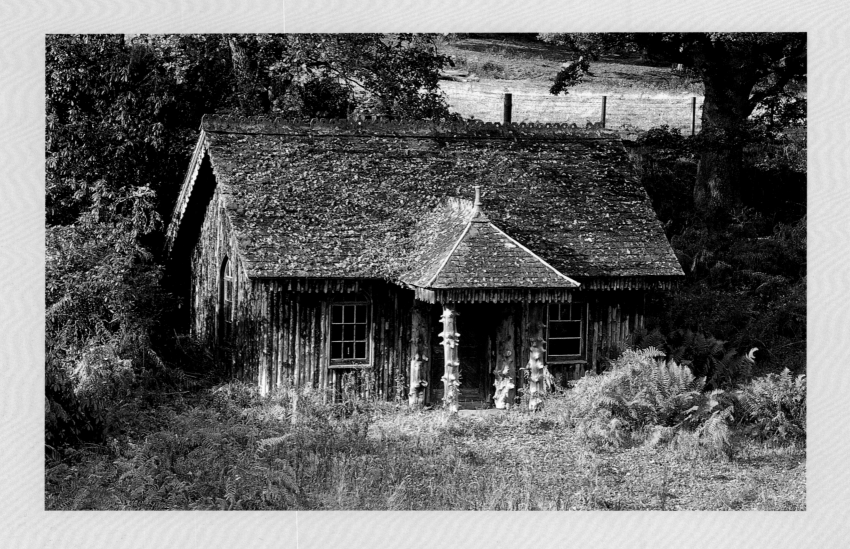

(above) A **pine cottage**

(right) **Loch Awe**

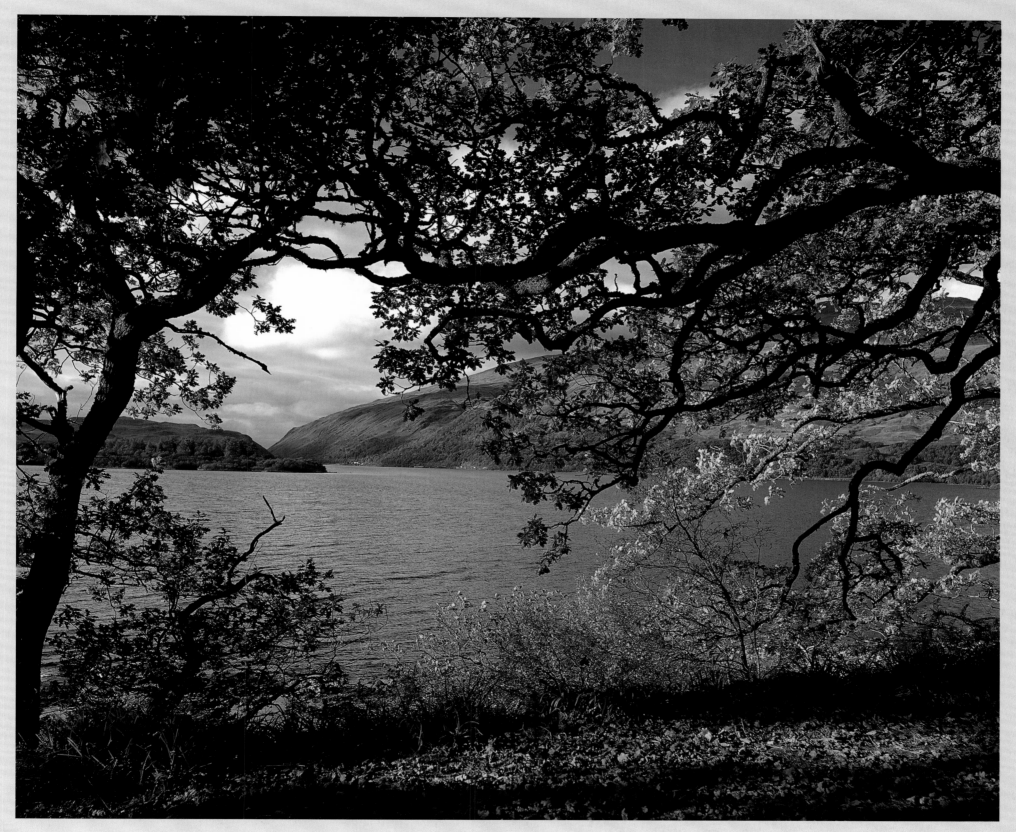

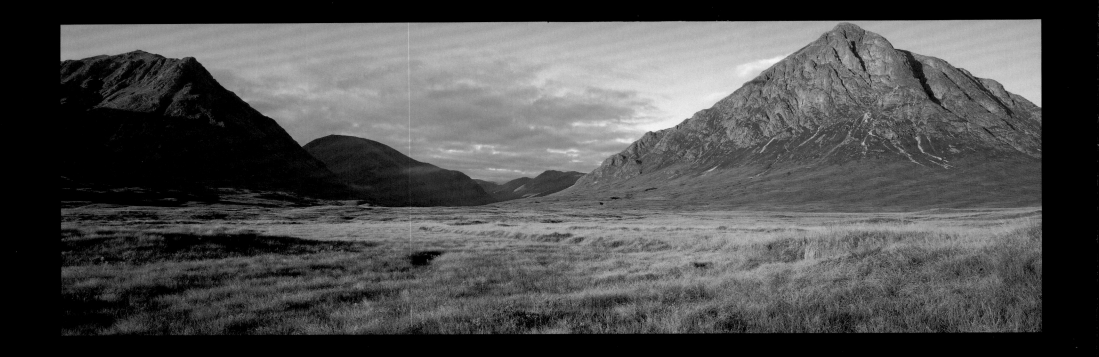

(above) Glen Etive

(right) A burn near Buchaille Etive Mor

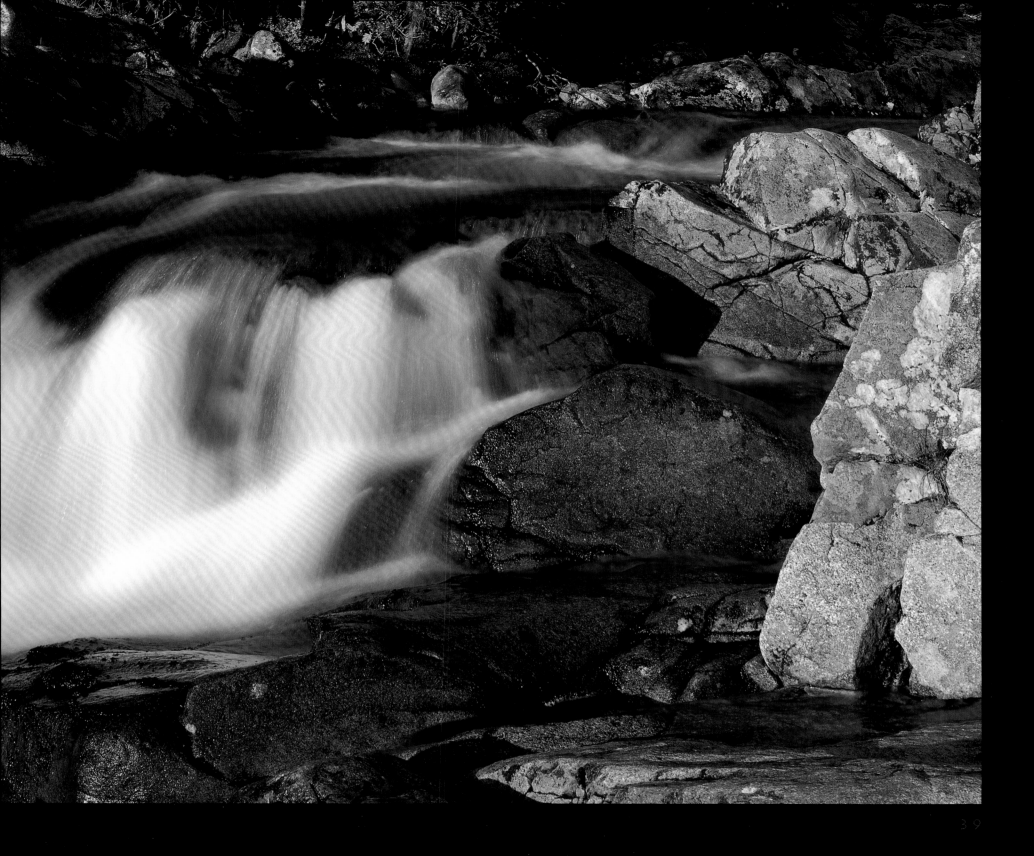

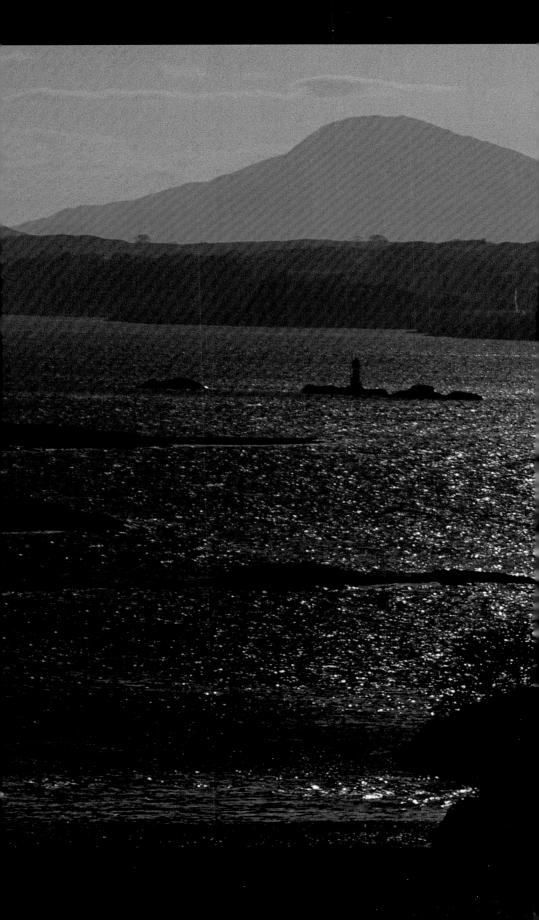

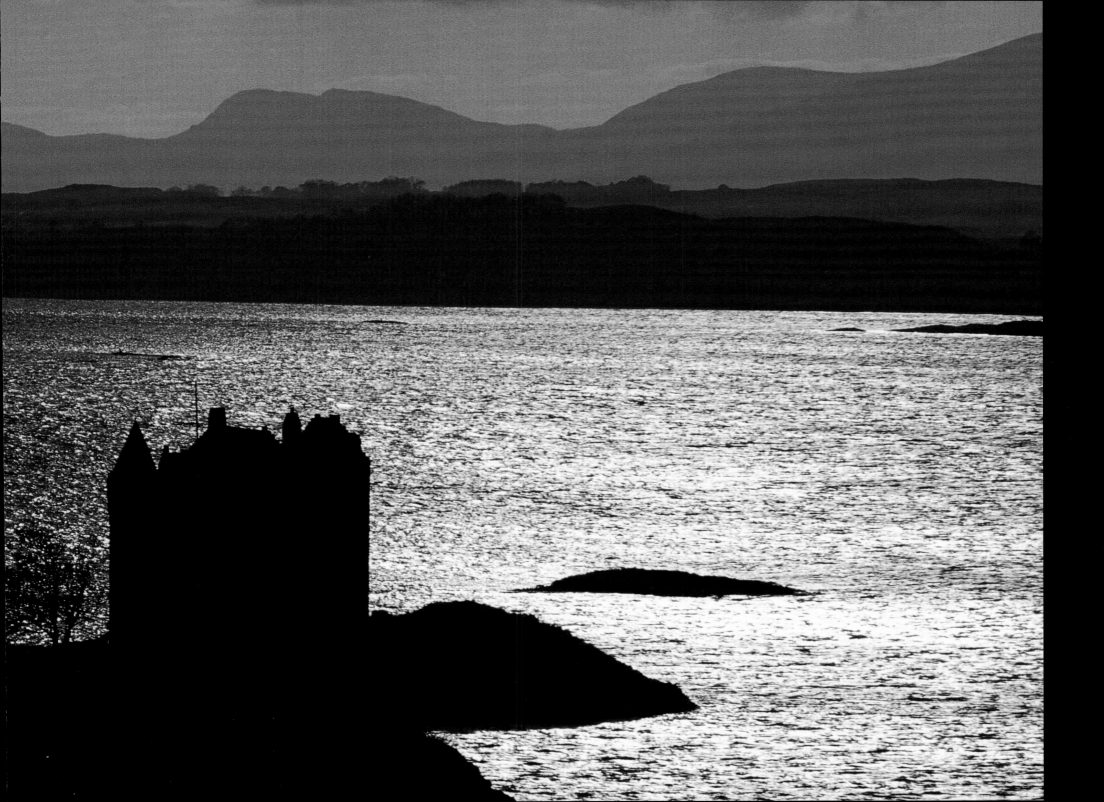

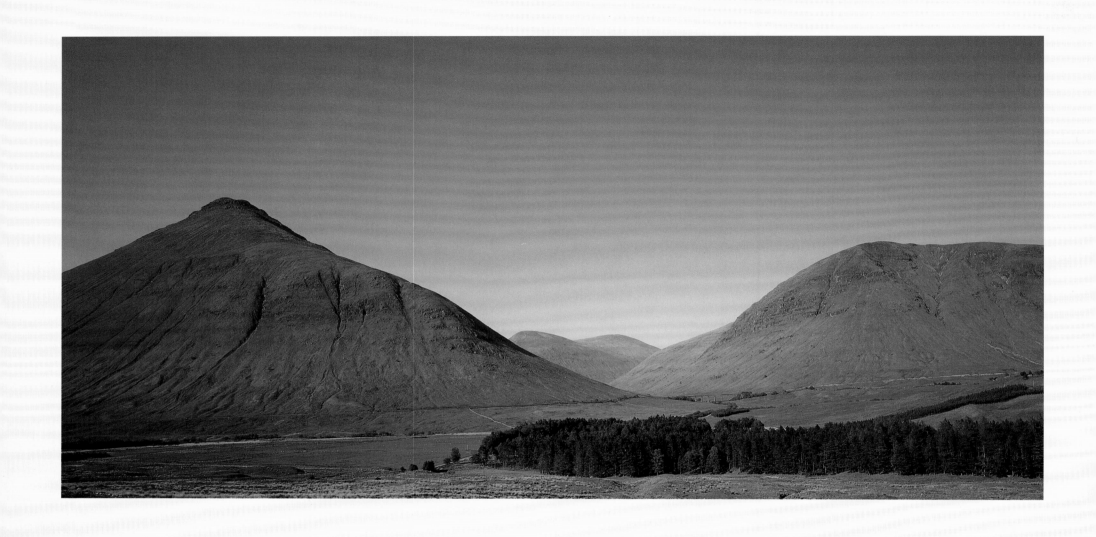

(above) Glen Dorain

(right) The Falls of Orchy

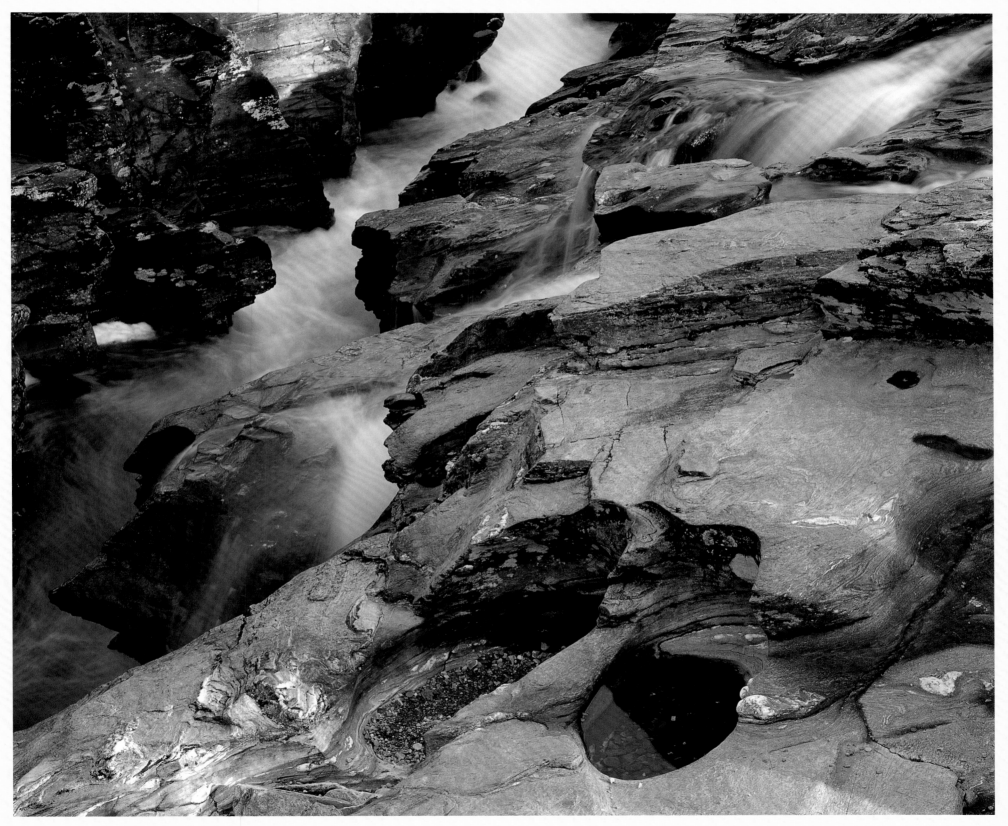

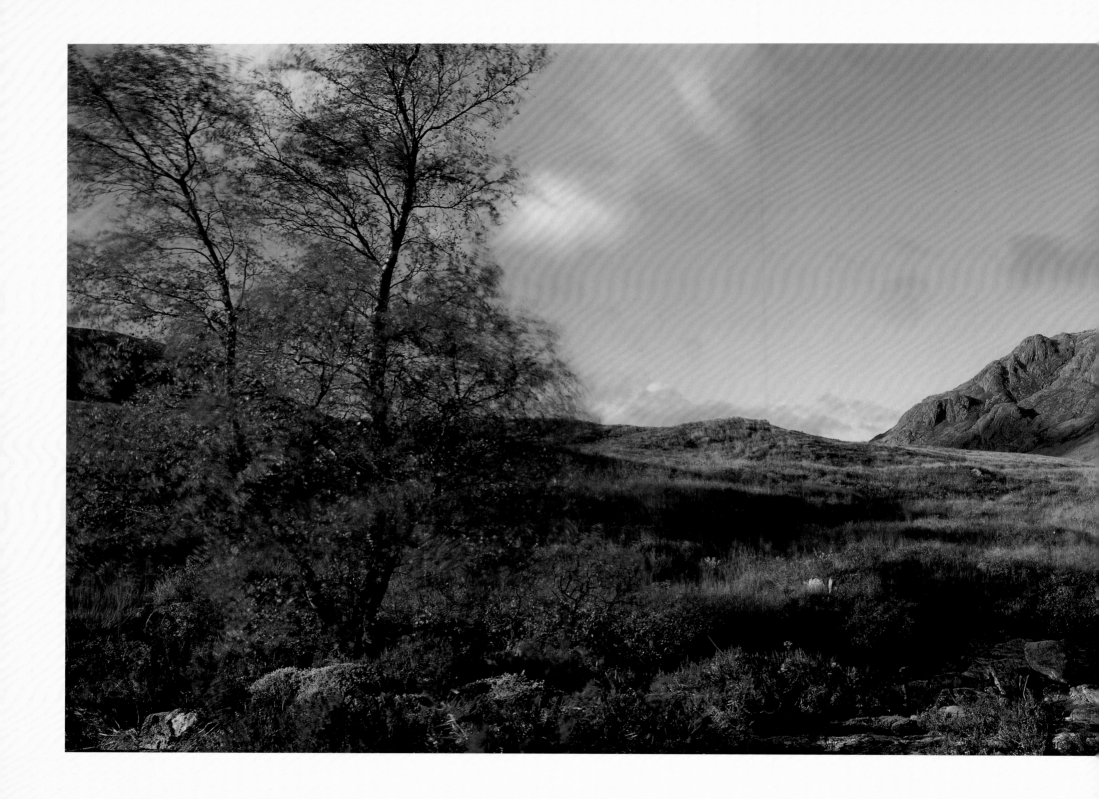

Buchaille Etive Mor

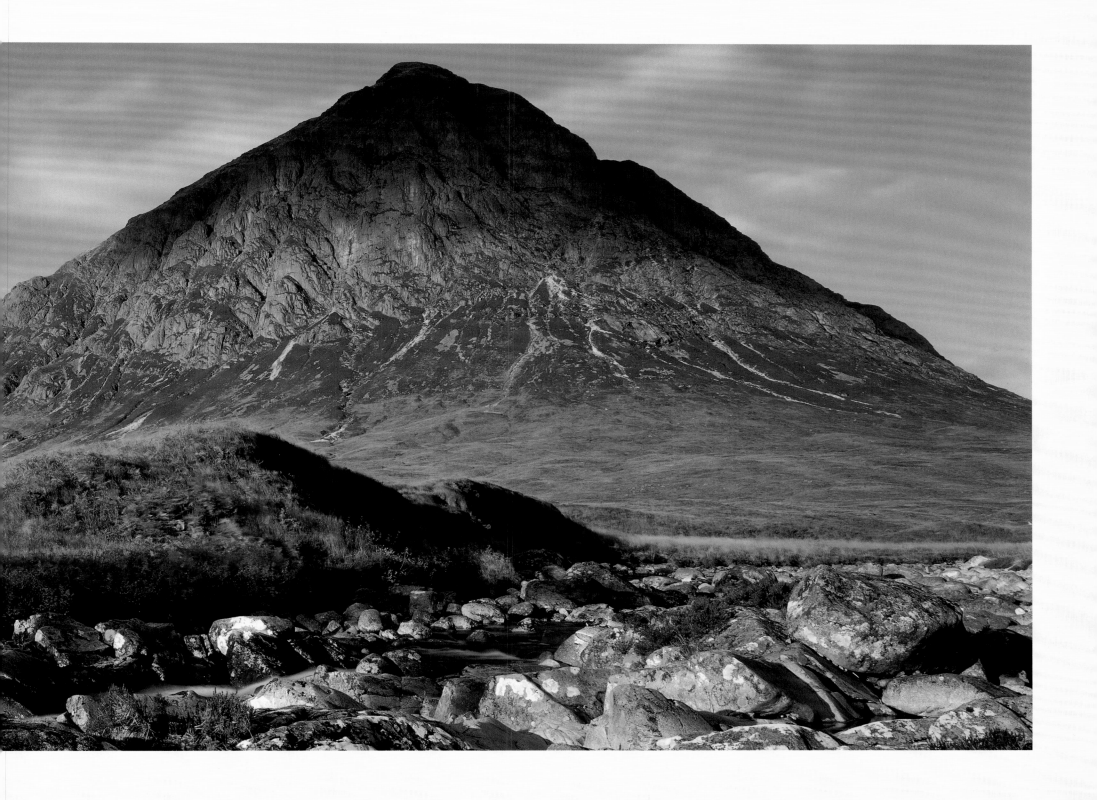

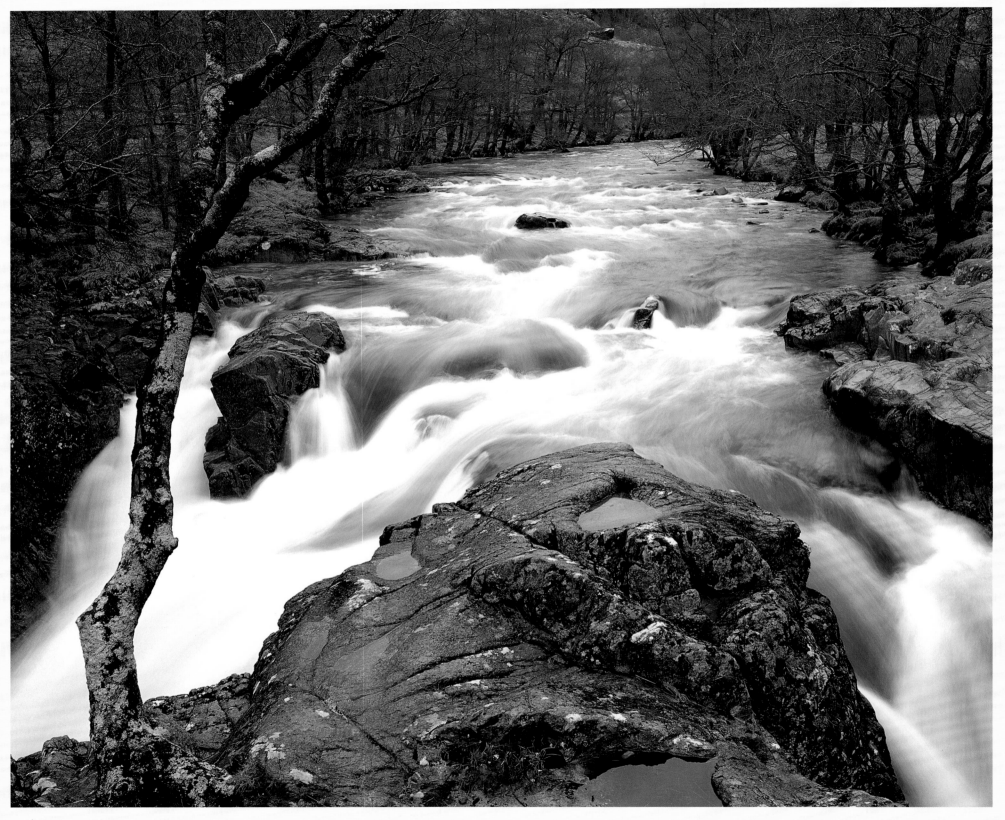

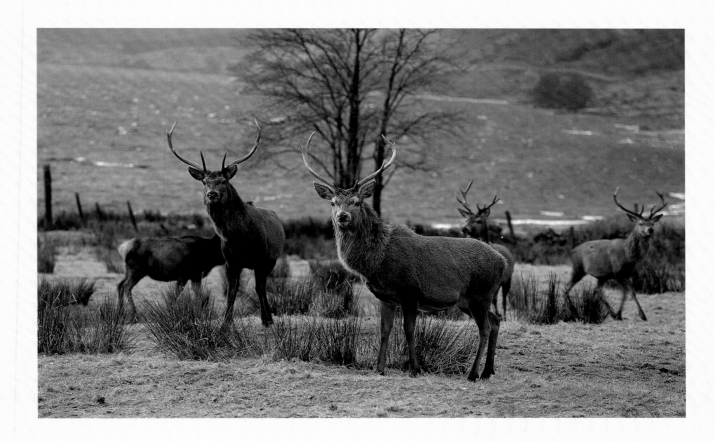

Lochaber

Lochaber is bounded by Badenoch to the north-east and by Moidart and Morvern to the north and west. To the south its limits are Loch Leven and Glencoe; to the east, Corrour. A hint of the region's sometimes violent history can be gleaned from the fact it has given its name to the "Lochaber axe", a long-bladed axe with a hooked handle, designed to unseat riders.

Brae Lochaber (Fort William through to Glen Spean) includes Glen Roy, famous as the route by which the Royalist army of Montrose and MacColla Chiotaich approached Inverlochy in February 1645. Nearby is Mulroy, the site of the last clan battle (1688), where the MacDonells of Keppoch, reinforced by the Camerons, defeated the Macintoshes, who were supported by Government troops. Inverlair House, a few hundred yards away from Cillechoiril, the spiritual centre of Brae Lochaber, was the site of the Keppoch murder (see page 51). Lochaber also contains the greatest number of Munros (Scottish mountains over 914 metres/3,000 feet, named after Sir Hugh Munro, who first catalogued them in 1891), including the best known Munro, Ben Nevis. At 1,343 metres (4,406 feet), Ben Nevis is the highest mountain in the British Isles.

The mountain's Gaelic name, Beinn Nibheis, has been linked with Irish and Gaelic words meaning poisonous or terrible; and indeed, as one wanders through the little town of Fort William, its brooding presence is never far away. Its summit is often shrouded in mist and some of its north-facing ravines are covered in "eternal snow". In former times legend had it that if these snows ever melted, the Camerons of Glen Nevis would lose their lands to the Crown.

(left) **Glen Nevis**

(above) **Stags in Glen Arkaig**

"The Owl of Strone"

One of Lochaber's most famous sons was Domhnall MacFionnlaidh nan Dan (Donald, son of Finlay, of the Songs), who was born in about 1550. He was employed by the chief of the MacDonalds of Keppoch as bard and head deer stalker. Donald was also renowned for his skill with a bow and his reputation was such that the saying *Cho cuimseach ri Domhnall MacFhionnlaidh nan Dan* ("As accurate as Donald MacFinlay") could still be heard in Lochaber up to the 1880s.

He is thought to have composed his most famous poem, " *Oran na Comhachaig*", in about 1585. In English the poem is sometimes known as "The Owl of Strone" and it has been described as one of the most remarkable poems ever written in the Gaelic language. The story goes that MacDonald of Keppoch held a feast at Eadarloch (Between Loch) in what is now, as a result of the raising of the water level, part of Loch Treig. Donald was not invited but decided to go all the same.

On arriving at the chief's hall he found that the party was over. Standing alone in the dark, he heard an owl hoot and felt that he and the bird shared their loneliness. He walked home to the head of Loch Treig and composed the poem. It is in the Celtic tradition of nature poetry and takes the form of a conversation with an owl, in which subjects such as the hunting of deer and the memories of past days are covered. The poem praises the chiefs of Keppoch and deals with old age, as the owl was traditionally thought to be an exceptionally long-lived bird.

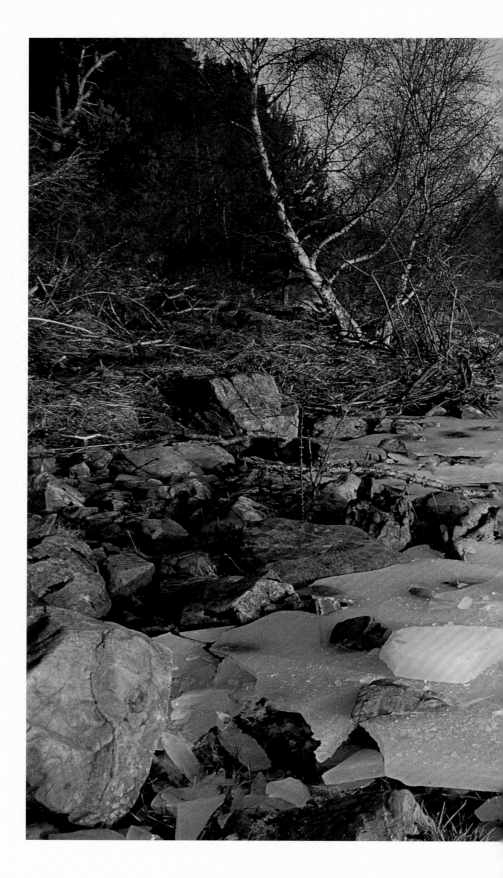

Loch Laggan

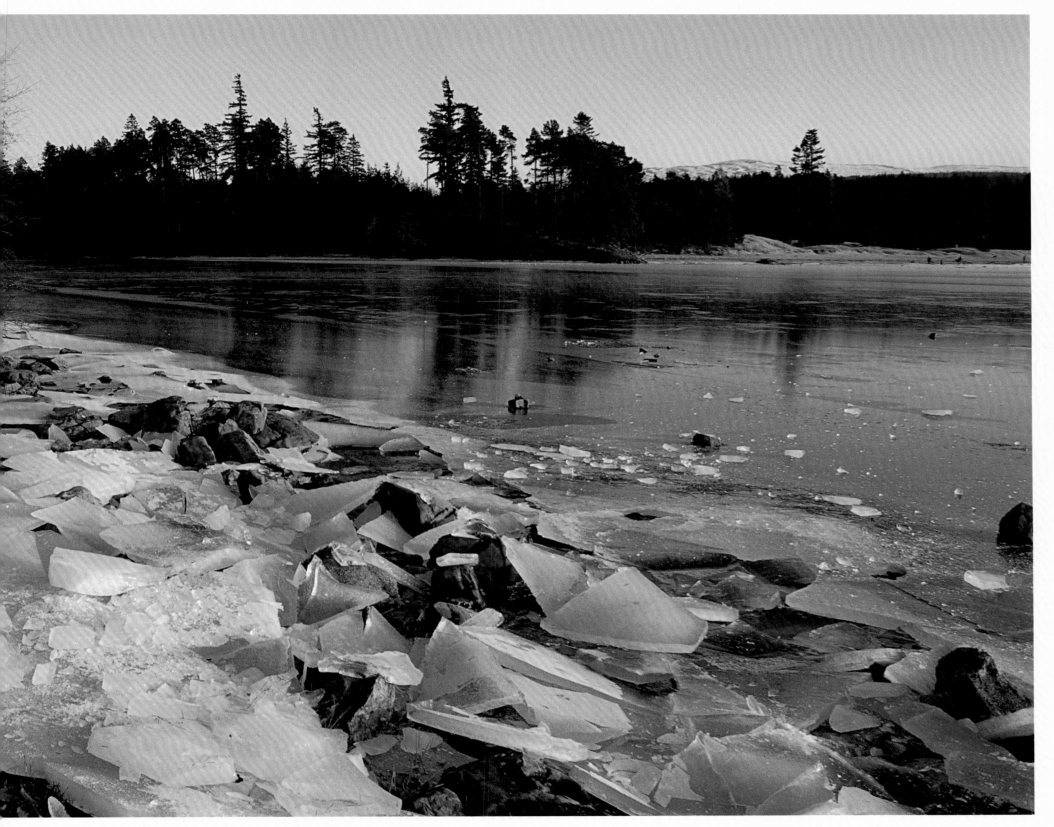

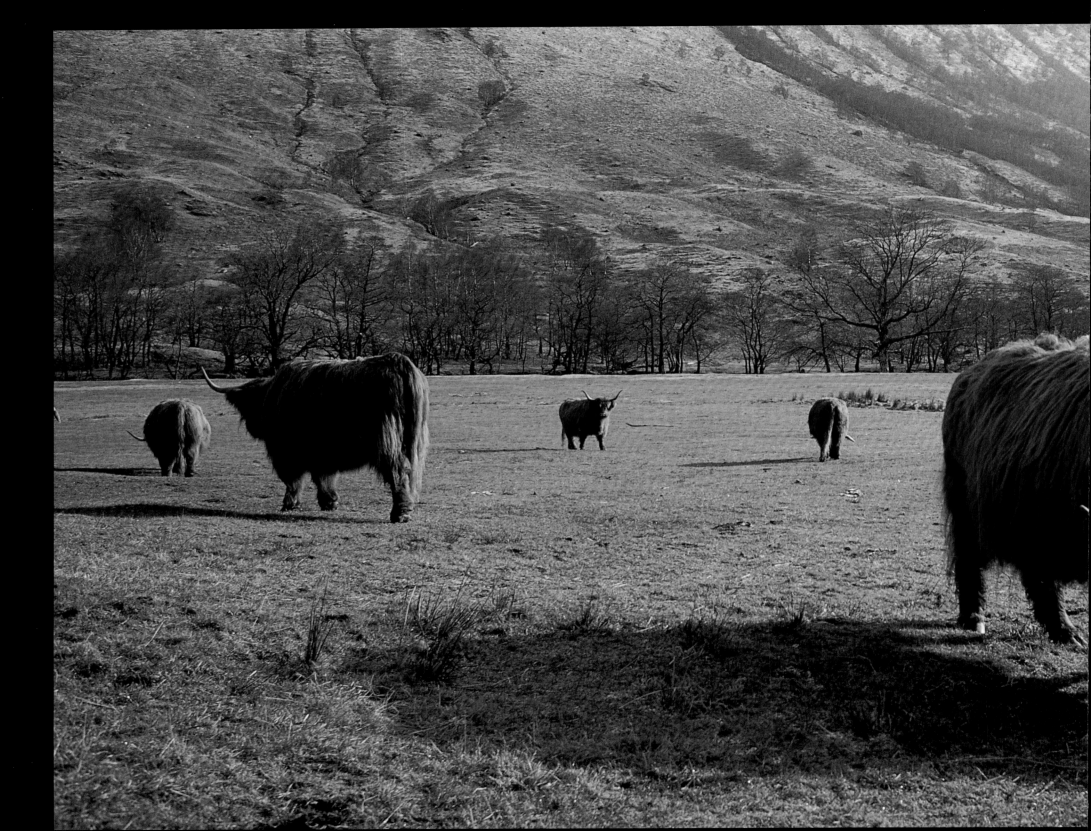

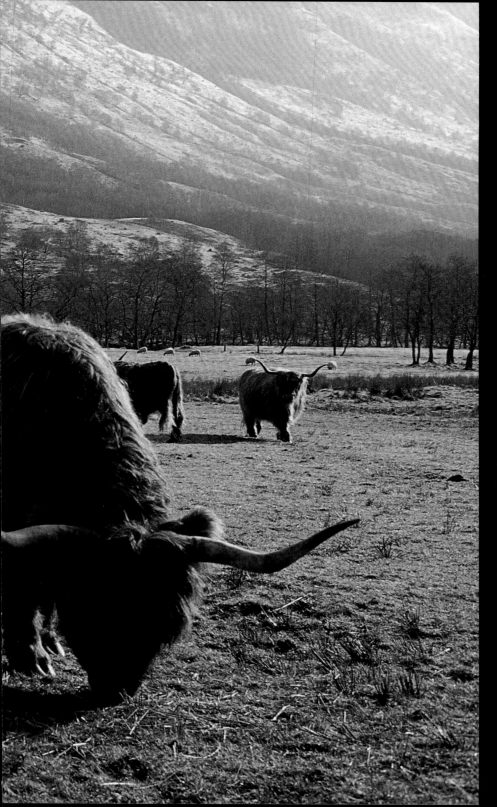

The Keppoch Murder

A gruesome murder, subsequent revenge on the killers, talking heads and a magic well are all woven together in a compelling tale that owes as much to the traditions of Celtic story-telling as to historical fact.

The story goes that the young sons of Domhnall Glas XI (Grey Donald), Chief of the MacDonalds of Keppoch, were brutally murdered by the sons of their cousin, Alasdair Buidhe, who had been managing the clan's land while the young men were being educated in France. There was apparently little inclination to avenge the murders – indeed, the clan showed what it thought by taking Alasdair Buidhe as their chief. However, Iain Lom, the Bard of Keppoch, urged a number of MacDonald chiefs to take action and in the end, MacDonald of Sleat provided him with some men.

The murderers' house at Inverlair was surrounded, and the seven brothers were killed and decapitated. Their heads were put into a bag and taken by Iain Lom to be shown to MacDonald of Glengarry. On the way to Glengarry Castle, the heads are said to have grumbled from within the bag in which they were being carried. "*Uhh, uhh!*" said Iain Lom. "*Nach còrd sibh 's gur cloinn chàirdean sibh fhein*." ("Oh, dear! Can you not get on – and you related to each other?") By the side of Loch Oich, Lom took the heads out of the bag and washed them in a well before presenting them to Glengarry. To this day, the well is known as the Tobar nan Ceann or The Well of the Heads (see page 67).

(left) **Highland cattle in Glen Nevis** (next page) **The Mamore Hills**

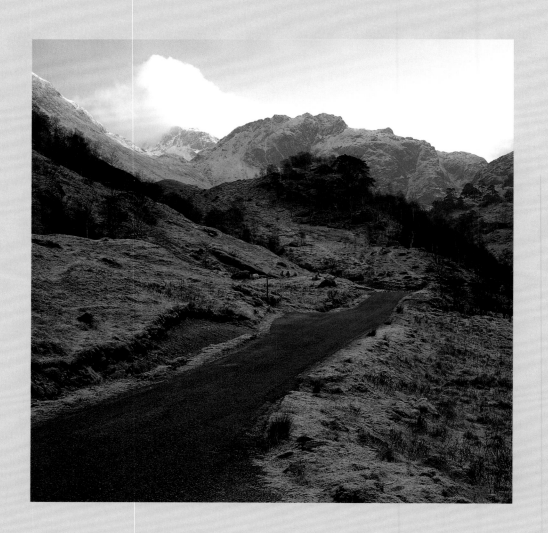

(above) Glen Nevis

(right) Steall Gorge

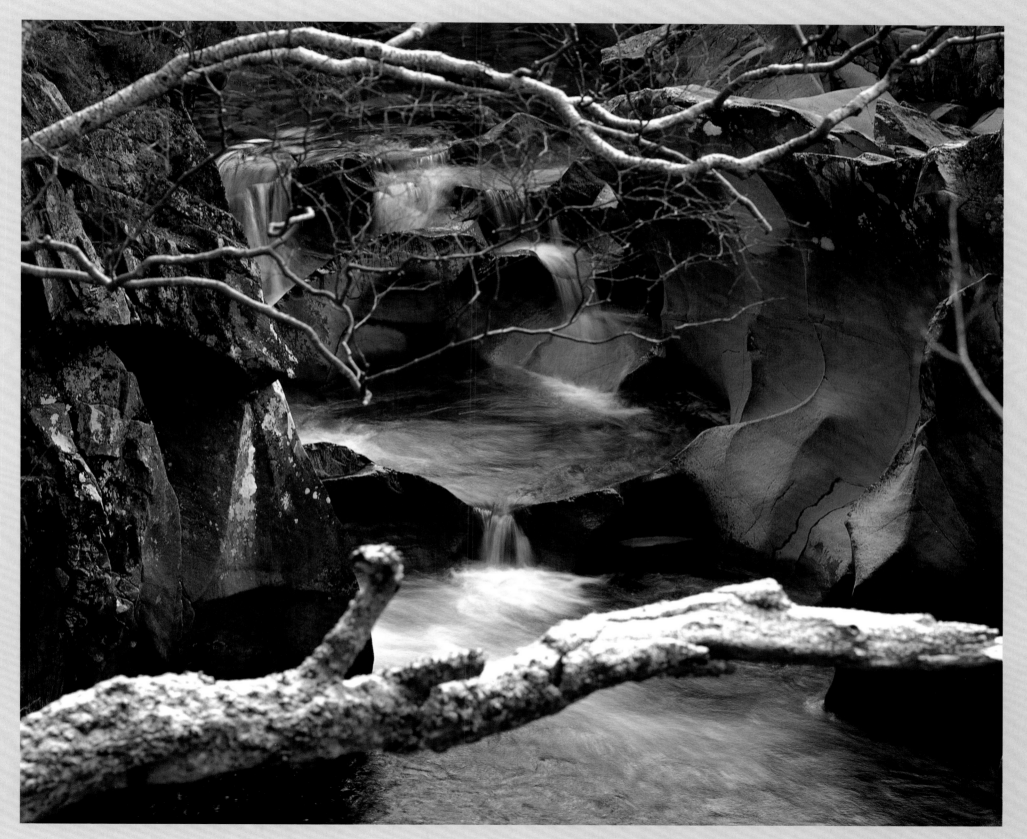

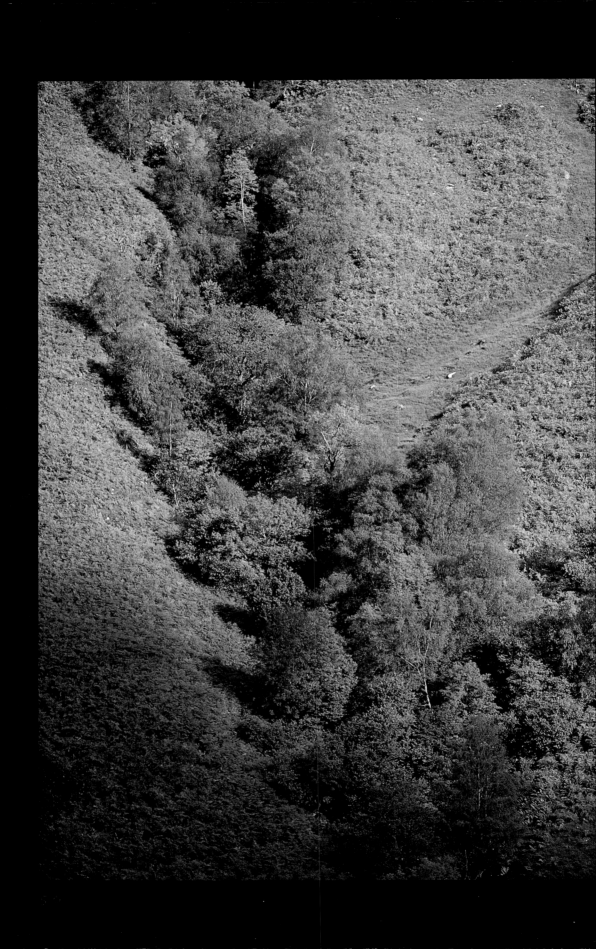

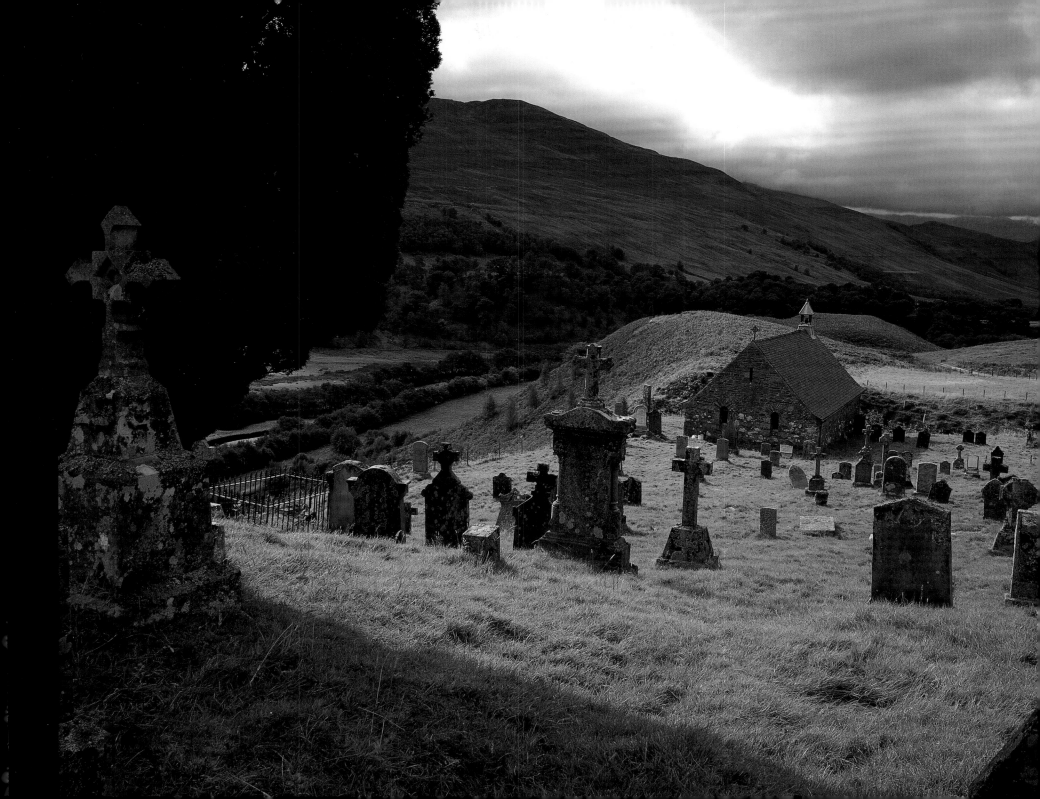

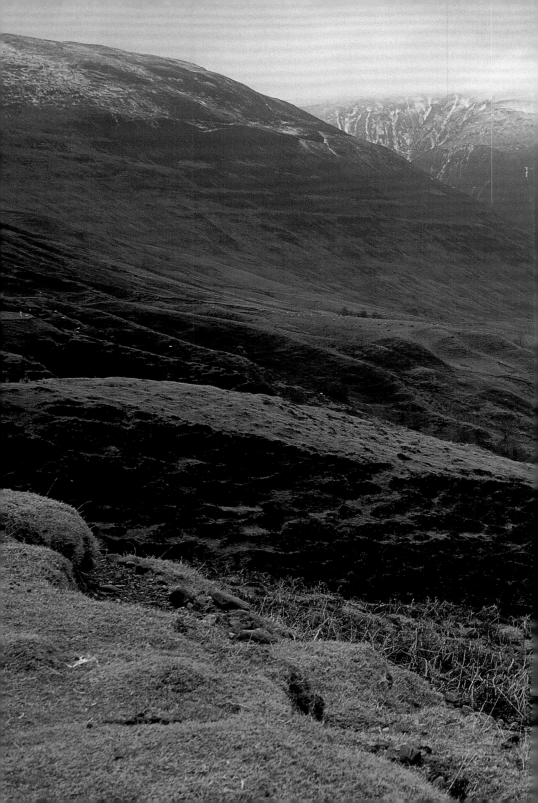

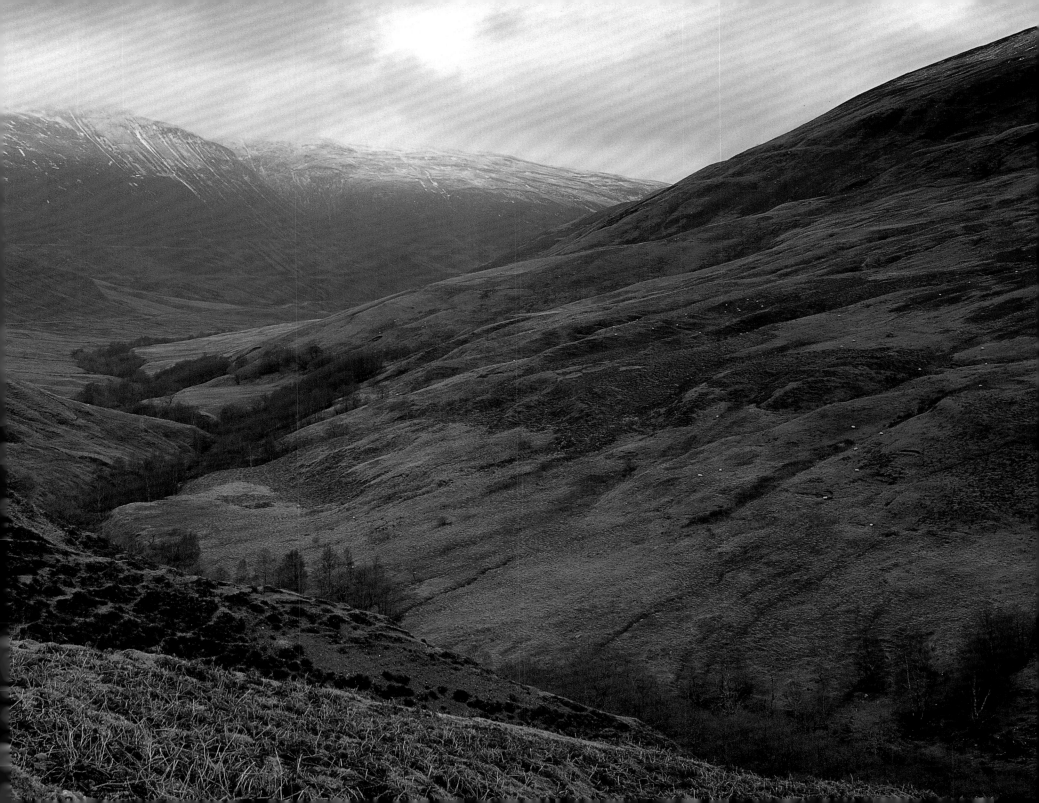

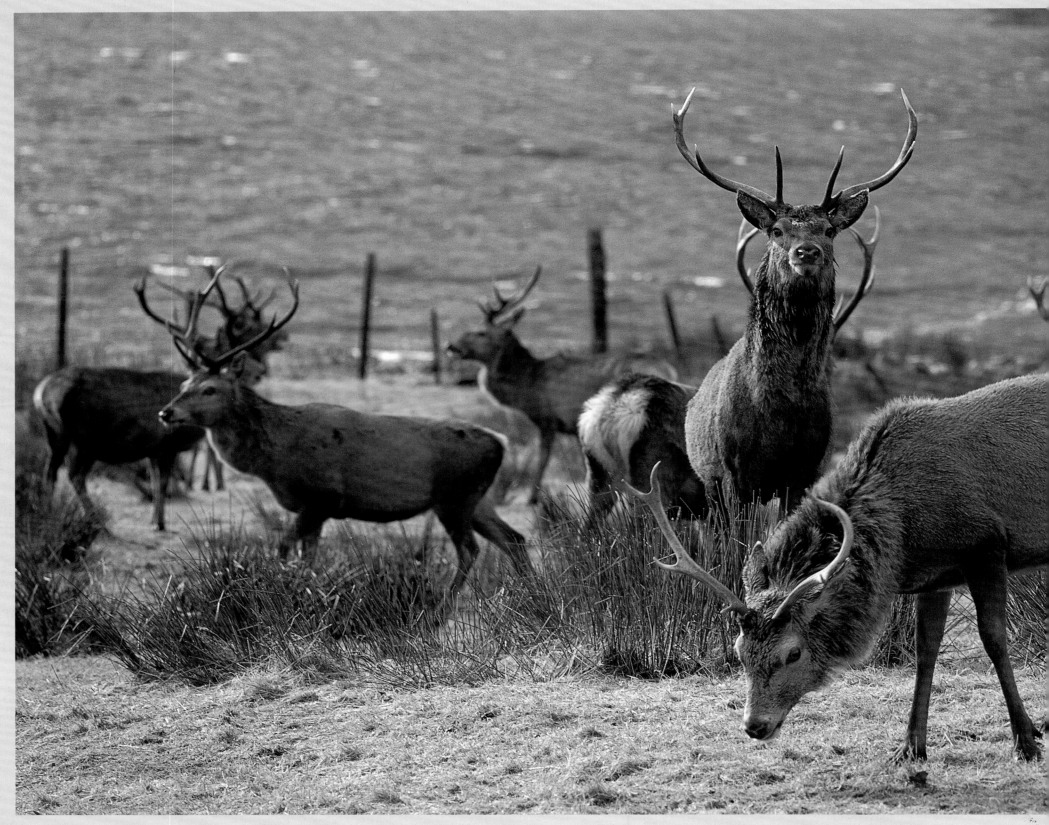

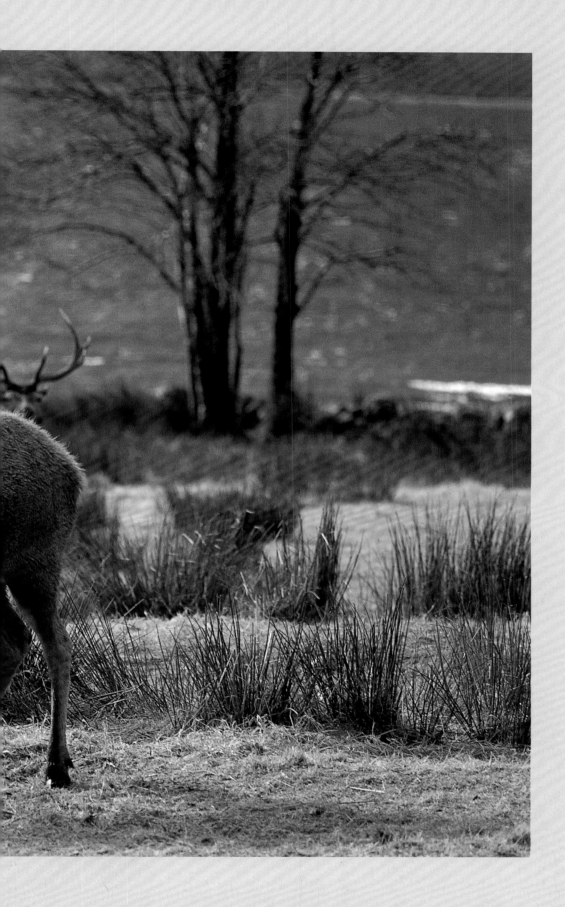

Stags in Glen Arkaig

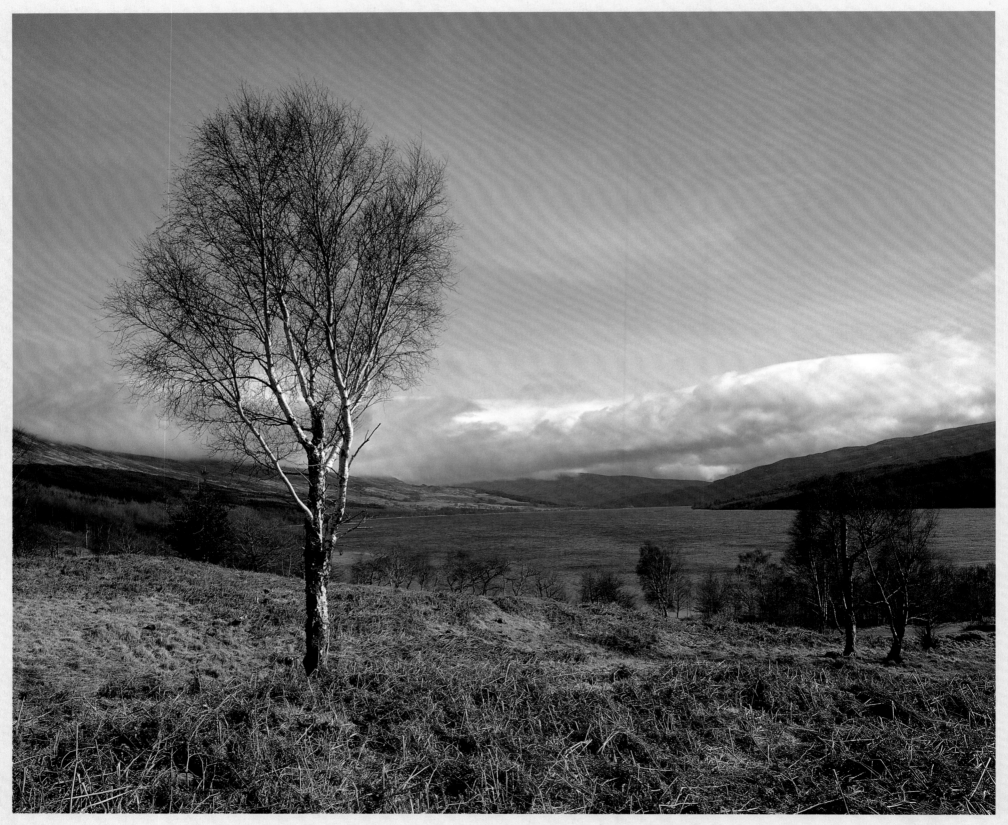

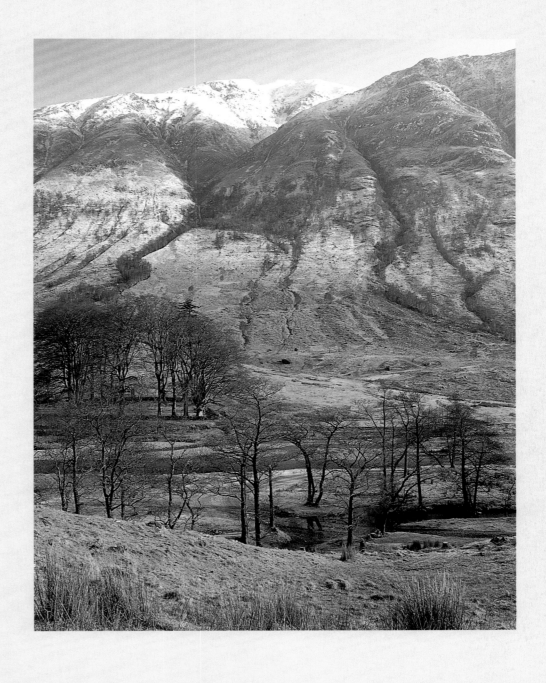

(left) Glen Arkaig

(above) Glen Nevis

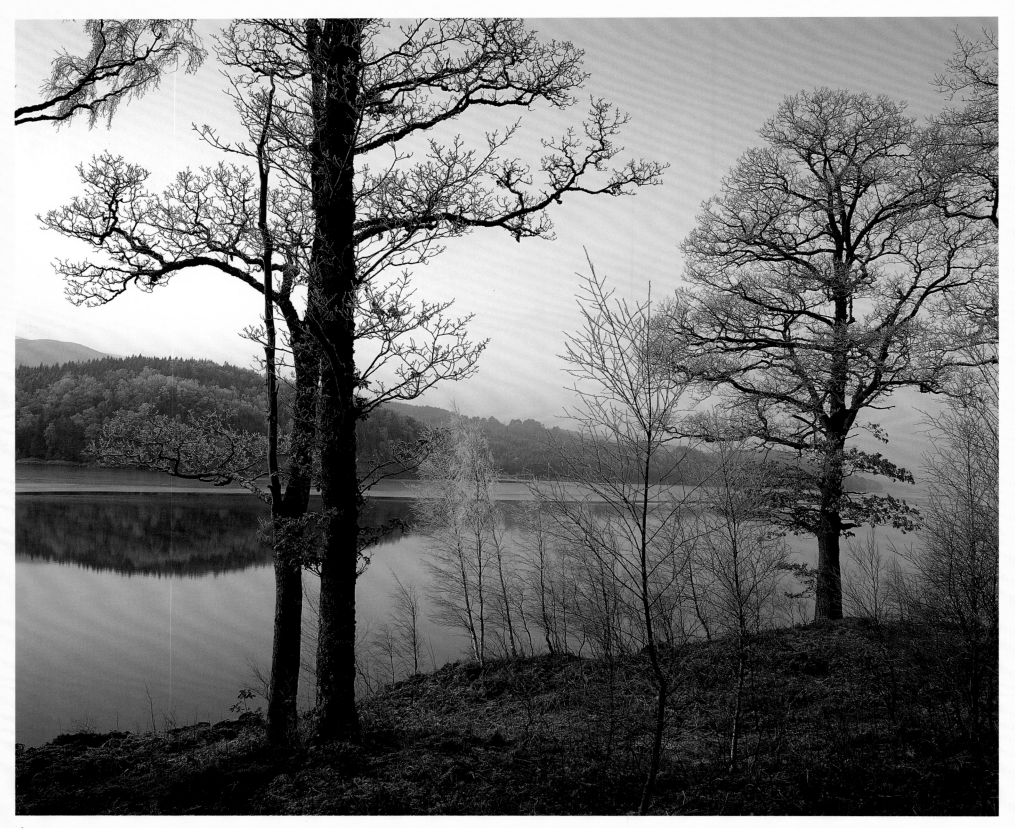

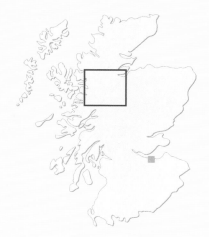

The Great Glen, Glen Affric and Strathglass

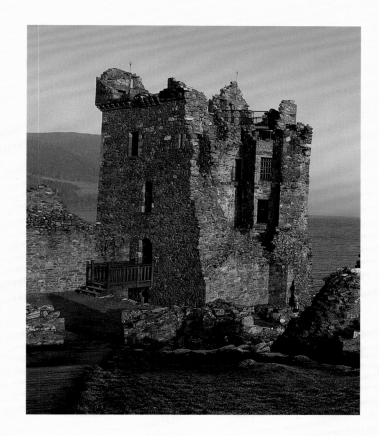

Glen More, the Great Glen, runs diagonally across the Highlands. It is the best example of a wrench or tear fault in the British Isles and was initiated about 300 million years ago, when the Highlands north of the Great Glen slid south and west as a block. Some indication of the extent of the faulting was given when it was shown that granite from Foyers on Loch Ness-side matched that around Strontian, in the country opposite the island of Lismore at the mouth of Loch Linnhe, some 105 kilometres (65 miles) away.

The bottom of this rift valley contains three freshwater lochs – Loch Lochy, Loch Ness and Loch Oich – and two fjords, Loch Linnhe in the south and the Moray Firth in the north. Loch Linnhe has been an important sea-way from earliest times: Saint Columba sailed through on his way to negotiate with King Bridei Mac Maelchon near

Inverness in AD 573. The freshwater lochs have been linked since the 1820s by the Caledonian Canal, which was built between 1803 and 1822 by Thomas Telford to open up the Highlands for commercial exploitation and to make life easier for British merchant ships by allowing them to avoid the stormy waters of the northern passage. A full 100 years before the canal was actually built, a local seer predicted that "Full-rigged ships will be seen sailing at the back of Tomnahurich" (the Hill of Yew Trees, situated at the top of the canal's flight of six locks).

Further north are the beautiful glens Affric, Strathfarrar and Cannich, with their magnificent remains of Caledonian pine forest. The glens' rivers flow down to Strathglass to join the Beauly. This is the Highlands at its most magnificent: wooded hills and narrow lochs bounded on each side by precipitous mountains.

(left) Loch Garry

(above) Urquhart Castle

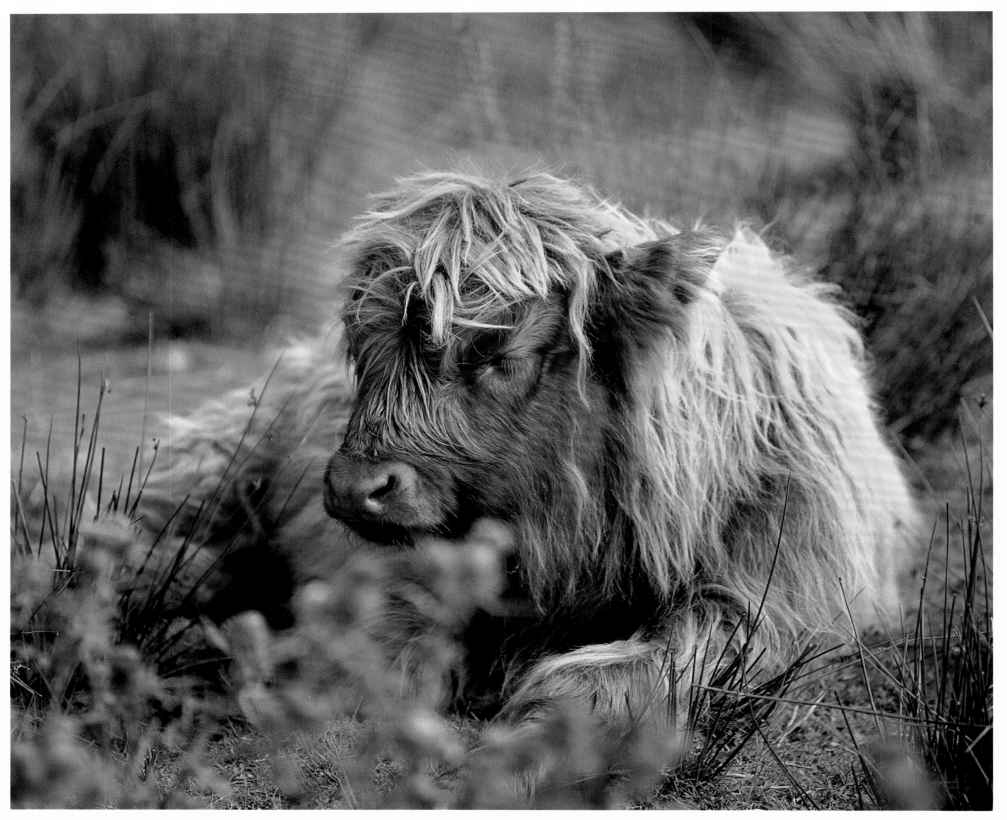

The Loch Ness Monster

Loch Ness is not the only loch or river believed to be haunted by a monster: Loch Morar, Scotland's deepest inland loch, is said to be home to Morag, a monster that appears whenever a MacDonald of Clanranald is about to die. But in terms of capturing the public's imagination, no other monster can hold a candle to Nessie, who has sparked numerous scientific expeditions and provided a highly lucrative boost to the local tourist industry ever since the first "photograph" (now known to be a hoax) appeared in 1934.

Tales of a monster in the depths of Loch Ness are nothing new, however; as long ago as the sixth century AD, no less a figure than Saint Columba encountered a monster at a crossing of the River Ness. It seems that Columba and his party had met a funeral party on the banks of the river, gathered there to bury someone whom the monster had killed. Despite the danger, Columba ordered one of his companions to swim back and collect a small boat that they had left on the other side. Unable to resist the provocation, the monster, which had been lurking nearby on the river bed, rose to attack the swimmer. Columba made the sign of the Cross, invoked the name of God, and ordered the beast away. All around were amazed by the power of the Christian God.

But is it really likely that such a beast inhabits the deep waters of Loch Ness now? It used to be suggested that Nessie might be something like a plesiosaur, a survival from an earlier geological period. There are two reasons why this is improbable: first, the last Ice Age covered the whole land and scoured out any fresh water bodies. Nothing could survive under these circumstances. Second, Loch Ness is very poor in nutrients: it simply cannot produce the amount of food that a large animal such as Nessie would need to survive.

(left) Highland calf

(above) The Well of the Heads (see page 51)

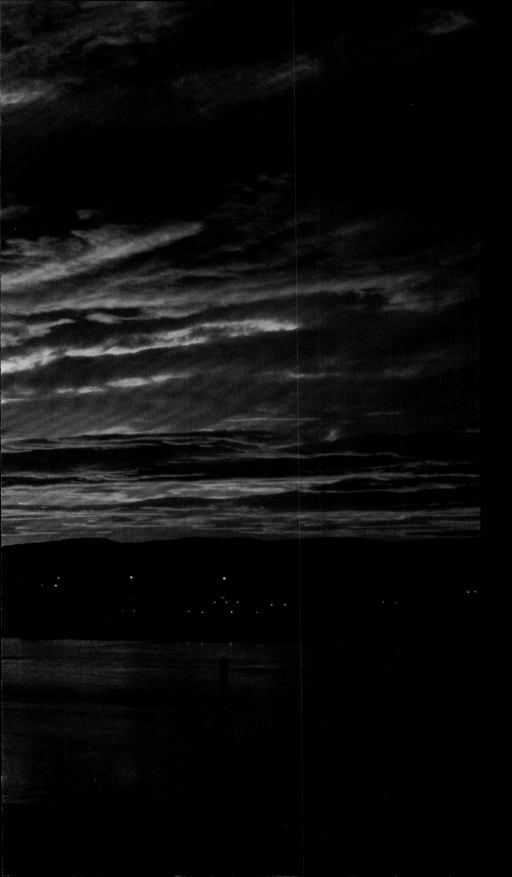

The Tartan Myth

Black Watch, Royal Stuart, Bruce: what could be more quintessentially Scottish than tartan? In fact, tartan is not an exclusively Scottish, let alone Highland, phenomenon. Wherever humans have learned to weave they have produced checks. Although tartan often indicated where someone came from because inhabitants of a district tended to weave similar patterns, territories were by no means exclusively occupied by one clan, and originally there seems to have been no idea of personal or family right to particular tartans.

Traditional tartans had almost died out in Scotland in the late eighteenth century, after the British Government banned the use of tartan and the wearing of the kilt, except in the military service of the Crown. Then, in 1822, Sir Walter Scott stage-managed the successful visit of King George IV to Edinburgh. Chiefly landowners were asked to turn out their followers, all dressed in the ancient garb. What was to be done? Luckily the famous firm of Wilson of Bannockburn had a pattern book showing the tartans that it wove. Many of these tartans are now known by the names of famous clans and are worn the world over as such. The royal visit stimulated new interest in tartans and Highland dress and prepared the ground for the phenomenon of the Sobieski-Stuarts.

This mysterious pair first appeared in Scotland in the 1820s, claiming to be the grandsons of Prince Charles Edward, and it was agreed that they had a very strong Stuart look about them. At any rate, the brothers persuaded a great many people that they were of royal descent. In 1838 they went to live at Eilean Aigas in Strathglass, under the patronage of the Lord Lovat of the day. There they learned Gaelic and researched the customs, dress and history of the old Highlands. Much of their scholarship has been corroborated, but controversy surrounds the publication of their beautifully produced book, *Vestiarum Scoticum* in 1842, in which a large number of tartans were reproduced. The brothers claimed that the authority for many of the tartans in their book came from a document dating from the sixteenth century. However, they were never able to produce this document, and it seems likely that, for the most part, they either invented the tartans themselves or consulted the pattern books of Messrs Wilson of Bannockburn. Many clan chiefs, knowing no better, accepted *Vestiarum Scoticum* as authoritative – and so many of the tartans described today as belonging to specific clans or families have no more authentication than the largely spurious attributions of the Sobieski-Stuarts.

The Kessoch Bridge

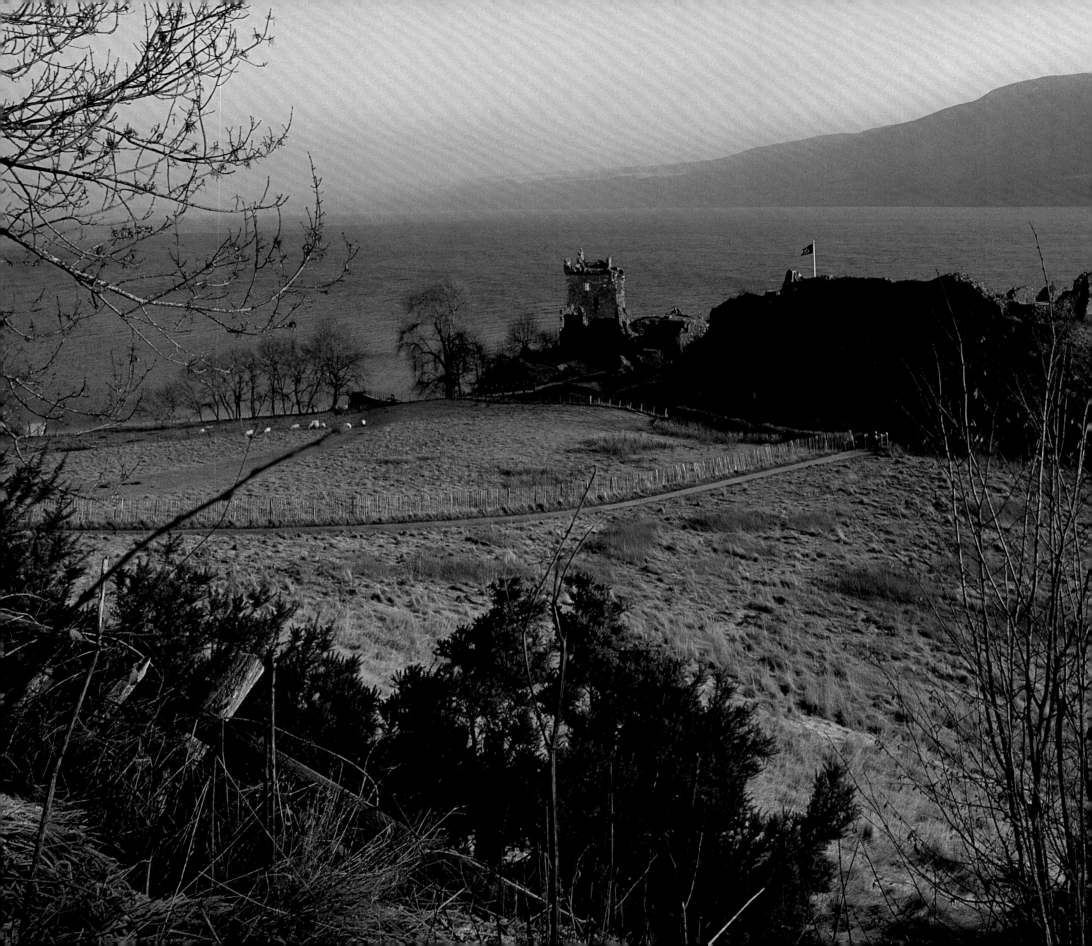

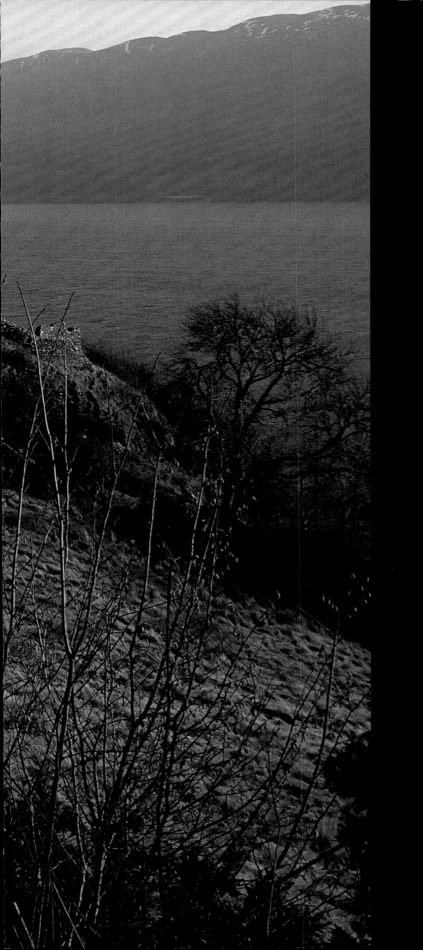

Urquhart Castle, Loch Ness

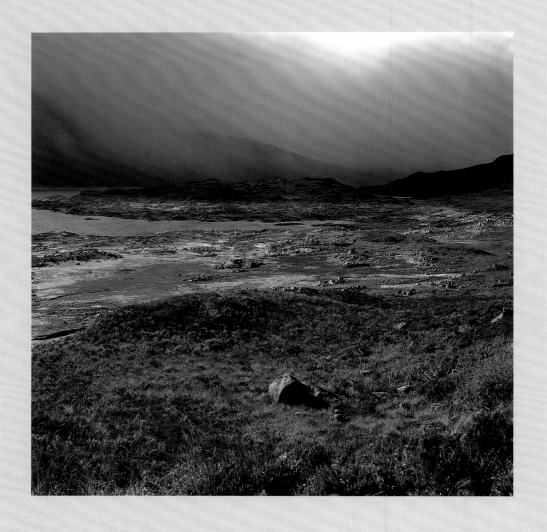

(above) **Loch Cluanie**

(right) **Glen Affric**

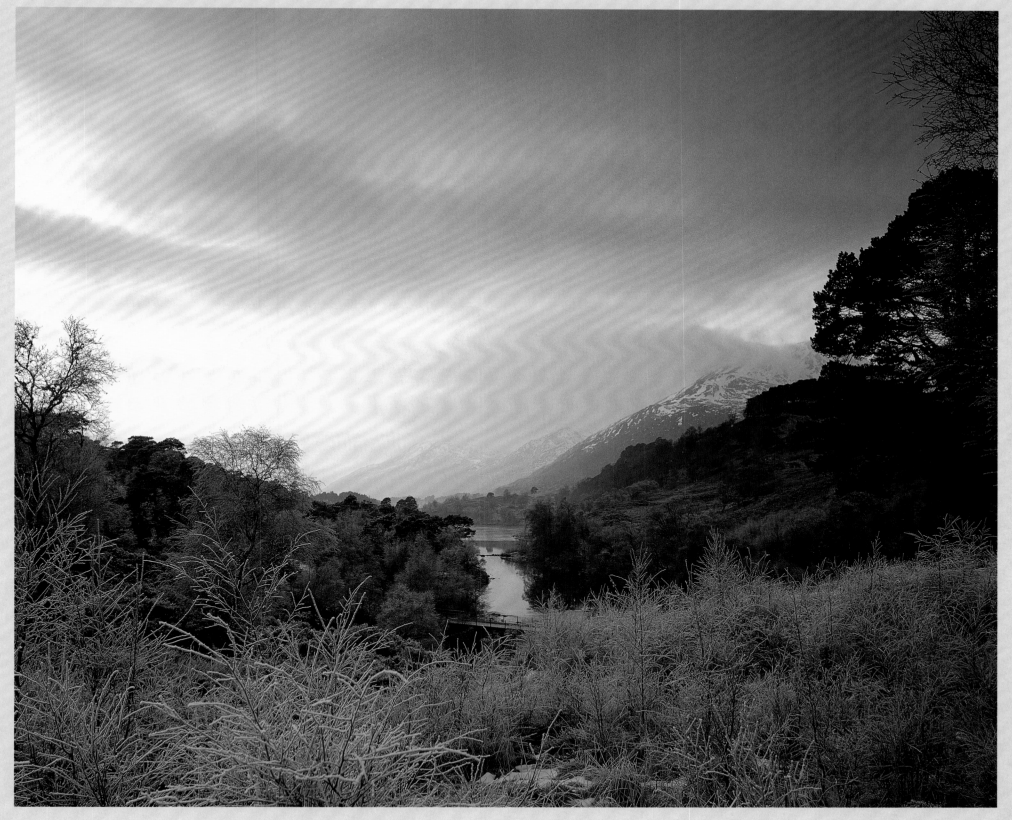

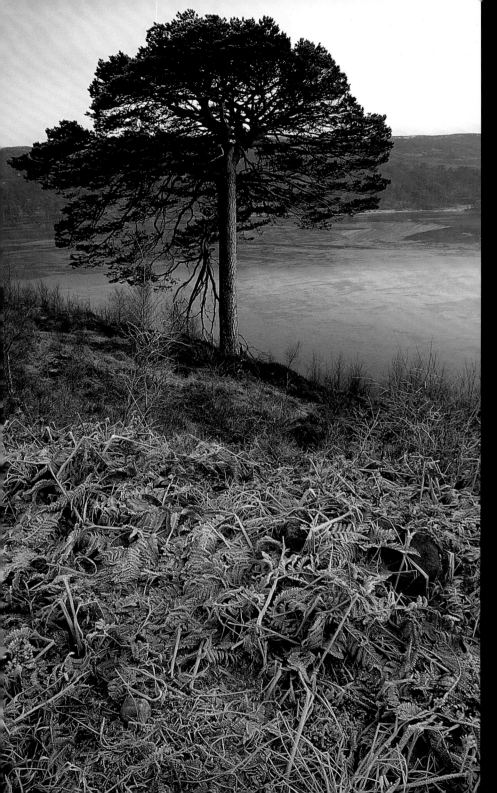

(left) Loch Affric (right) The Caledonian Canal

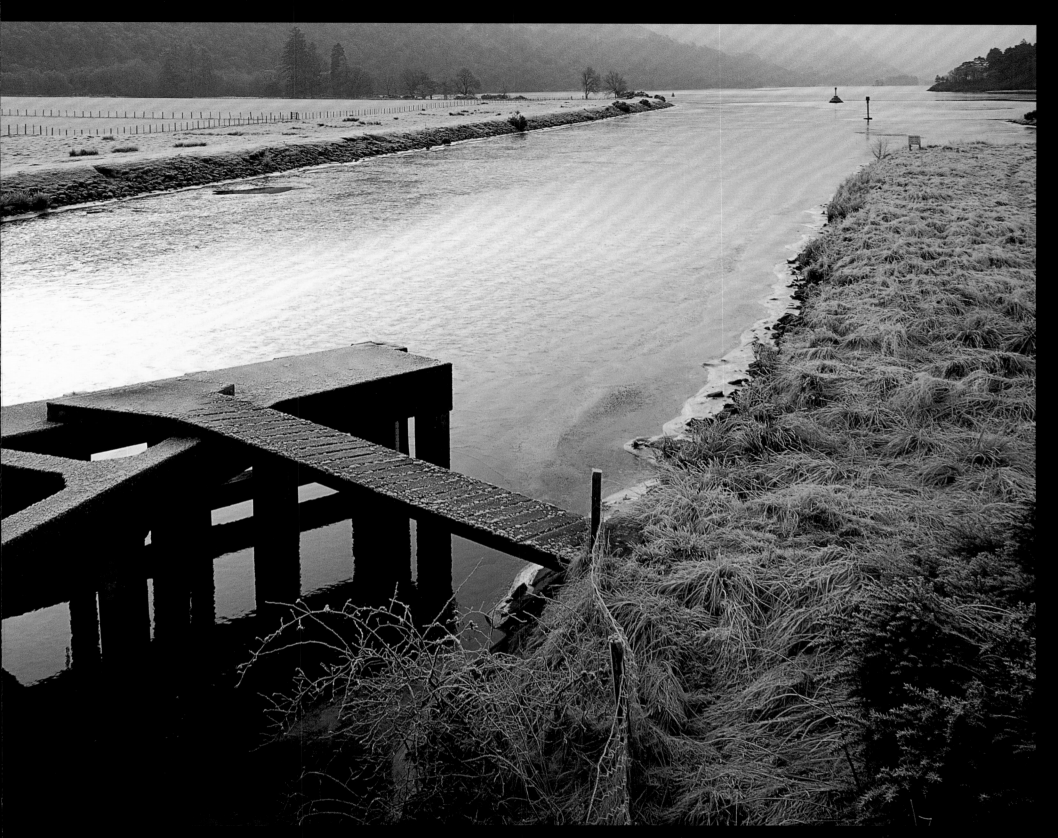

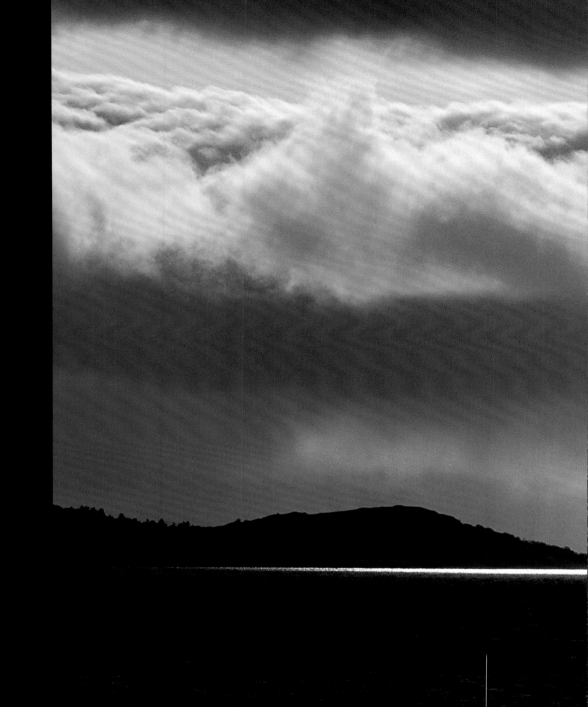

Linnhe

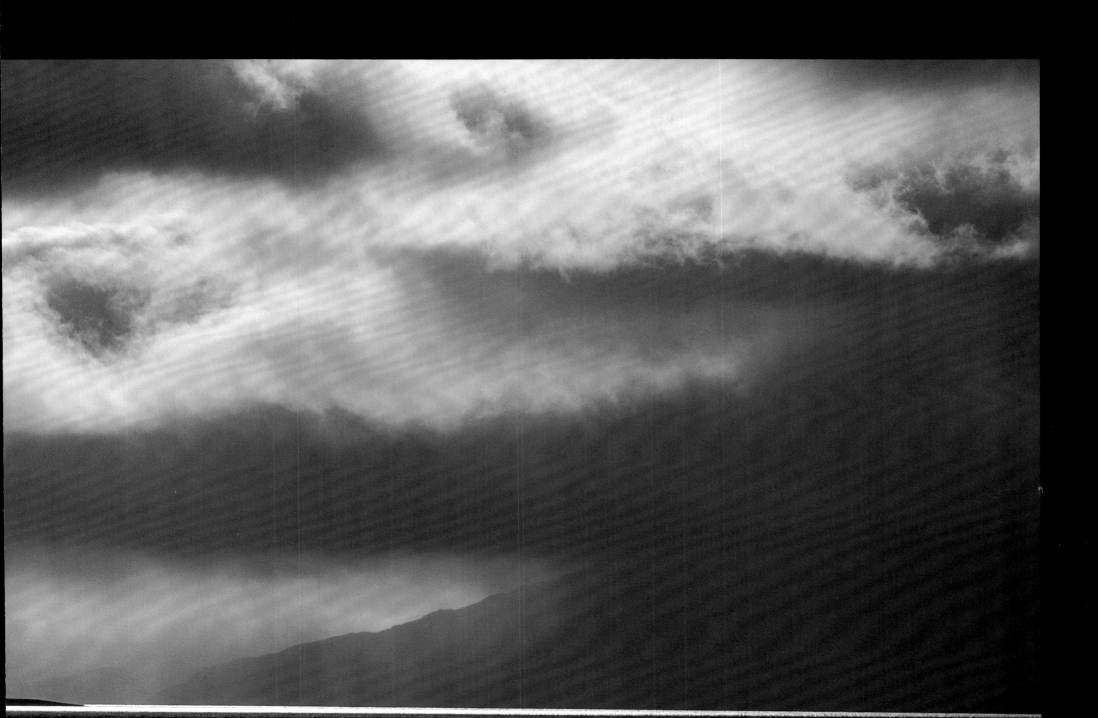

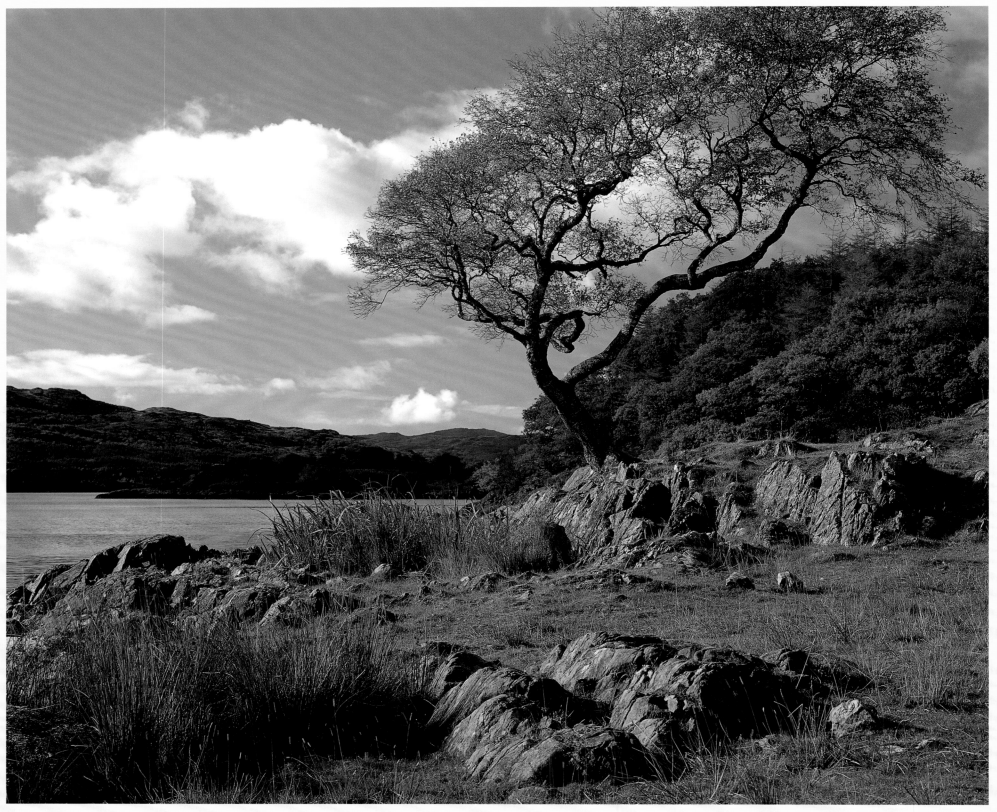

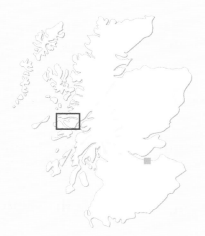

Morvern to Moidart and Arisaig

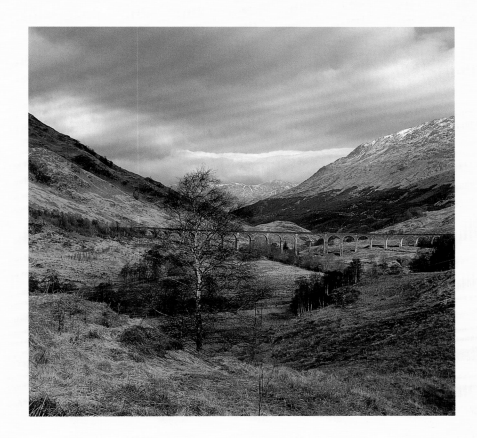

As so often happens, many of the place names in this region originally described the topographical features of the land. The name Morvern, for example, which describes the country west of Loch Sunart and Glen Tarbert, comes from the Gaelic *Morbhairne*, meaning the great gap.

Much of Morvern is overlain by basalt, which culminates in the fine cliffs at Ardtornish on the Sound of Mull. Other place names indicate not just features of the landscape, but also successive waves of invaders who shaped its history. The country around Loch Sunart was famous for its oak woods; the Gaelic description *Suaineart ghorm an daraich* means Green Sunart of the oak trees, Sunart itself being

a name of Norse derivation that means Sween's Fjord. Remnants of this vast oak forest still survive around Loch Sunart (see page 80). To the north-west of Morvern lies the Ardnamurchan peninsula, the most westerly point of the Scottish mainland and home for some years to the great Gaelic poet Alasdair MacMhaighstir Aladsair, or Alexander MacDonald, a prime mover in the Jacobite cause. North of Ardnamurchan, from the harbours of Arisaig and Mallaig, there are fine views across to the islands of Eigg, Rum, Canna and Muck; boats operate to these islands from Mallaig, as well as to Skye, Barra, and the Knoydart peninsula. Inland lies the spectacular Loch Morar, Sotland's deepest inland loch, with its beautiful white silica-sand beach.

(left) **Loch Sunart**

(above) **The Glen Finnan Viaduct**

Oakwoods of the Highlands

About 8,000 years ago, the highland pine forests stretched from the north coast of Scotland down through the Central Valley and into the Southern Uplands. The wetter climate that followed brought conditions to the West Highlands that favoured deciduous trees. Oak forest developed, and with it an assembly of subsidiary trees and plants. Within the forest mosaic there were birches, holly and hazel. Elsewhere, there were wych elms, ash, rowan, aspen, alder and, occasionally, yew.

Remnants of this vast oak forest survive by Loch Sunart and in Moidart, on the north-east shores of Loch Maree and into Sutherland as well as further south, along the southern shores of Loch Earn and Loch Tay, the shores of Loch Etive at Bonawe, and in Appin.

Although one might think of land management as a relatively modern phenomenon, in the North-west Highlands, management of the oak woods for coppice from which to make charcoal had begun as long ago as 1607. Throughout the estates of the dukes of Argyll, from at least the eighteenth century, leases were made to ensure that the oak woods were exploited and managed in such a way as to ensure their survival.

Oak bark for the leather tanning industry was another important product of coppiced woodland. From the middle of the eighteenth century, the oak woods on the shores of Loch Lomond were being managed on 20- to 30-year coppice rotations, as were many other oak woods through Perthshire, Dunbartonshire and Argyll.

The woods were always at the mercy of the market and of their owners. When the value of coppice was high (as it was during the Napoleonic Wars), oak itself was safe after a fashion, and less important species were cut out to favour its growth. However, if the value of the ground as grazing for sheep was greater than its value as woodland, it might be let for grazing with serious consequences for the wood's ability to regenerate. The general failure in the West Highlands to keep some standard trees (that is, trees that were allowed to grow straight and tall rather than being coppiced) meant that where woods have survived it is usually as scrub. Nonetheless, the management of the oak woods for coppice to produce charcoal or tanbark ensured the survival of many woods, even if as impoverished relics.

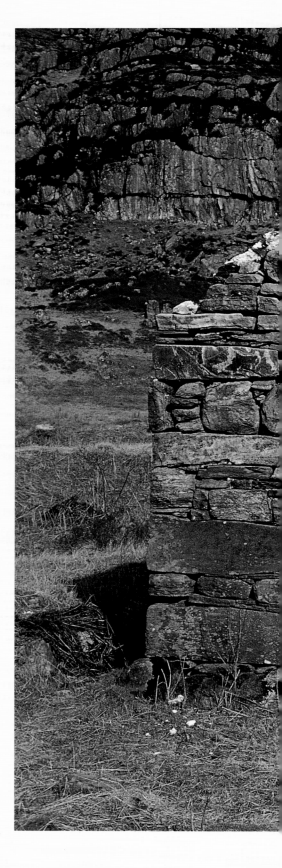

An abandoned stone building

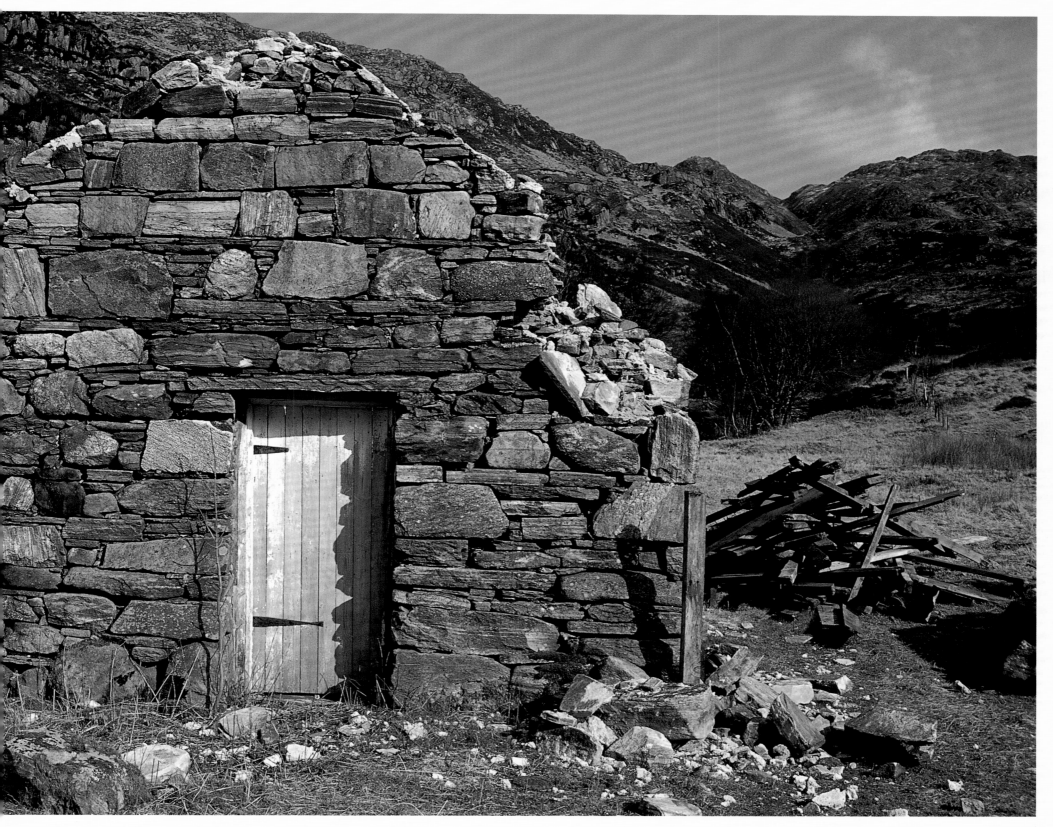

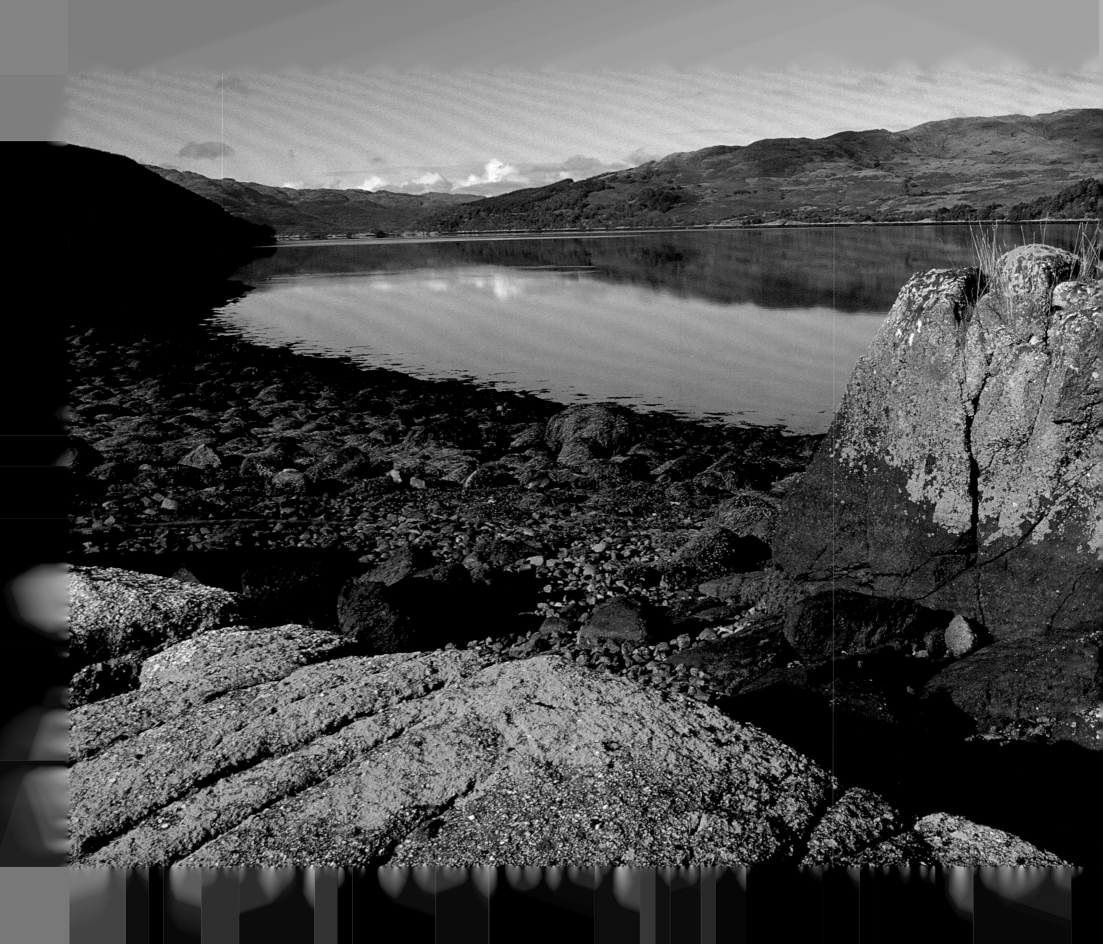

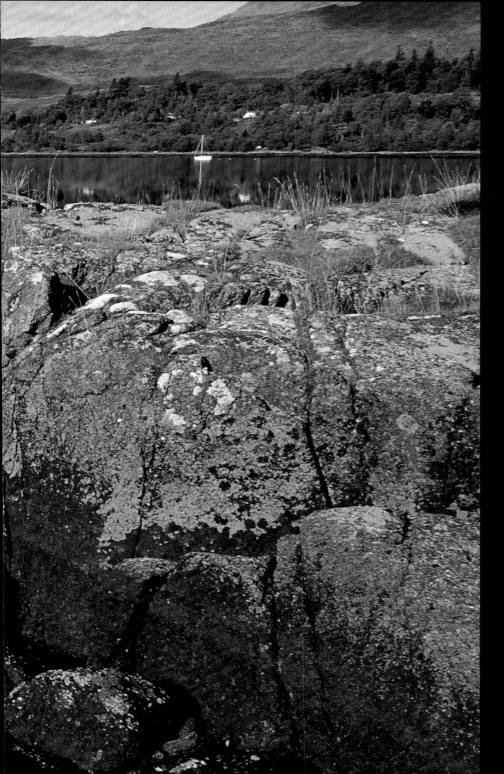

The Young Pretender

It was at Loch nan Uamh in Arisaig, on 4 August 1745, that Bonnie Prince Charlie, grandson of James VII and II, landed to begin his attempt to restore a Stuart to the throne of Scotland. On 19 August he raised the standard of the Stuarts near Glenfinnan, the signal that the rising had begun. By early September, he had reached Edinburgh and established a 'royal court' in Holyrood Palace. After defeating government troops at Prestonpans on 18 September, he felt confident enough to march on London.

Sadly for the Prince, his confidence was misplaced. Despite support from certain Highland clans (and even that was far less than he had expected), there was precious little support for his cause among the Lowlands of Scotland. In December he got as far as Derby, but his advisers urged him to return to Scotland, where he set up his winter quarters in Inverness.

In the meantime, government forces were massing in Aberdeen under the command of the Duke of Cumberland. On 16 April 1746, on Culloden Moor, Charles's ragtail army of Highlanders, ill equipped and short of food, was comprehensively routed: in less than an hour, they lost 1,200 of their 5,000 men, the slaughter pursued with such vigour that it earned Cumberland the nickname of 'Butcher'.

Little more than a year after he landed at Loch nan Uamh, the Young Pretender was forced into exile, his dreams shattered and a price on his head. In an attempt to finally subdue the Highlanders, the government passed the 1746 Disarming Act, which not only banned the carrying of claymores, dirks and other weapons, but also proscribed the wearing of tartan and the playing of the bagpipes. Charles never returned to Scotland; he died in Rome in 1788.

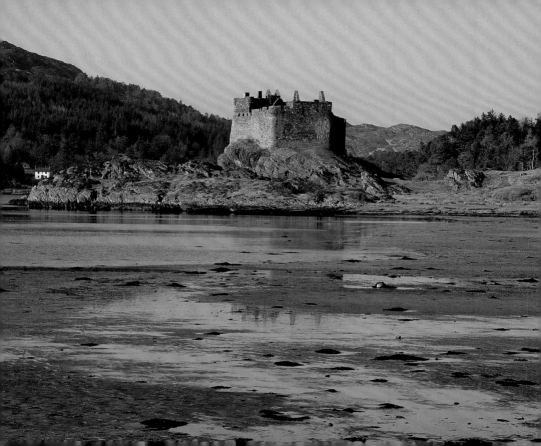

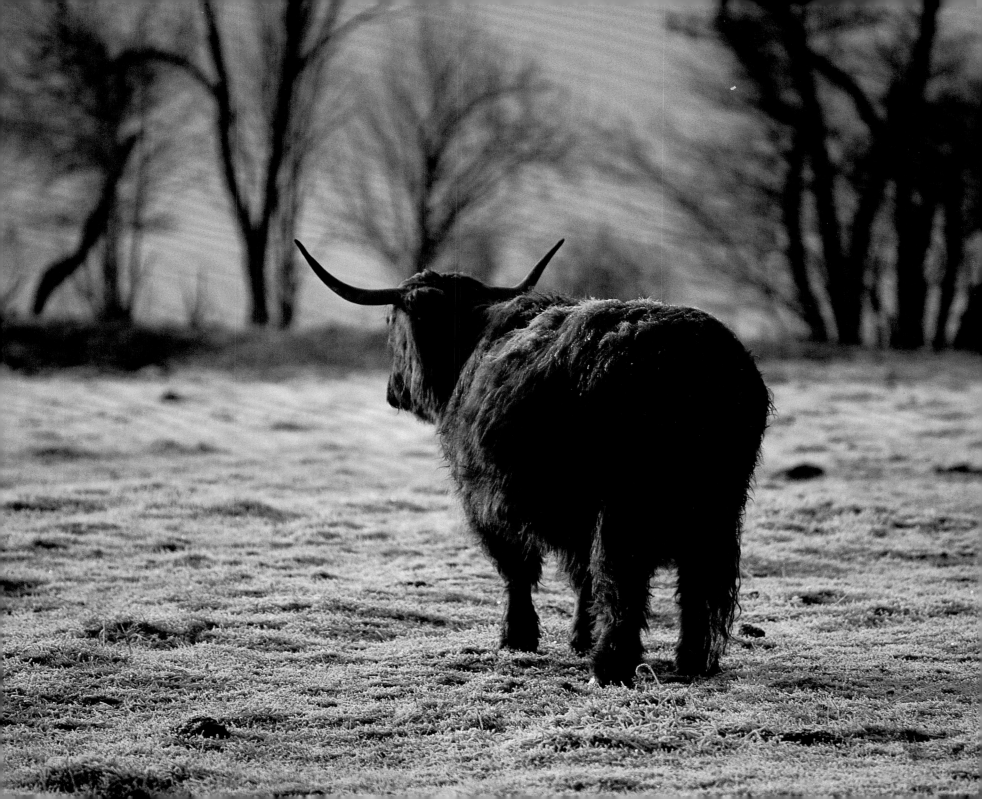

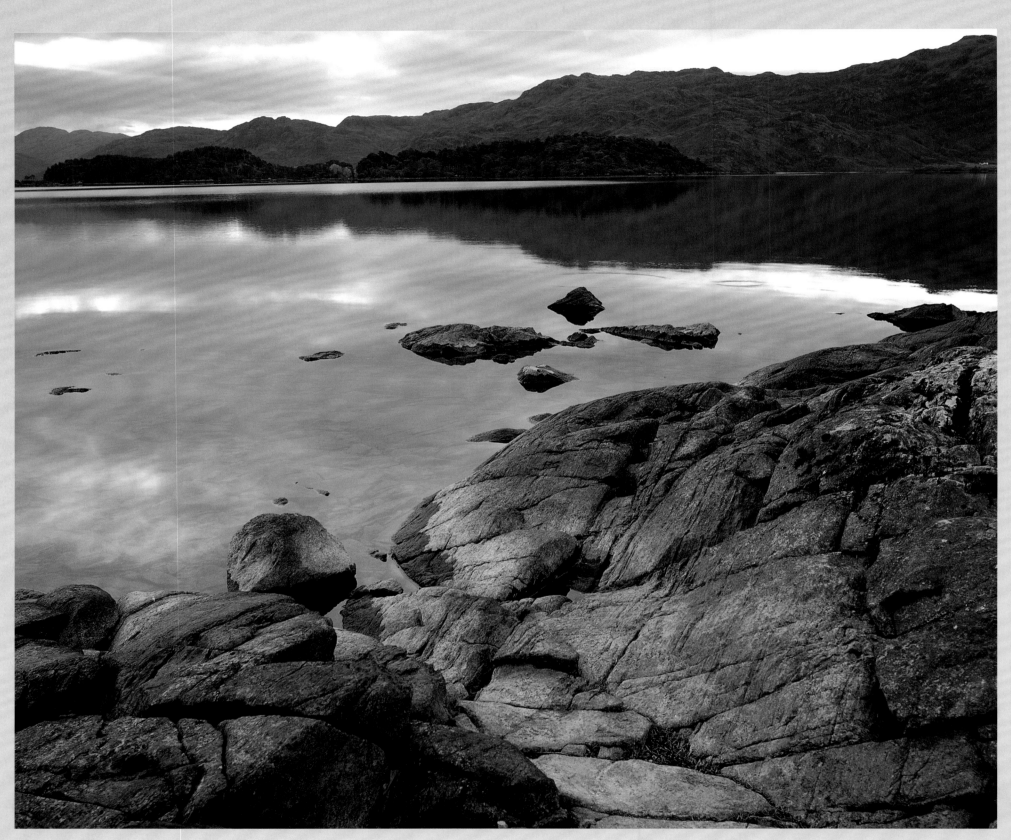

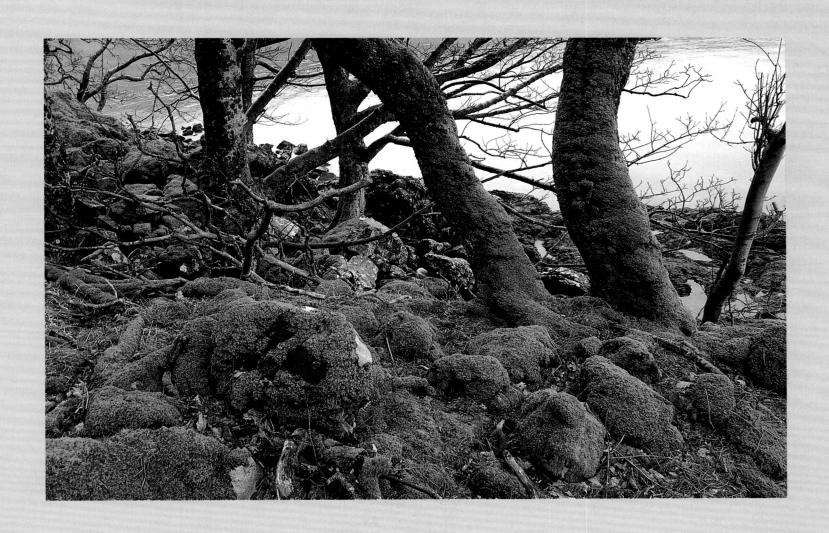

(left) Loch Morar

(above) Beech trees near Ardtornish

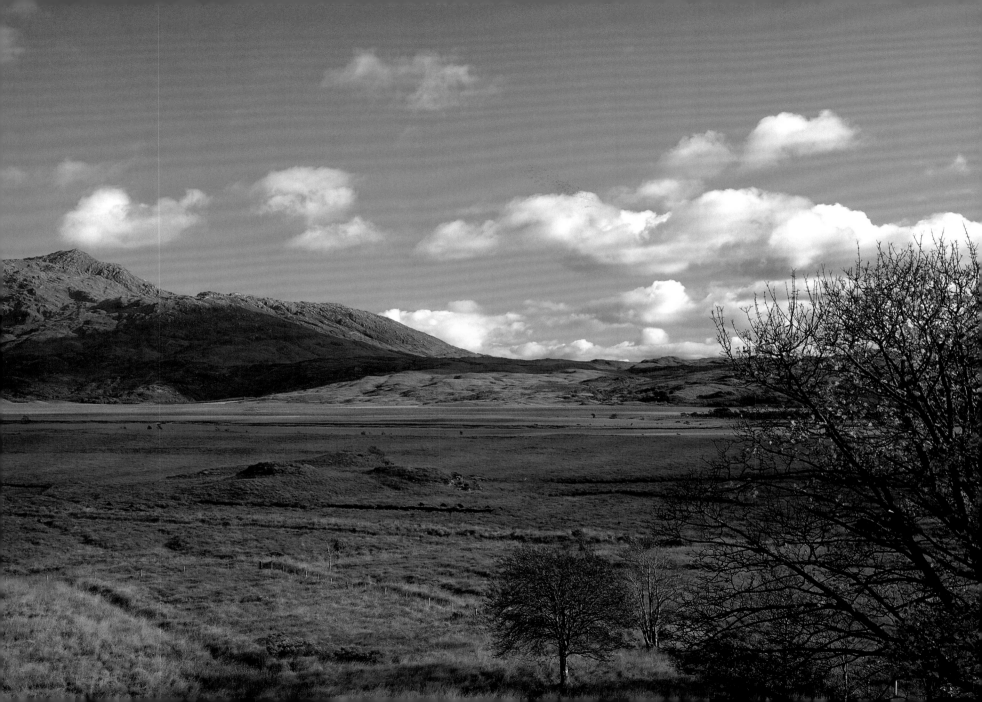

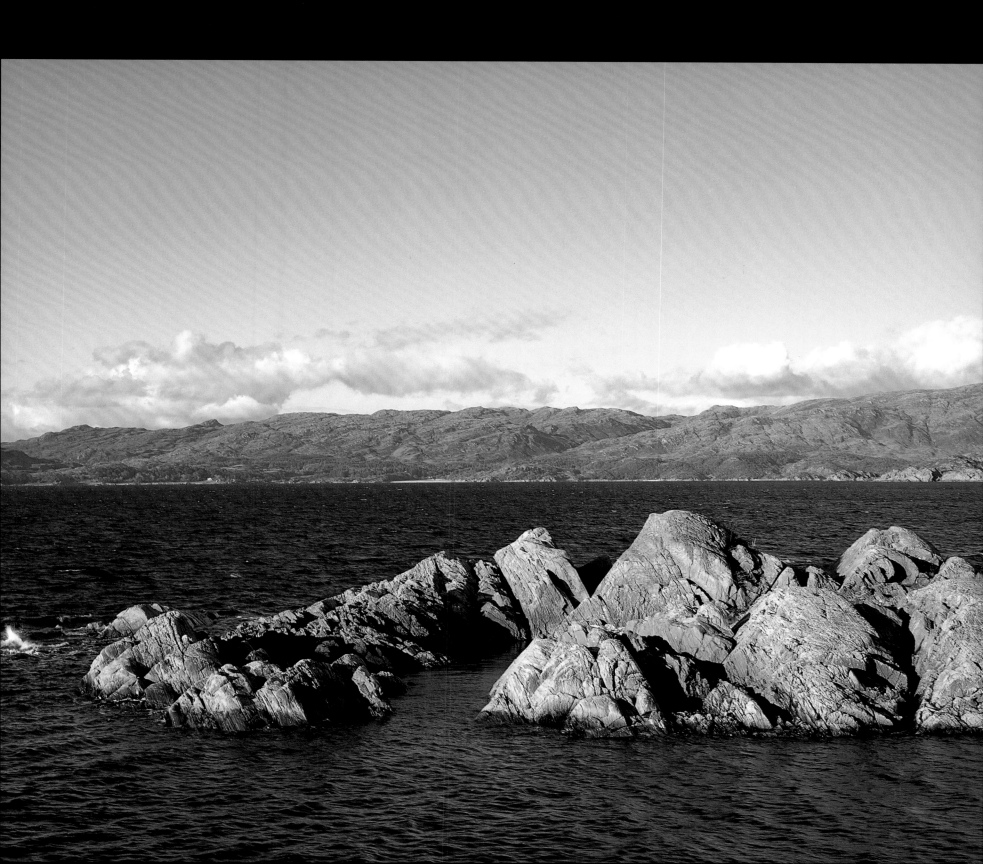

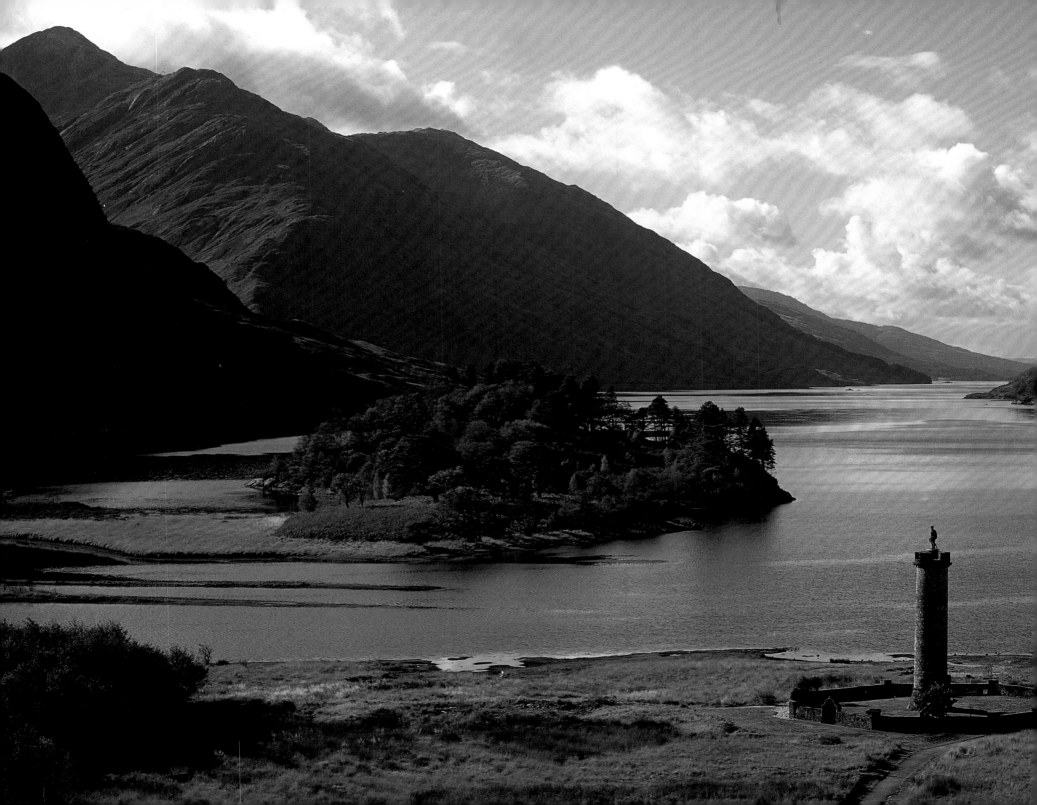

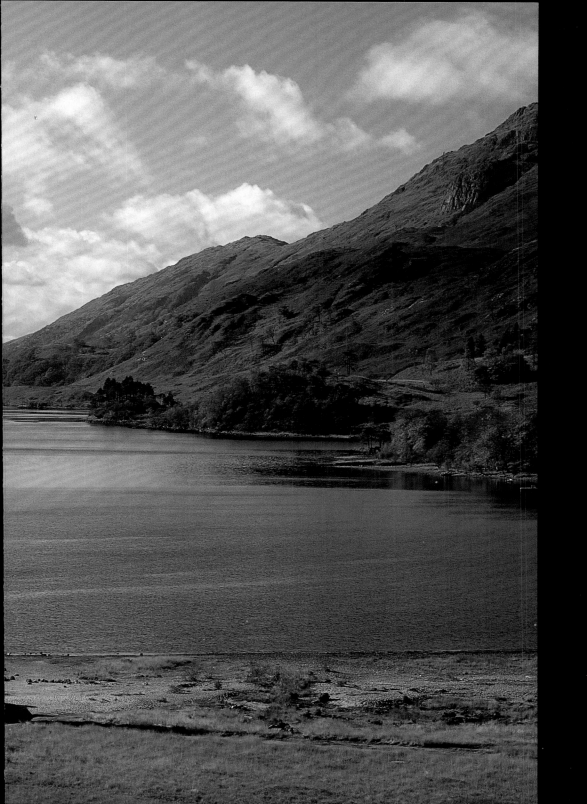

The Glen Finnan Monument

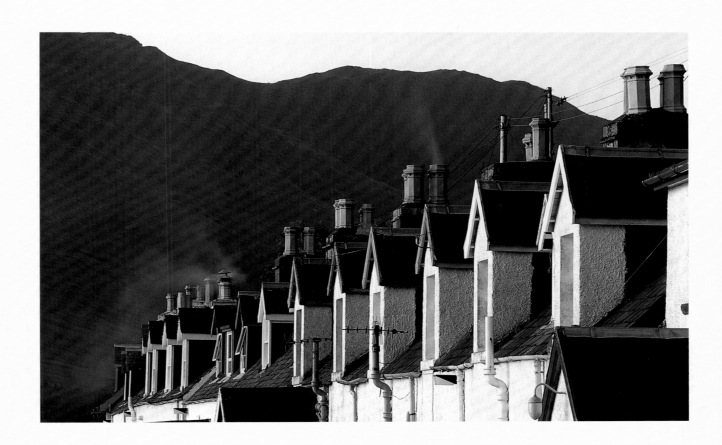

Kintail to Loch Broom

From Glen Elchaig in the south to Loch Broom in the north, Wester Ross was once described by Queen Victoria as totally isolated from civilization – and it is probably fair to say that, in many respects, little has changed. Picturesque coastal villages, twisting roads over moorland and mountain passes, dramatic peaks around which golden eagles and peregrine falcons swoop and soar, cristal-clear lochs and lochans, and historic castles such as the thirteenth-century Eilean Donan combine to make the scenery of this area among the most spectacular in Europe.

Beyond Loch Kishorn, is the peninsula of Applecross, to which access could only formerly be obtained by the steep Bealach nam Bo (Pass of the Cows). The views are amazing: small lochs dotted over the moorland, countless fjords cut into the coastline and, in the distance, the faint outlines of the Cuillins of Skye and the islands of the Outer Hebrides. The Gaelic name for Applecross is '*A'Chromraich*, meaning "The Sanctuary" – appropriate for Applecross's history as a religious settlement, for this land has strong associations with the Christian missionaries of the generations after Saint Columba. Further north is the valley of Glen Torridon, dominated by Liathach (The Grey One) and the Beinn Eighe massif, whose red sandstone peaks (up to 800 million years old) are capped with white quartzite.

Loch Maree, overlooked by Ben Slioch, is considered by many people to be the most beautiful loch in Scotland. Named after the Irish monk, Maelrubha, who died in AD 722 and is said to be buried on one of the loch's islands, Loch Maree is remarkable for the old Scots pines that line its shores. The highest peak in the area, the descriptively named an Teallach (the anvil), towers 1,046 metres (3,483 feet) above Little Loch Broom. Loch Broom itself became known as the starting point for many emigrant ships (of which perhaps the terrible voyage of the *Hector* in 1773 is best known) bound for Canada and the United States of America.

(left) Kintail hillside

(above) Cottages in Applecross

The Caledonian Forest

After the last ice age, the plants gradually came back and the pine forests of mainland Europe crowded across the land bridge that connected it to Britain. It has turned out, however, that the sub-species of pine in the Highlands of Scotland is genetically distinct from the sub-species that came across the land bridge into England.

So where did the Scots pine come from? We may never know for certain, but recent research suggests that the native Scots pine of the north-west survived the last glaciation in ice-free areas in peninsulas off the west of Ireland. As the ice retreated and the climate warmed, the soil improved enough for the pines to grow. Released from their isolated sanctuaries and facing no competition from rival species, the Scots pine was given full opportunity for expression.

These pines once covered pretty much all of what we now know as Scotland, from Loch Shin in Sutherland to Loch Lomond in the south, and from Knoydart in the west across to Buchan in the east.

About 7,000 years ago, however, the climate became wetter and colder and blanket peat started to form, making it harder for the pine woods in the West and Northern highlands to regenerate. Eventually regeneration became possible only on slopes that were too steep for peat to form on. In the Central and Eastern Highlands, the rainfall remained low enough for the trees to continue to regenerate and it is in these areas (for example, on the shores of Loch Maree) that we can still see today the remnants of the great Caledonian forest of 8,000 years ago.

The Blind Harper

Harpers were senior figures in the clan society of the medieval Highlands, and one of the greatest was Ruaidhri MacMhuirich, an Clarsair Dall (the Blind Harper), who is known above all for his "*Oran do MhacLeòid Dhùn Bhegain*" ("Song to MacLeod of Dunvegan").

Apart from the beauty of the song, it is an important social document. From the middle of the seventeenth century the great chiefs, such as the Earls of Argyll, the MacDonalds of Sleat, the Camerons of Locheil, and the MacLeods of Dunvegan, saw themselves as players on the national stage. To do this they had to go to Court. On the other hand, the people wanted their chief to rule over them at home, to act as arbiter in disputes, to lead them, and to entertain in the traditional way. Ruaidhri MacMhuirich's song laments the frequent absence of the chief in Edinburgh and the extravagance of the demands that his new way of life places on the clan, and accuses the chief of gambling away his inheritance and falling into debt. Harpers and bards, who travelled about the country and heard what was going on throughout the Highlands, were often spokesmen for the clan, expressing feelings that others did not like, or dare, to voice.

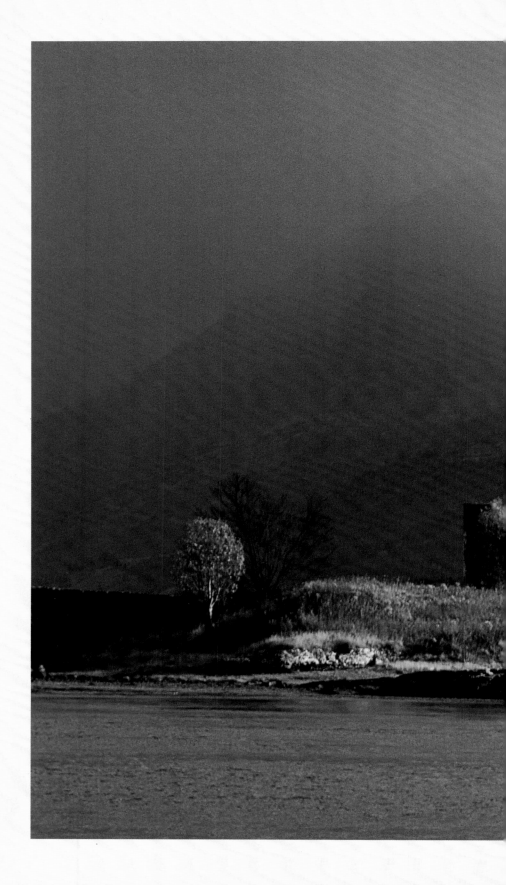

Eilean Donan Castle

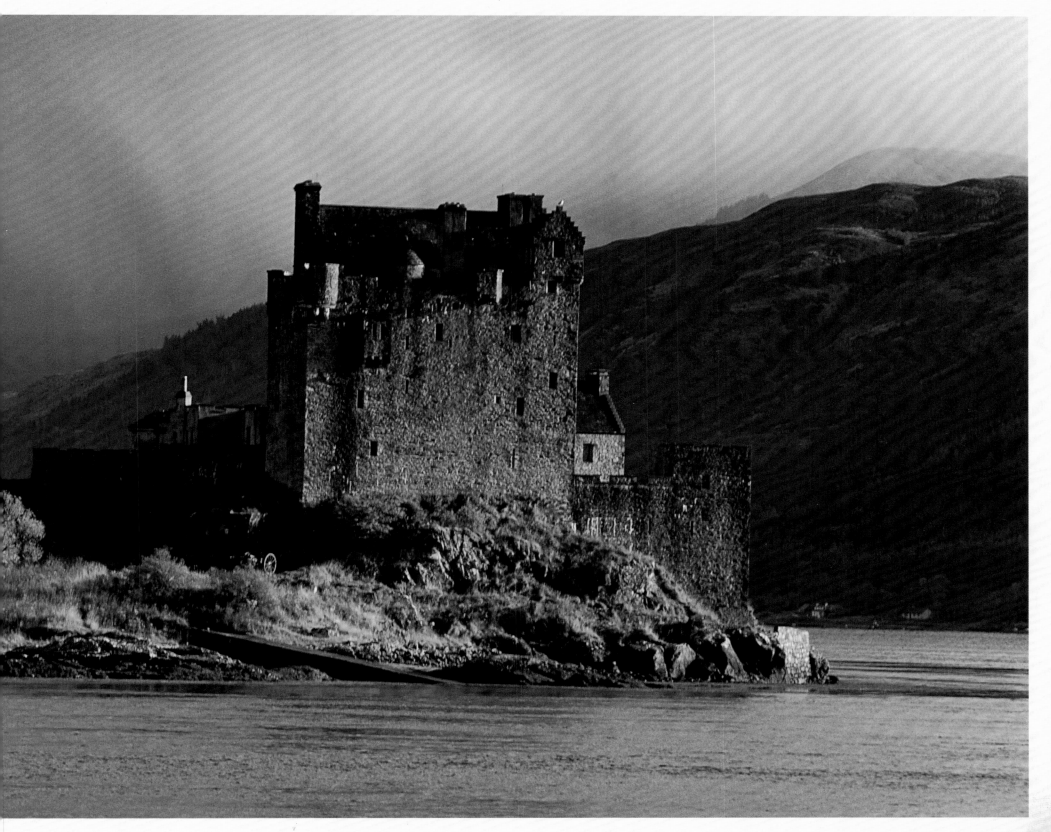

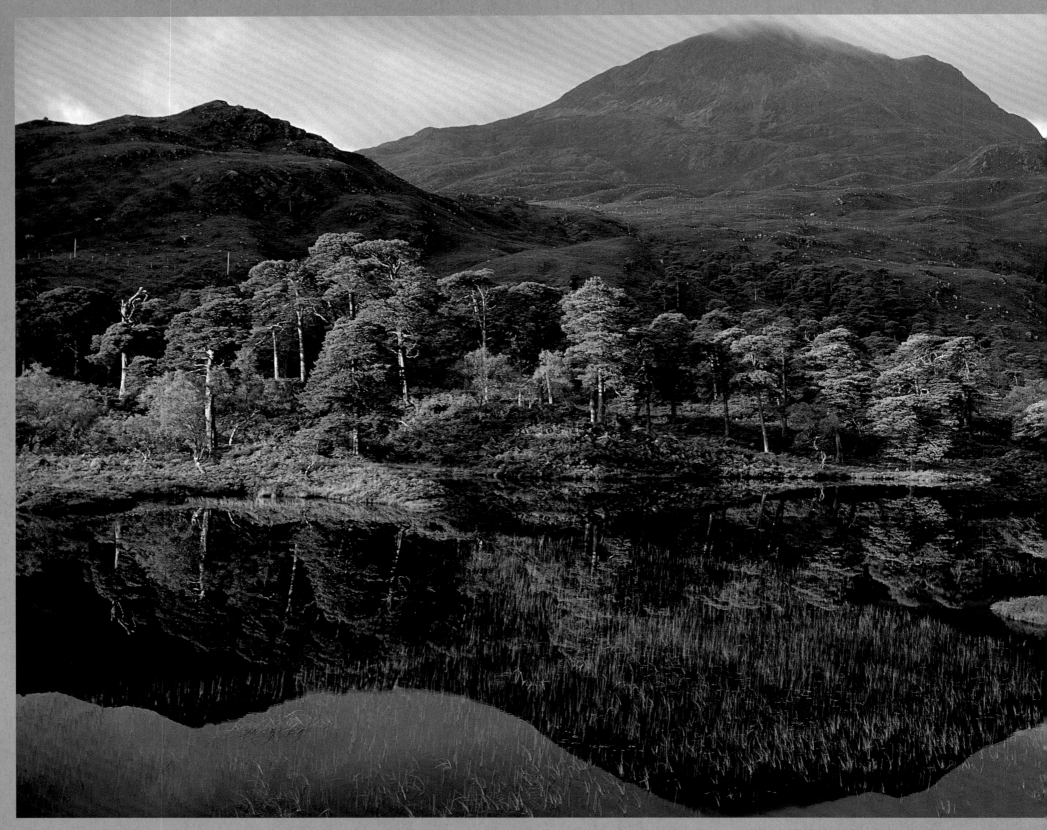

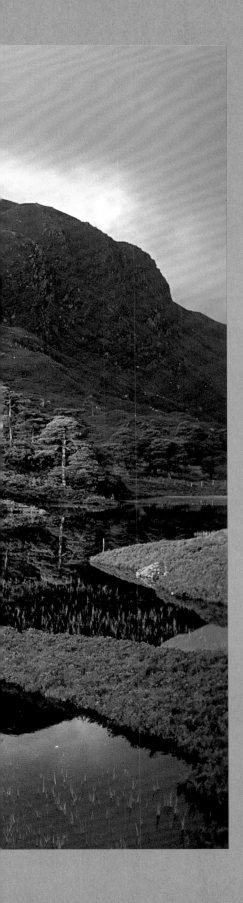

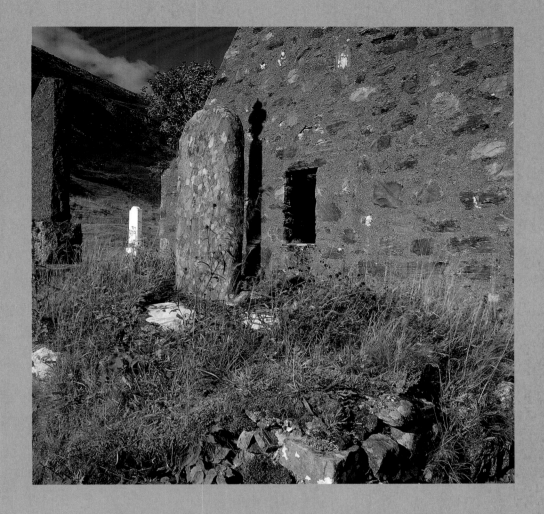

(left) Coulin pinewoods (above) The Kirkton of St. Duthac (next page) Above Loch Broom

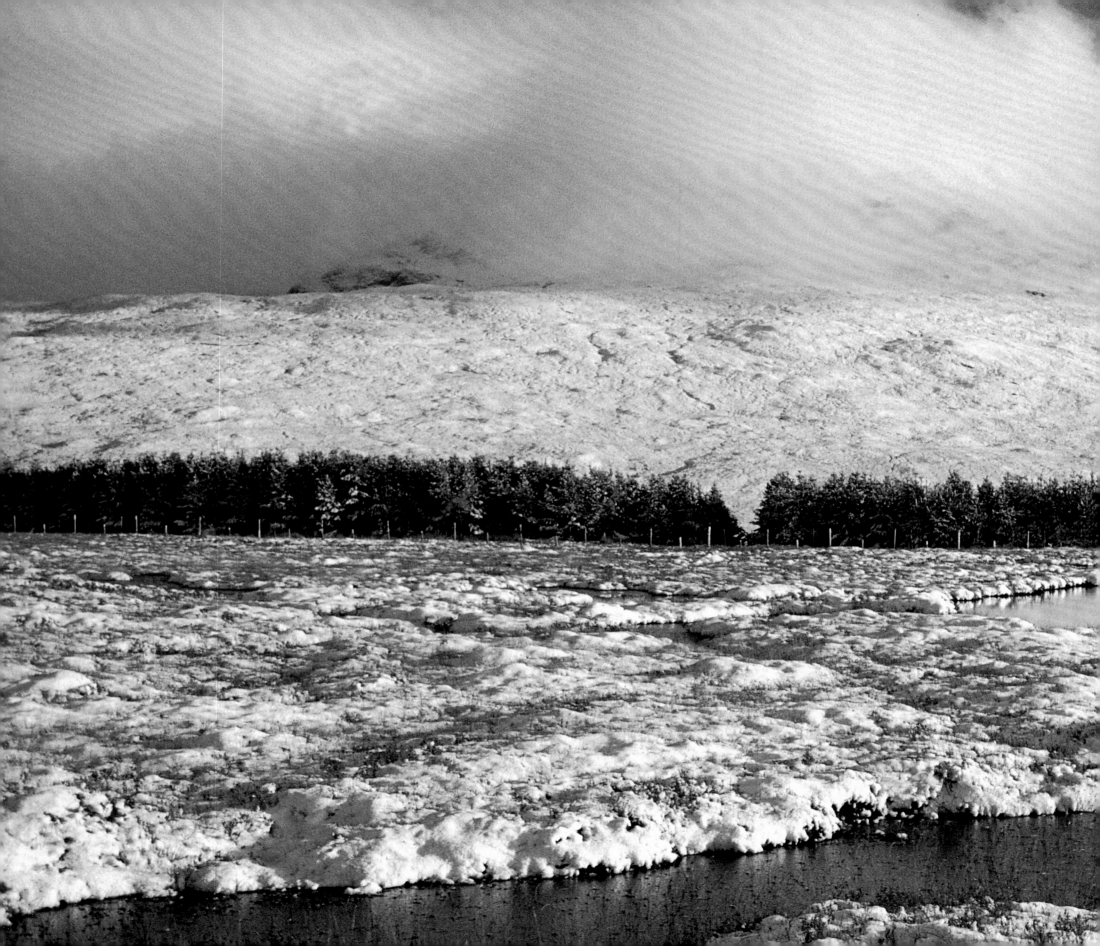

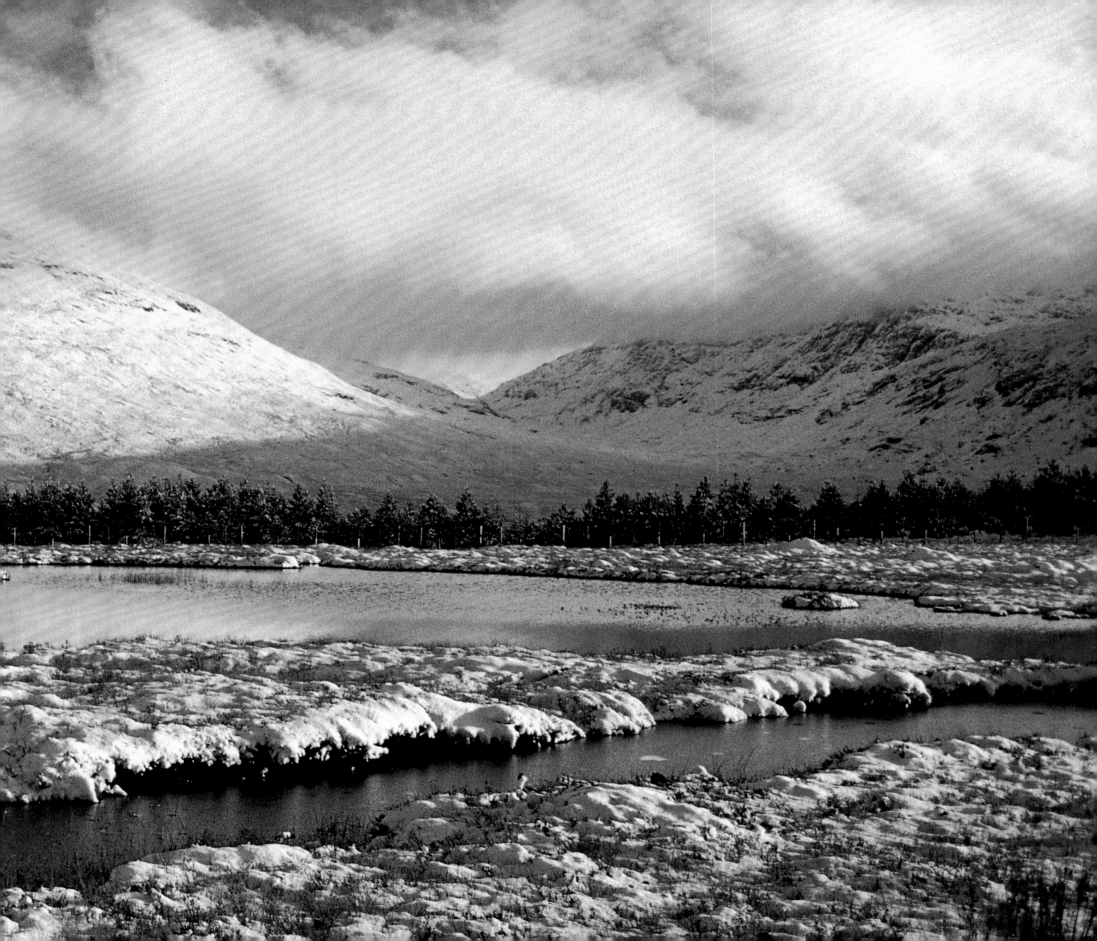

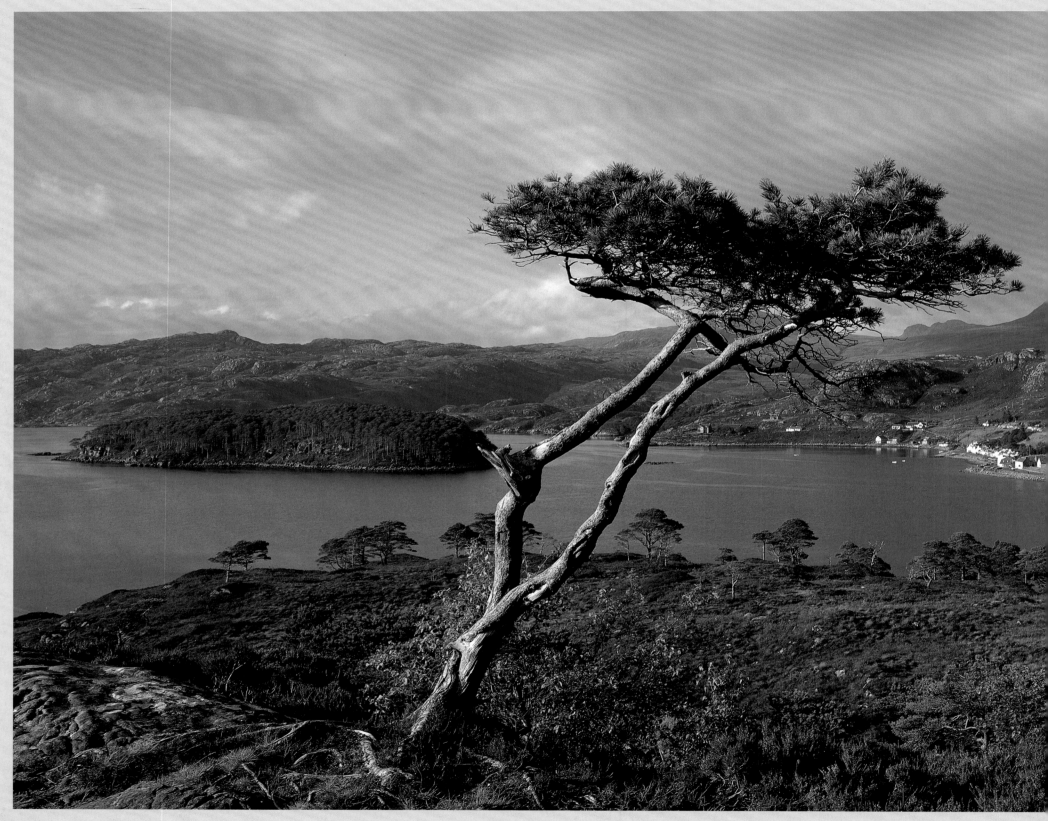

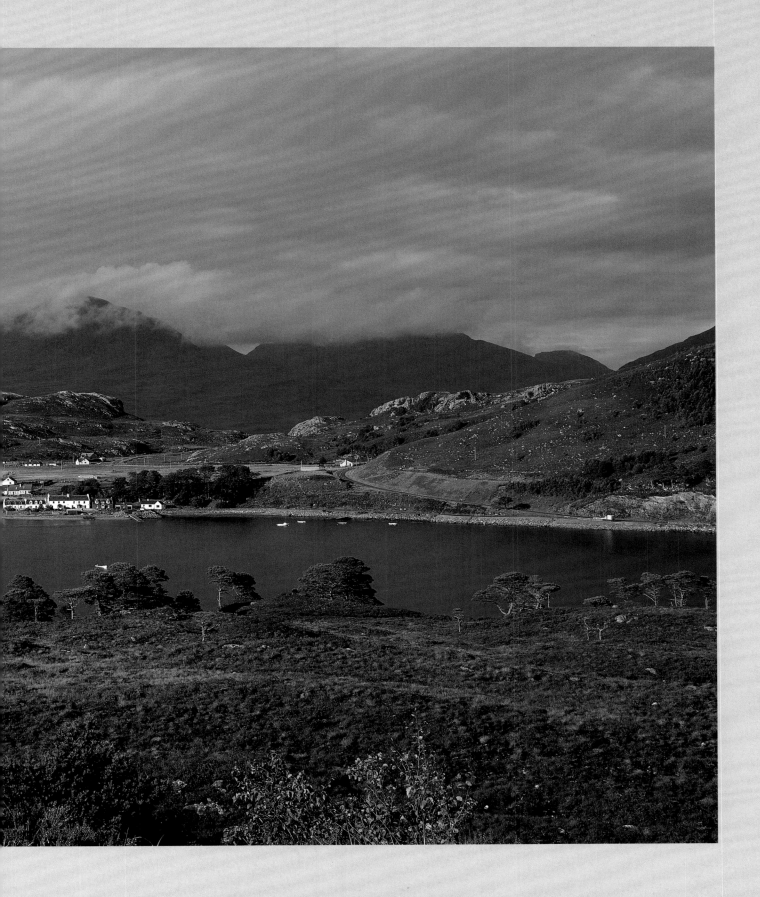

Shieldaig

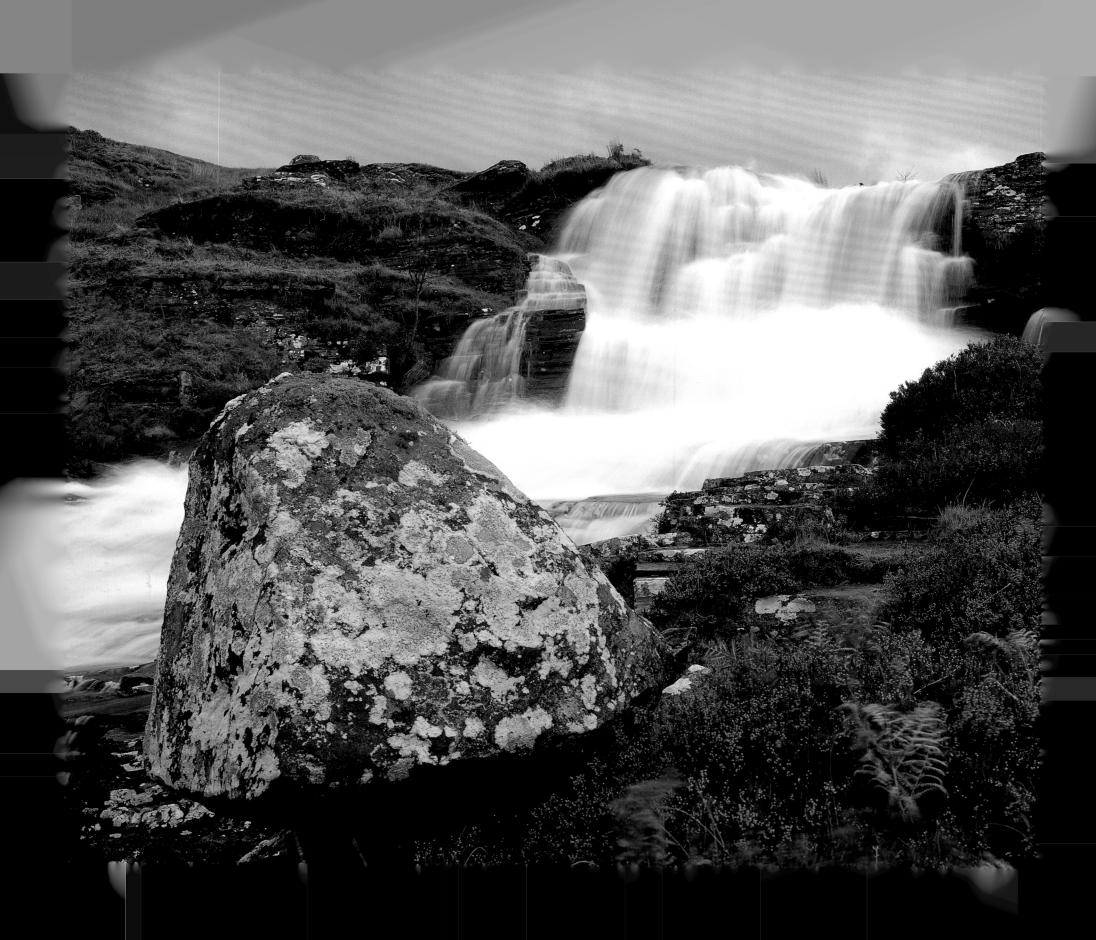

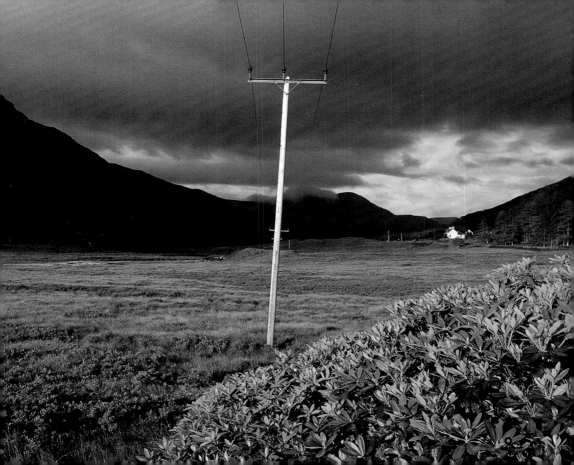

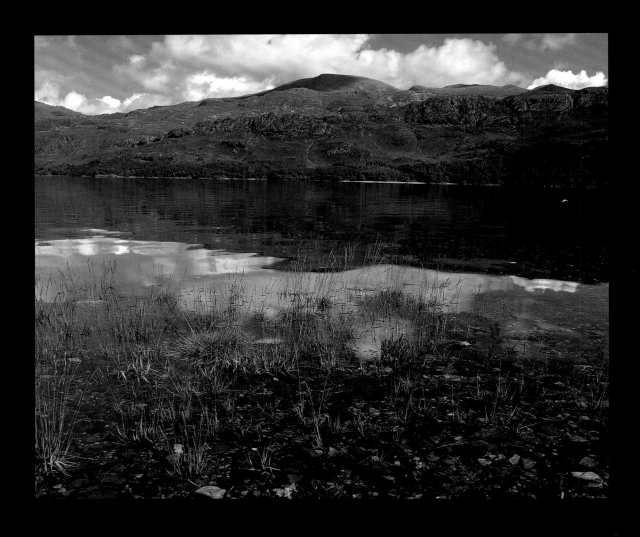

(above) Loch Maree

(right) The Five Sisters of Kintail

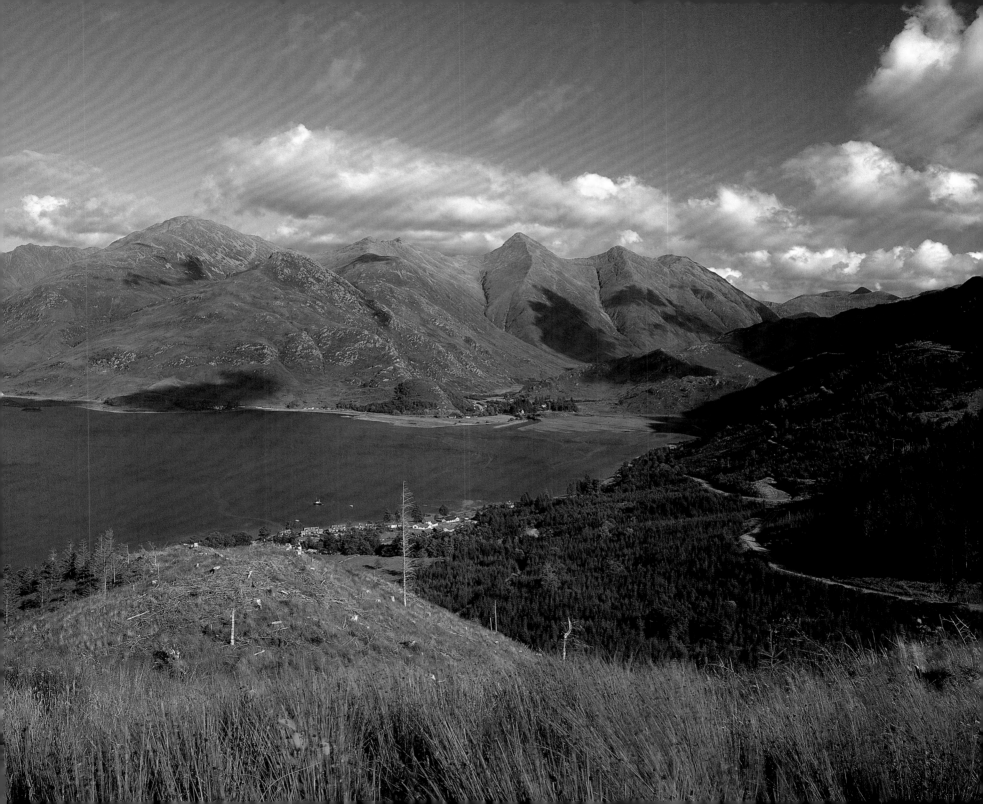

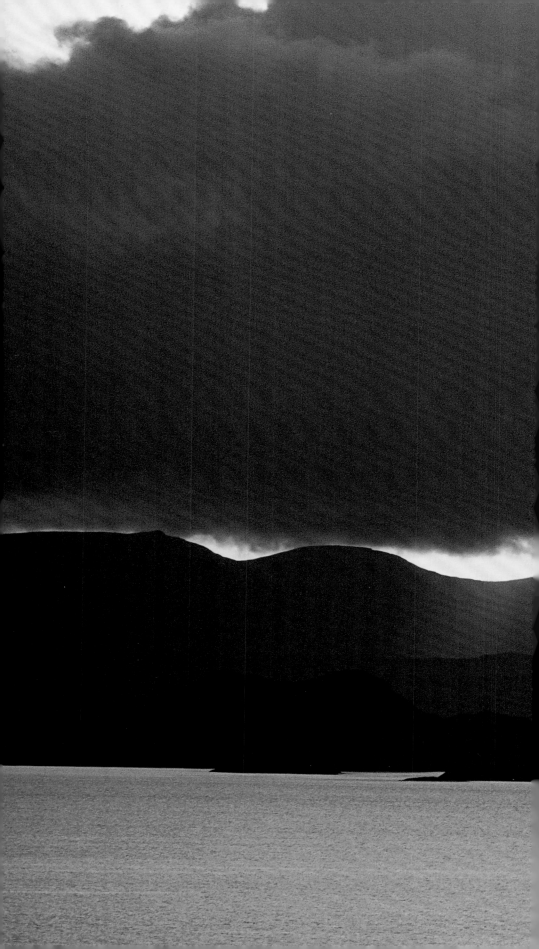

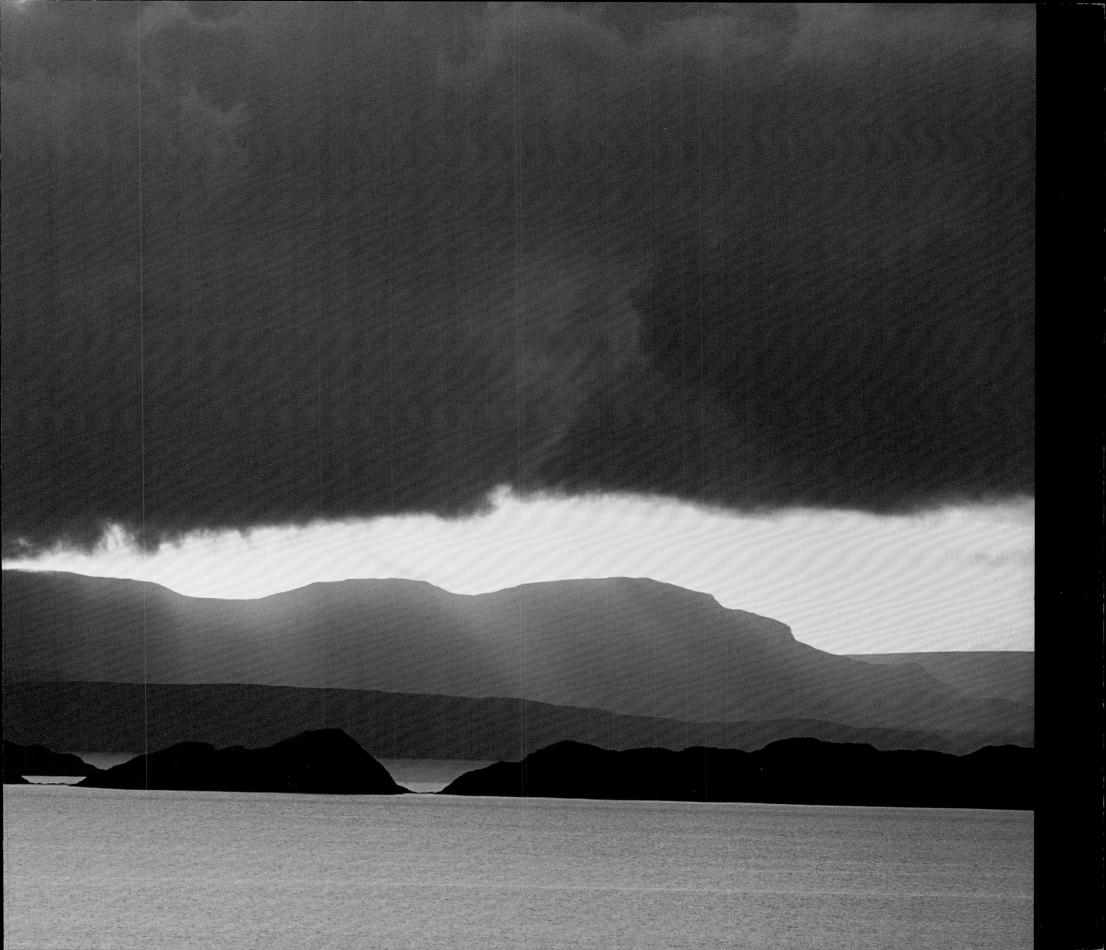

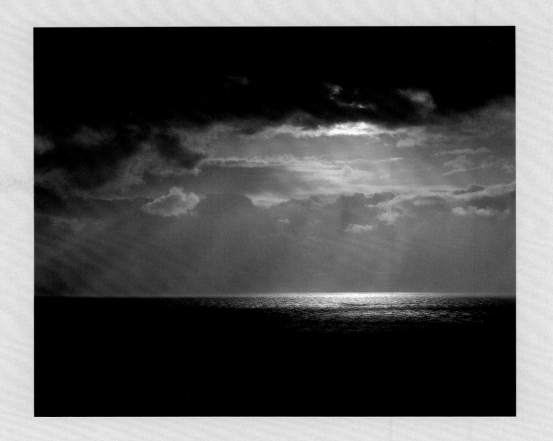

(above) **Raasay**

(right) **Ullapool**

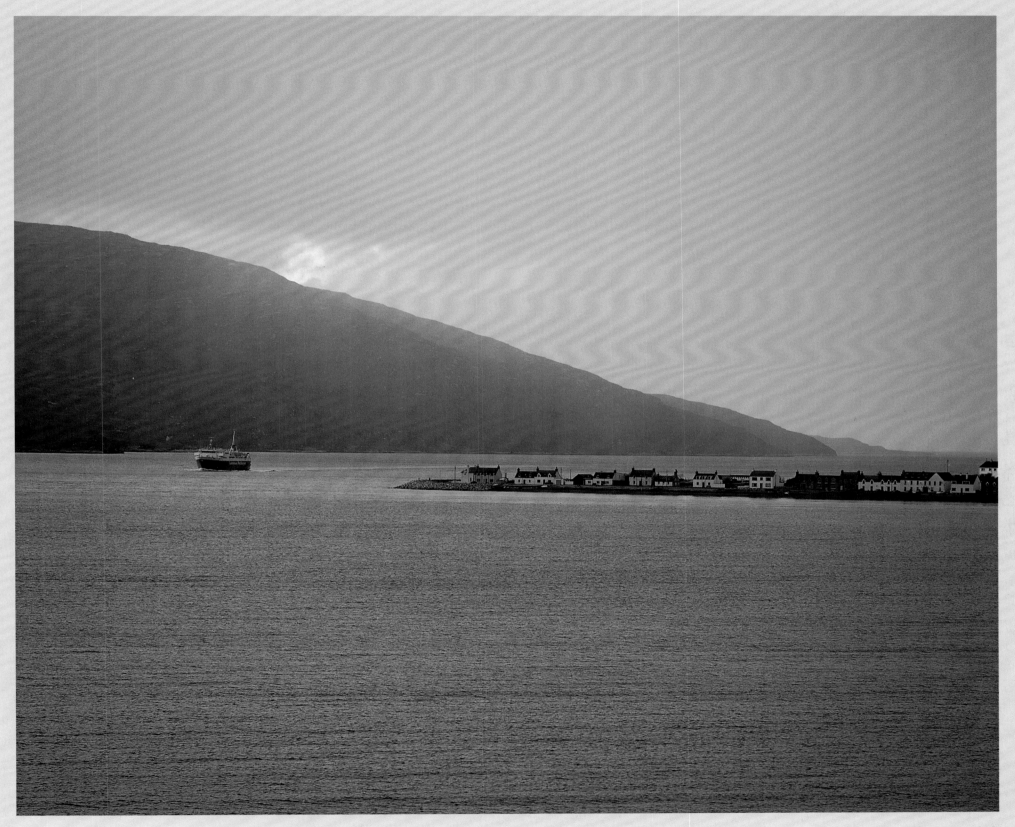

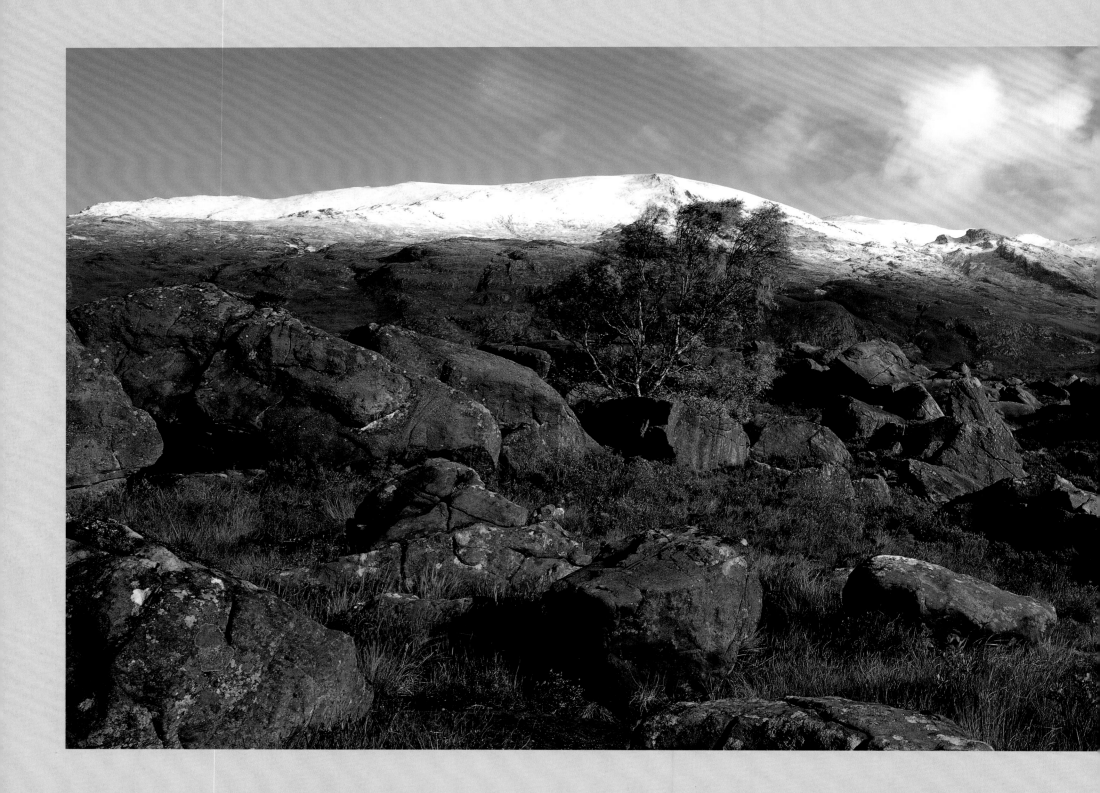

Loch Maree

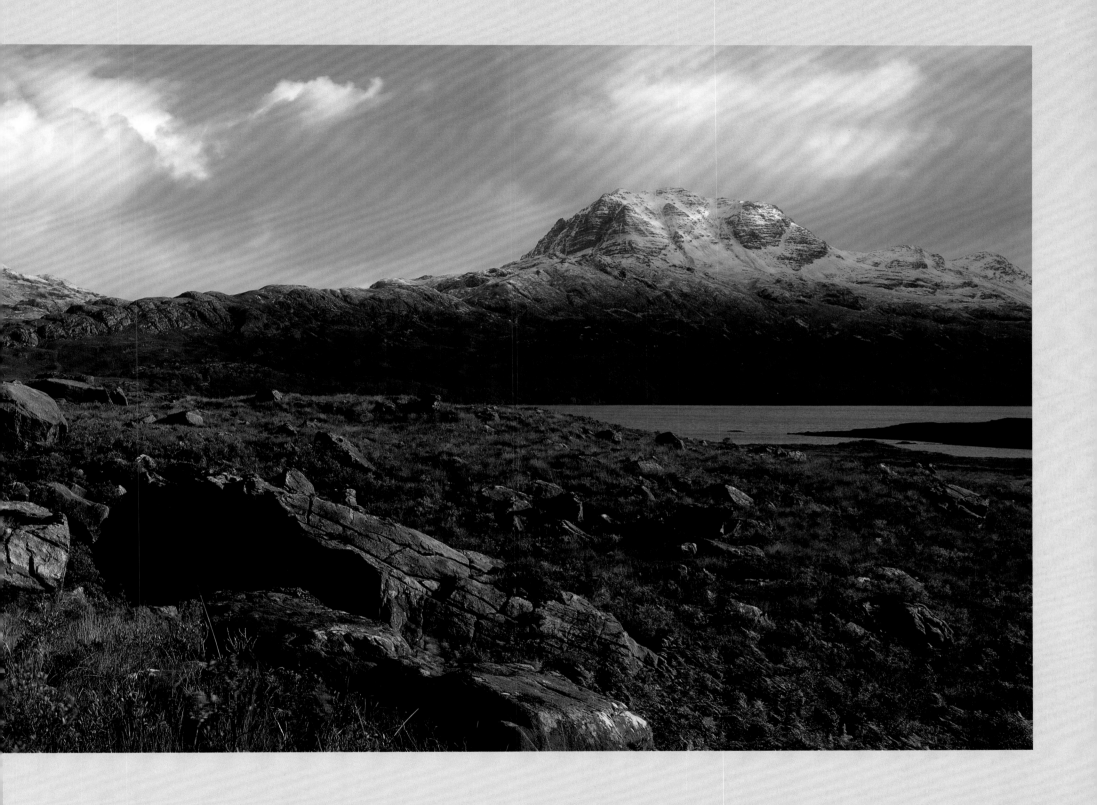

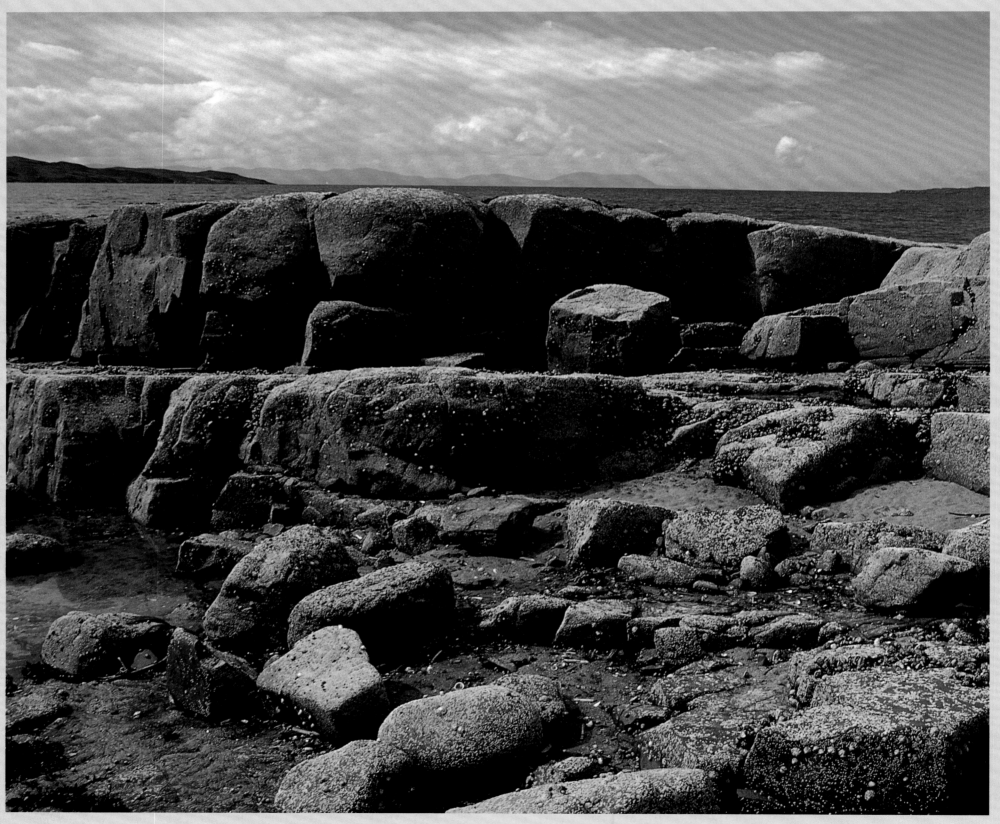

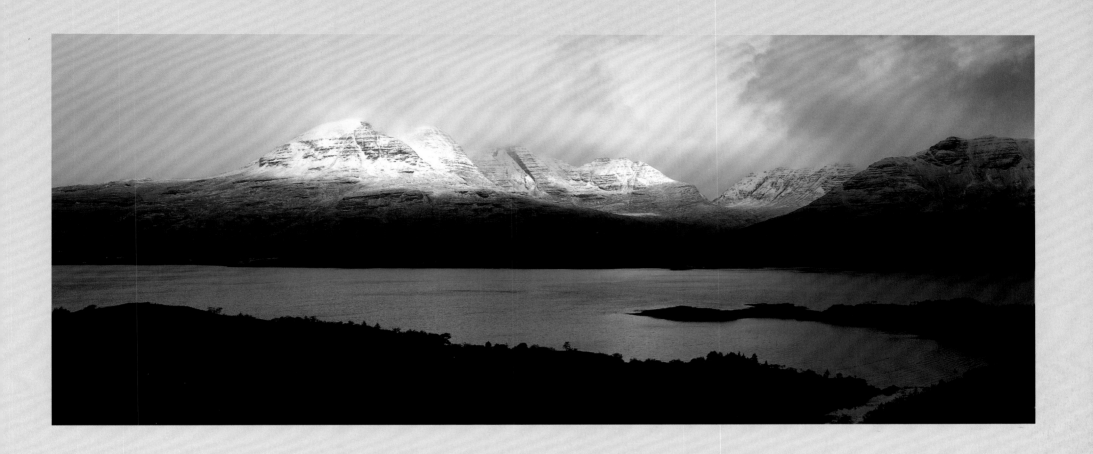

(left) Gairloch beach

(above) The Torridon Hills

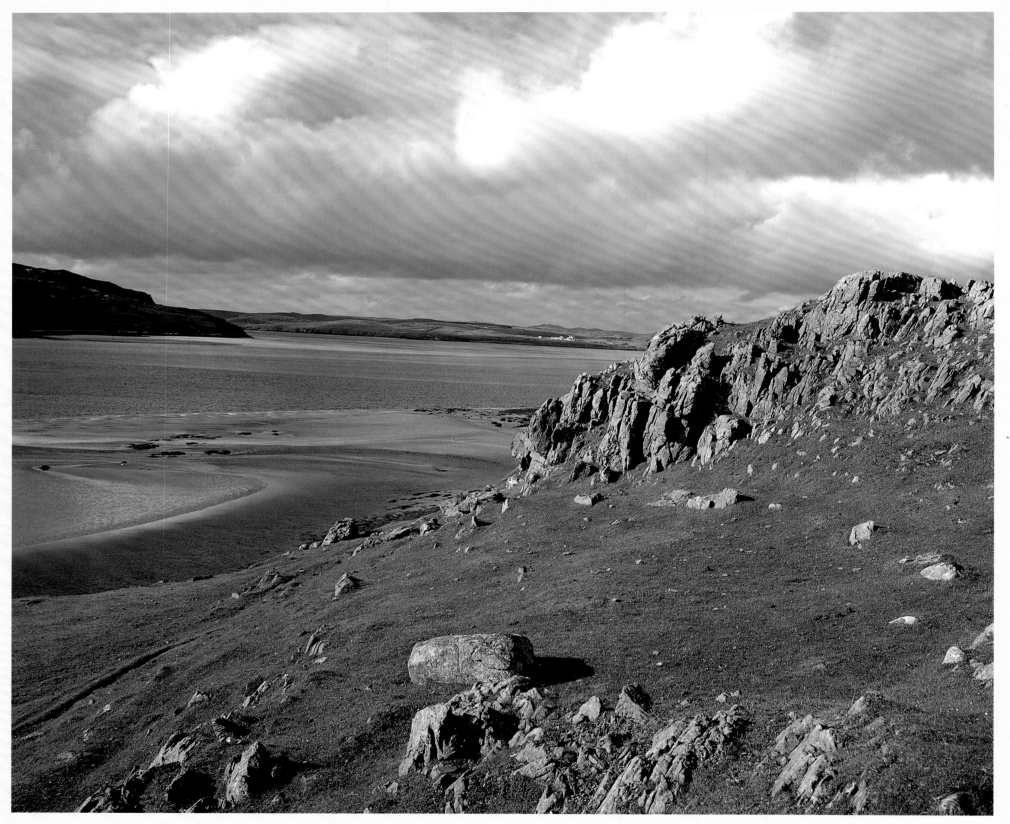

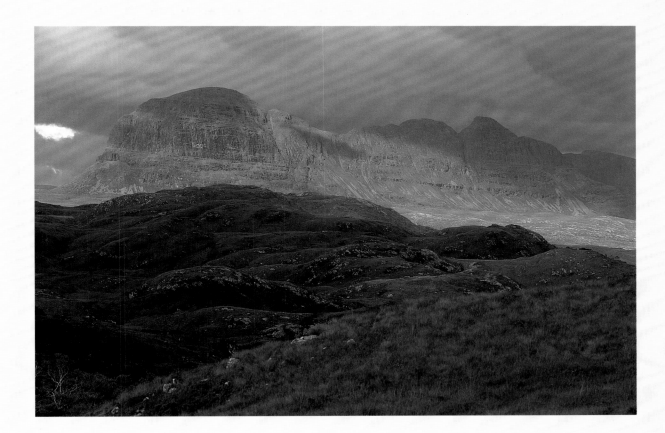

Sutherland

Sutherland and Caithness stretch from coast to coast across the whole of the north of Scotland, with Sutherland alone occupying one-eighth of Scotland's total land area. This remote area, sparsely populated even today, is one of the last true wilderness areas of Britain. Vertiginous cliffs – home to colonies of sea birds – plunge down to the sea, sandy coves cut into the shoreline, and heather-covered moorland seems to stretch as far as the eye can see. Perhaps because the area has always been so remote, many ancient cairns, standing stones, burial chambers and brochs (circular dry-stone towers thought to have been used as fortified homes) remain well preserved throughout the region. One of the most astonishing is the Hill O' Many Stanes at Mid Clyth in Caithness, site of 200 standing stones arranged in 22 rows in the shape of a fan, which dates from around 1800 BC (the Early Bronze Age). Many place names bear witness to more recent settlements and peoples. To the Gaels, Caithness was *Gallaibh*, The Strangers' Country, because its fertile sandstone plain was a place of Norse settlement. The Norsemen of the eighth century called Sutherland so because it was the southern land, the first large chunk of mainland they reached as they sailed round Cape Wrath and down the Minch on their way to harry and settle the lands and islands down to the Isle of Man and Ireland.

Names like Laxford (the Salmon Fjord) and the many names ending in "dale" all the way down the west coast of the Highlands and the Western Isles are evidence of the Norse occupation which lasted from about AD 800 to 1266.

(left) **Durness**

(above) **Suilven**

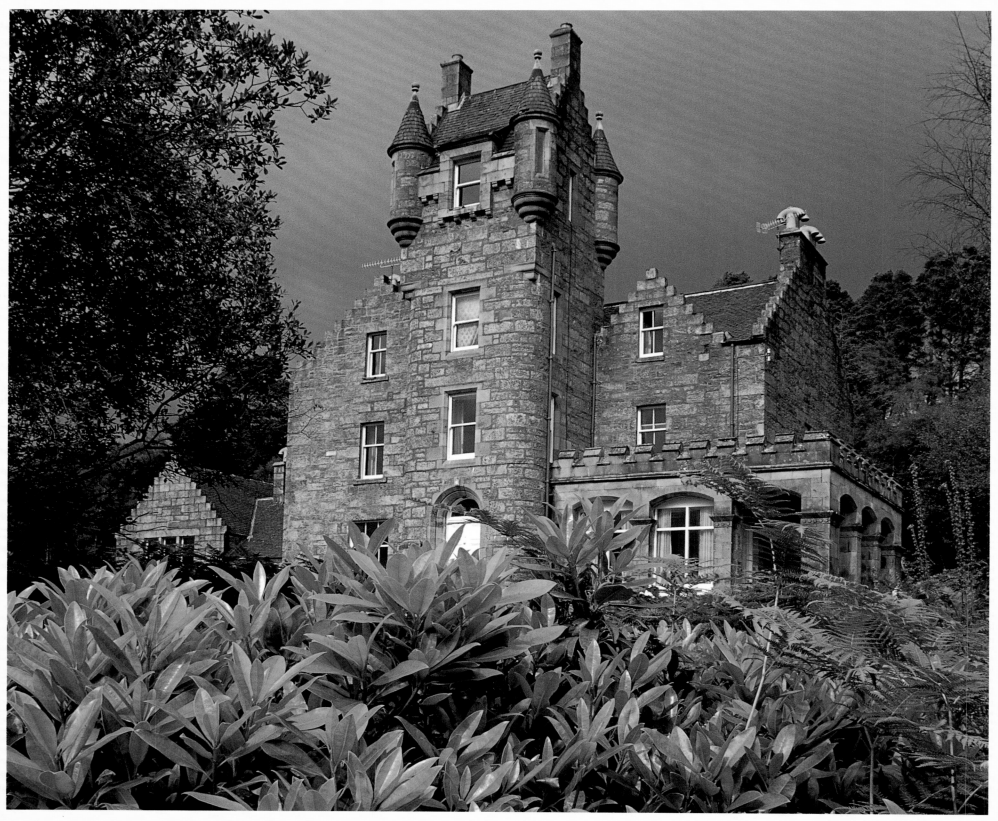

The Flow Country

The change in climate about 7,000 years ago, bringing colder and wetter weather, reduced biological activity in the soil and so prevented soil organisms from decomposing the dead vegetation. Peat started to form and where there were ill-drained hollows in the land, it accumulated and the hollows became bogs. The bogs began to spread, and the plants that had thrived in the warmer and drier phase found it more difficult to live and regenerate.

In the peatlands of Caithness and Sutherland, we have one of the most remarkable extents of this vegetational type in the world. Known as the Flow Country, from the old Norse word meaning marshy ground, at certain points it reaches depths of up to 6 metres (20 feet). It is a breeding ground for many of Britain's most important wading birds, such as the black-throated diver, the merlin and the greenshank. Since the Second World War, however, the Flow Country has come under increasing pressure from afforestation, although a Peatland Management Scheme, launched in 1992, appears to be having some success. We can only hope that this unique habitat is preserved for future generations.

The Clearances in Sutherland

The Highland economy collapsed after the end of the Napoleonic Wars and landowners realized that they could no longer sustain the growing numbers of people on their estates. The problems they faced were beyond their financial and administrative capacities. The only solution they could see was clearance followed by emigration. In some cases, however, the clearances were part of a programme of development and agricultural improvement. This is what happened on the Sutherland Estates.

The Countess of Sutherland had married the Marquess of Stafford, an English nobleman who drew up plans for the development of her vast estates in Sutherland. The plan envisaged the reorganization of the interior into holdings that were to be let to commercial sheep farmers. The people who occupied the existing grazings and lived in overcrowded poverty in such settlements as Rossal would be moved to the coast, where they would be allocated land for crofts (small-holdings). It was proposed that they would become fishermen and catch the herring that at that time were plentiful off the northern and western coasts of Scotland.

In many ways, the plan was carefully thought out, although in theoretical rather than practical terms, and designed to benefit the people as well as the owners. So what went wrong? The landowners' logic was incomprehensible to the Gaels. So far as they were concerned, they had occupied the ground since time immemorial. It seemed to them that the Earls of Sutherland should look after their tenants. Uncertain and miserable as their lot might sometimes be, it was preferable to the horror of banishment from the land of their ancestors.

The Staffords' agents did not help matters by treating the Highlanders as idle savages. Some evictions were carried out with great violence and little or no warning. Roofs were burned and, at Rossal, an old and sick woman evicted from her house died shortly afterwards.

Then there was the question of the fishing. The Gaels were pastoralists and farmers, and had never been great fishermen. They found themselves on the sea-shore without boats and without suitable skills. In addition, the herring that had been so plentiful during the late eighteenth century changed their pattern of migration and ceased to swim past the coast of Scotland. There were, therefore, no herring to form the basis of the crofters' hypothetical prosperity as fishermen, even if they had been able to acquire boats. Despite the bitterness that the first Clearances caused, large-scale evictions continued throughout the Highlands up to about 1880. For the people, the Clearances confirmed that the role of the chiefs had changed irrevocably. They had become landowners for whom commercial interests had priority. For the Gaels, the betrayal was completed by the way in which Lowland Scots and Englishmen were usually preferred to Gaels as prospective tenants for the new farms.

Glencassley

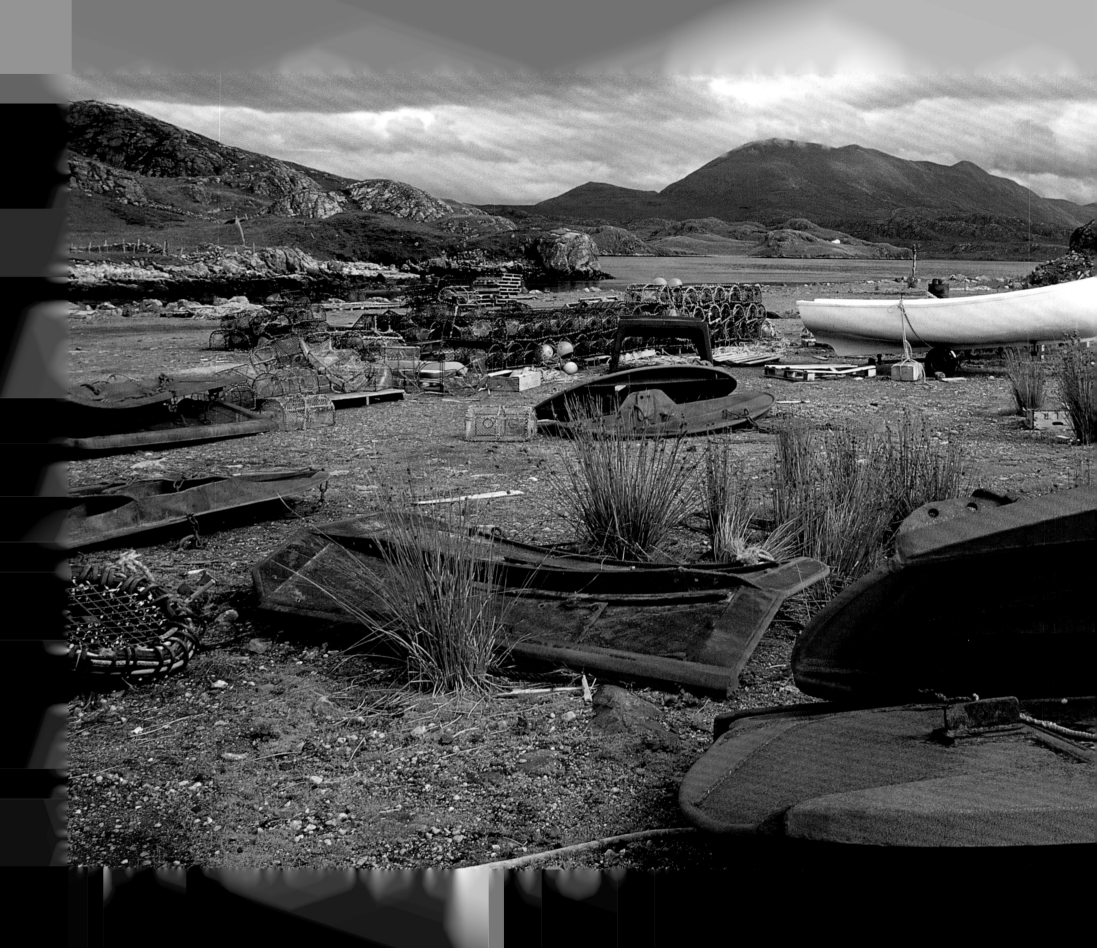

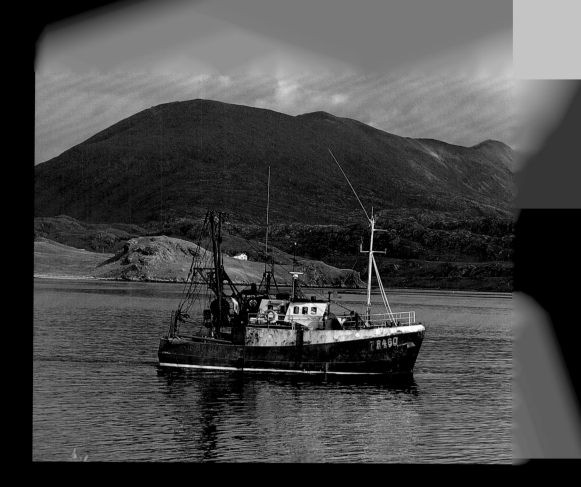

(above) Kinlochbervie fishing boat

(left) Kinlochbervie

(next page) Fishing nets

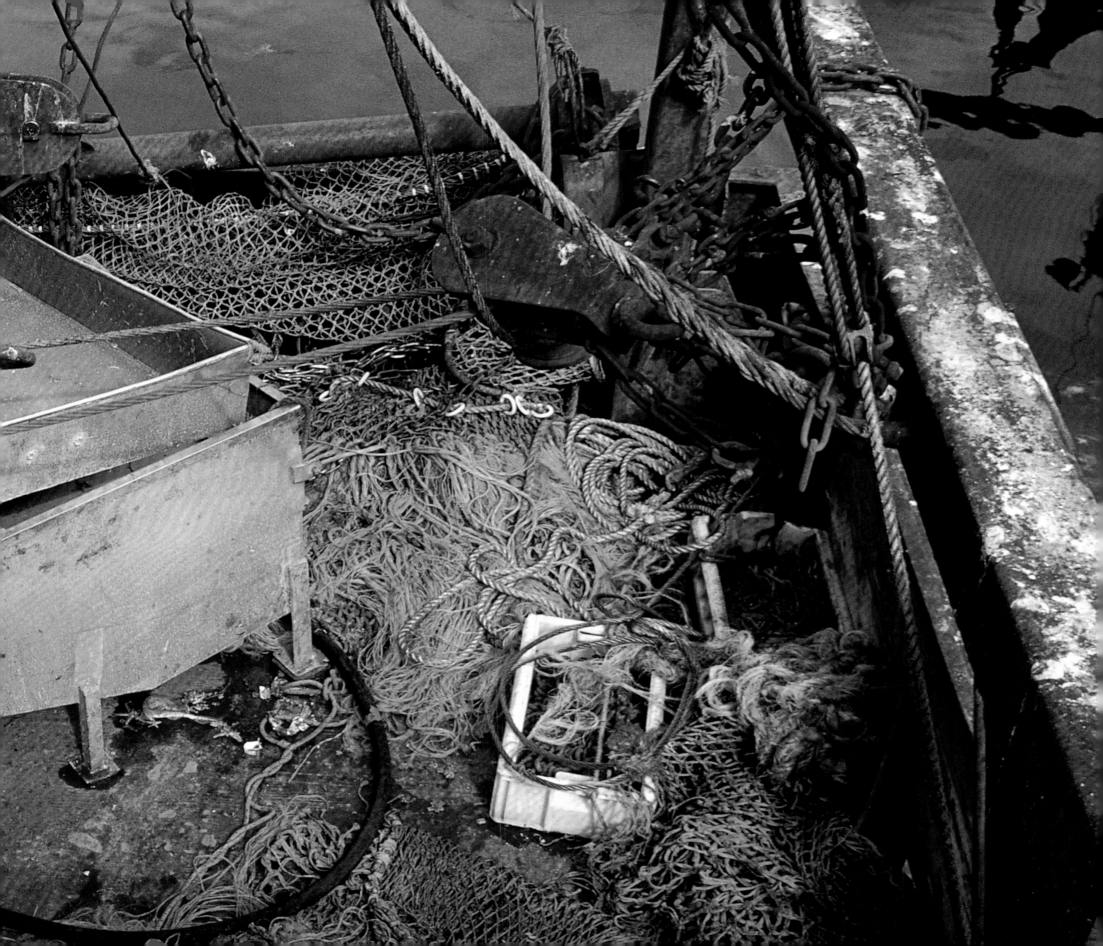

(above) West coast sheep

(right) Highland ponies

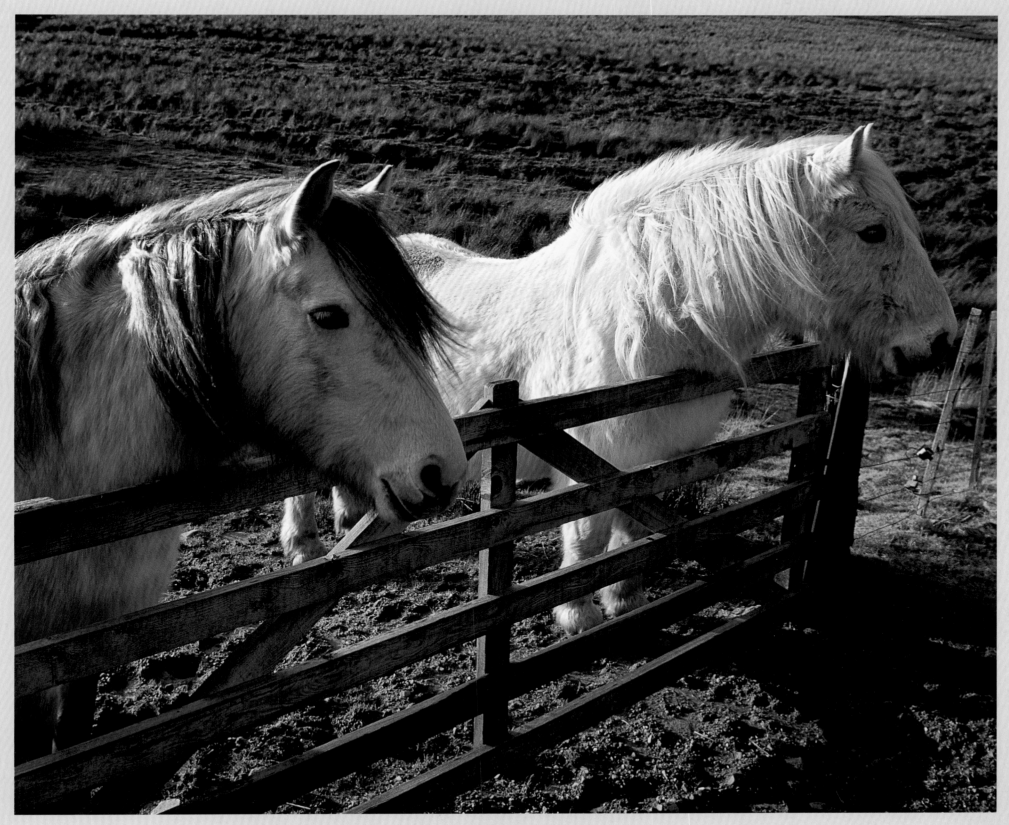

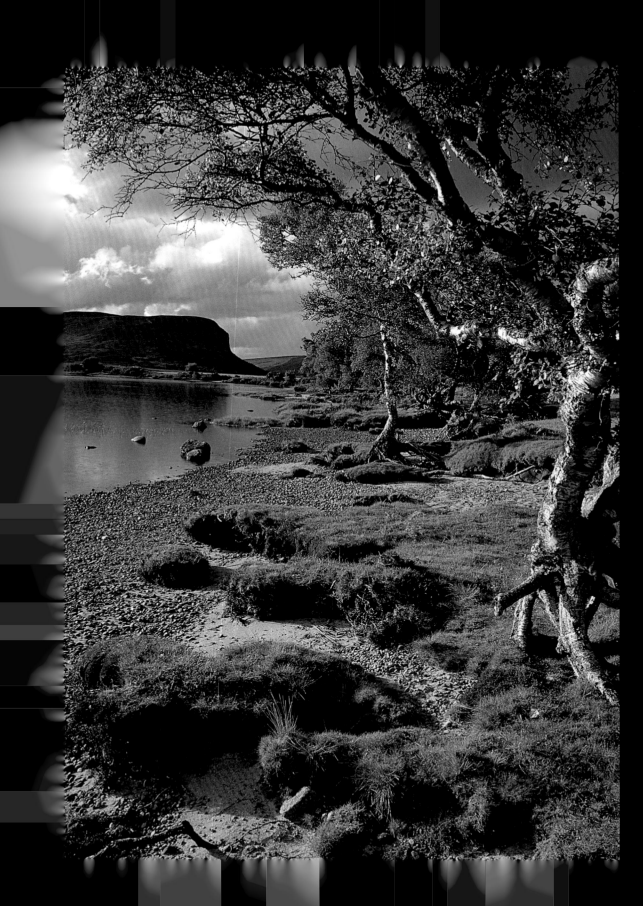

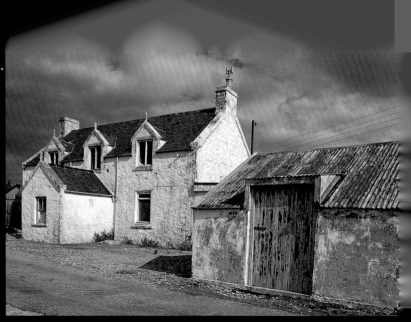

(above) House at Kinlochbervie

(left) Loch Brora

(right) Drystone wal

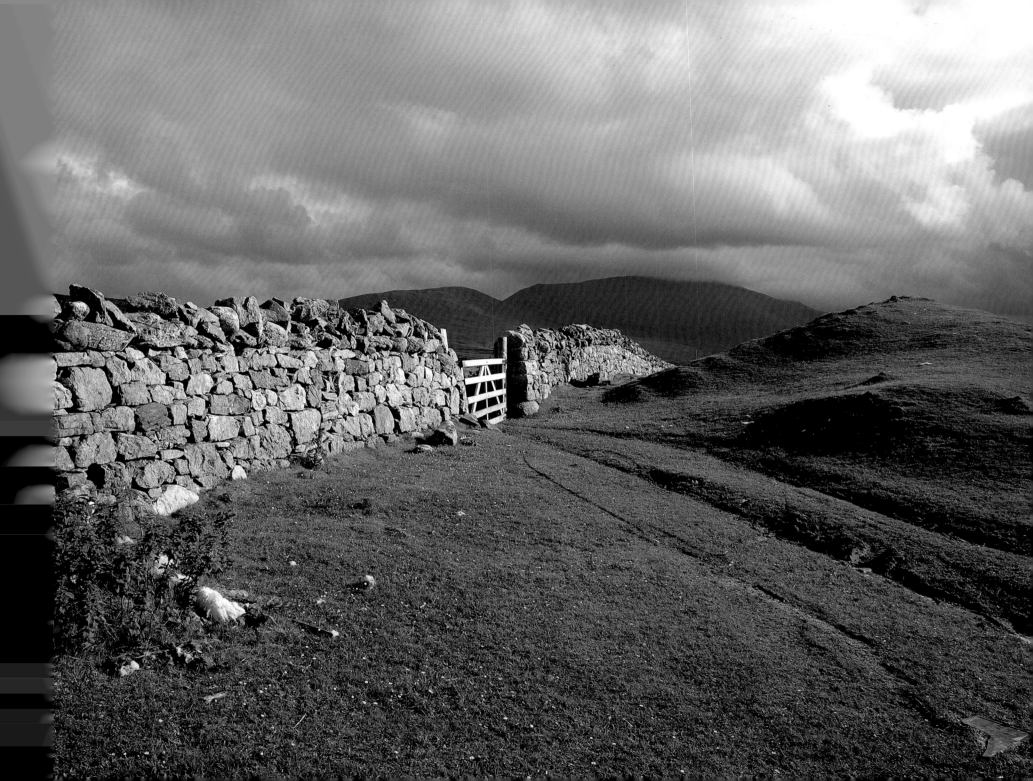

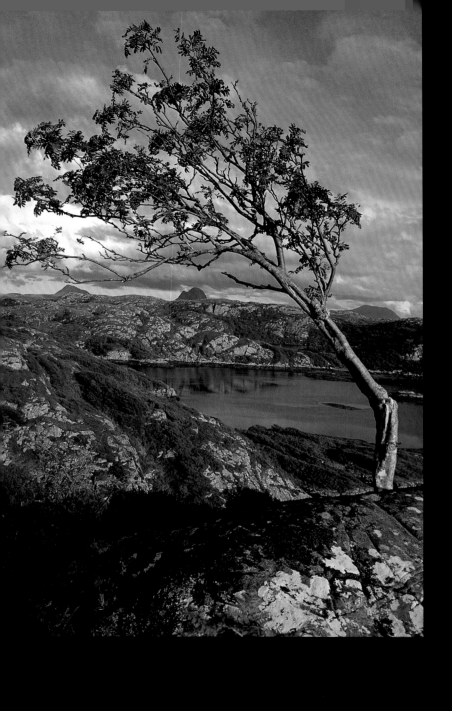
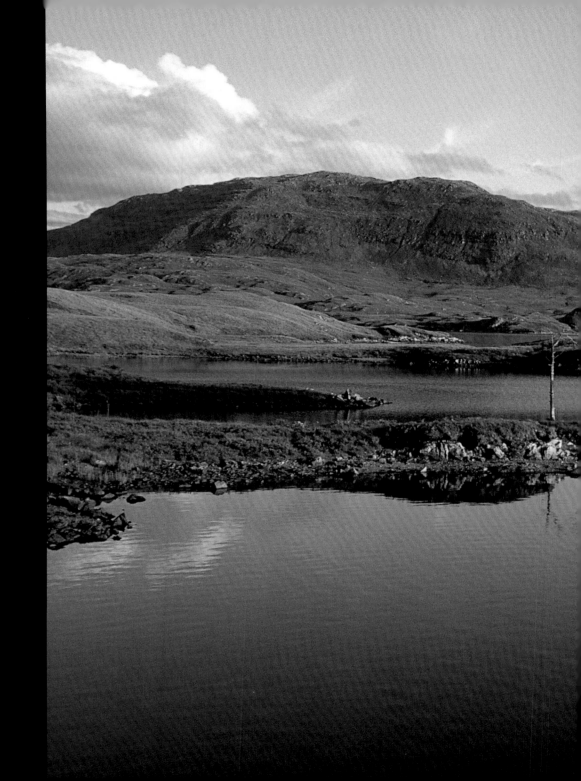

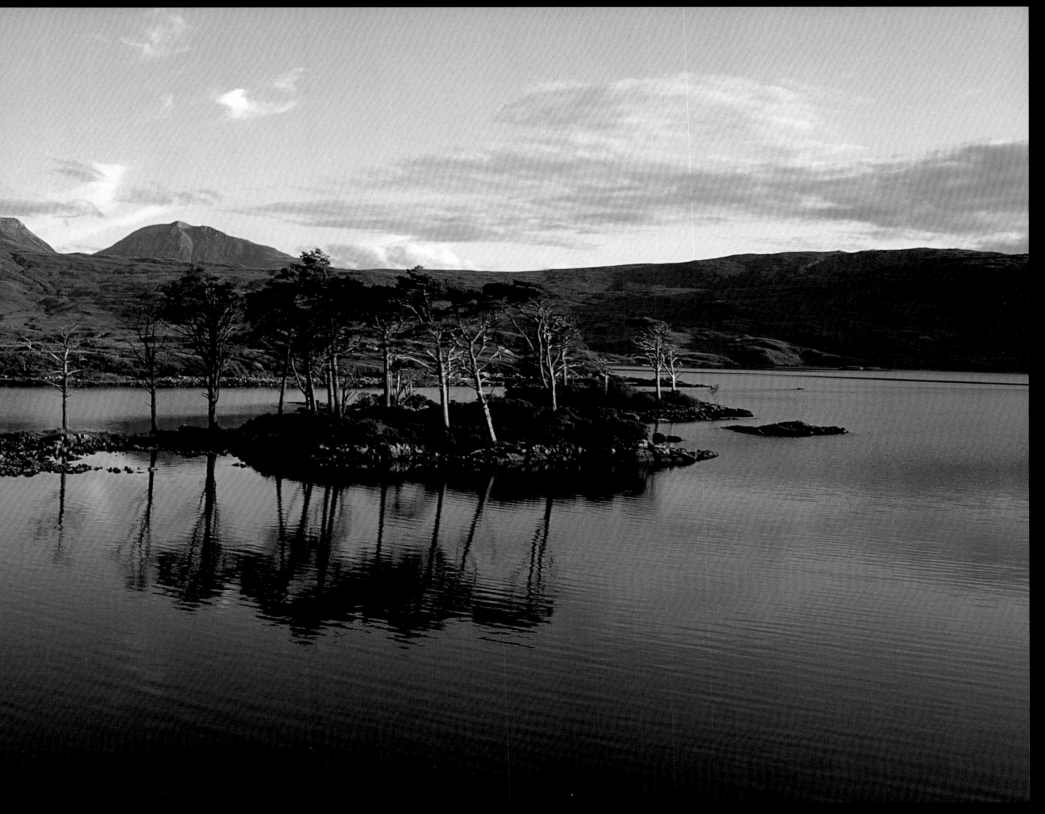

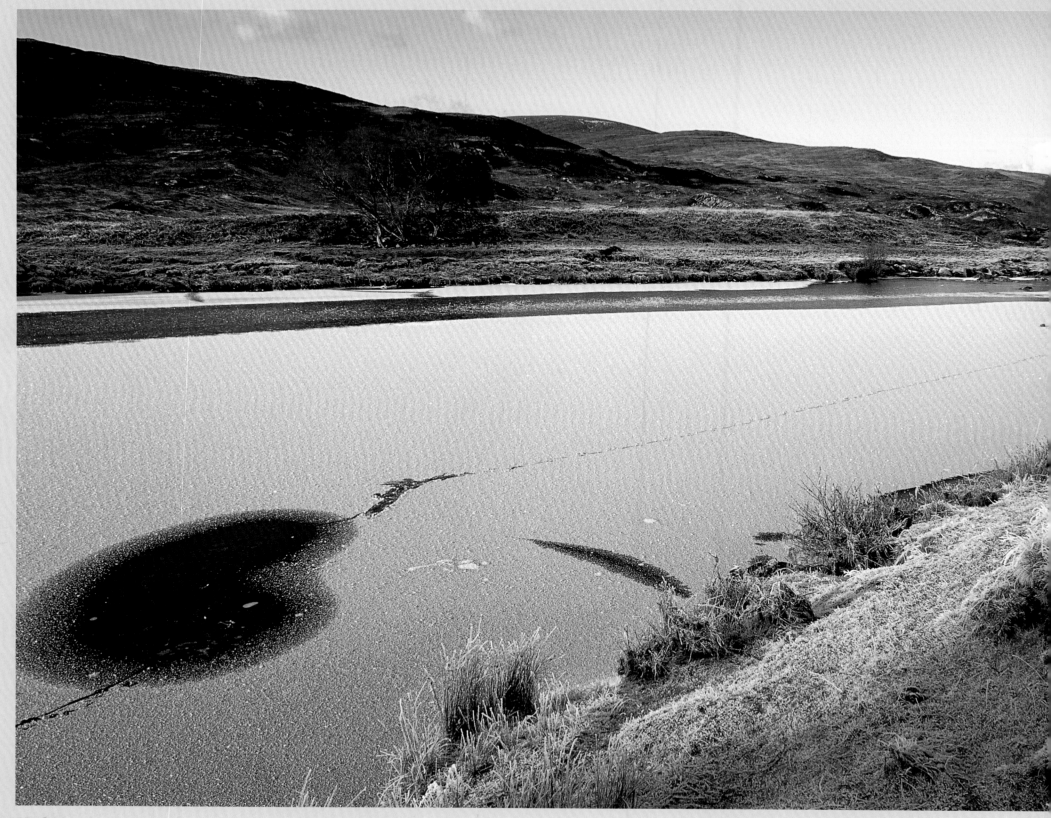

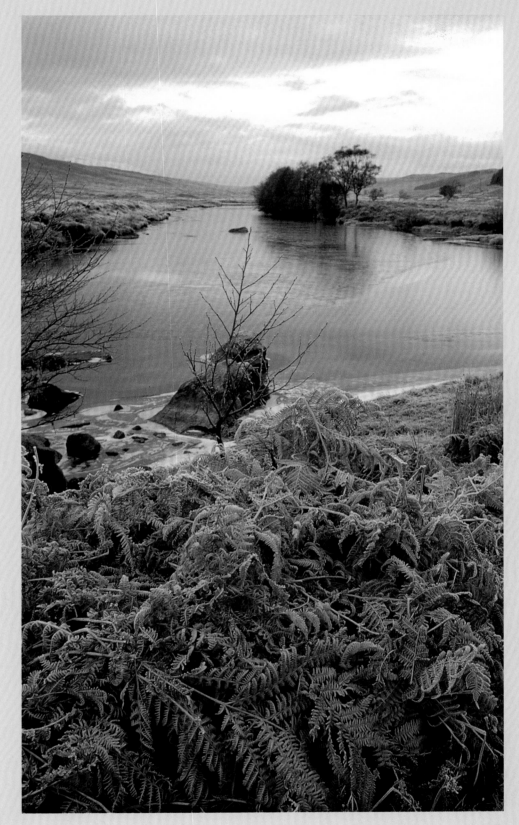

(left and right) River Cassley

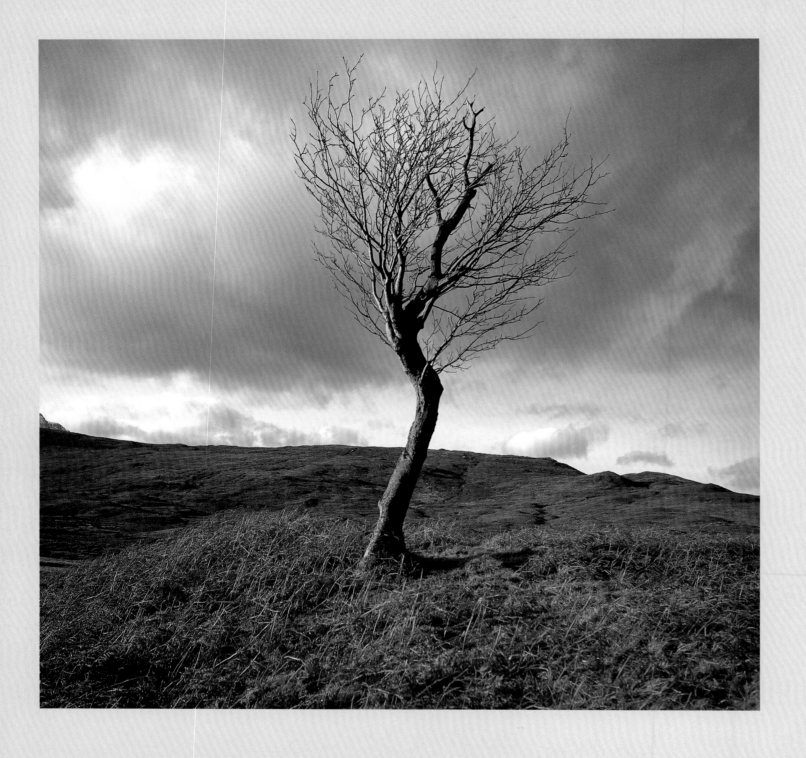

(above) **A tree near Canisp**

(right) **Invershin**

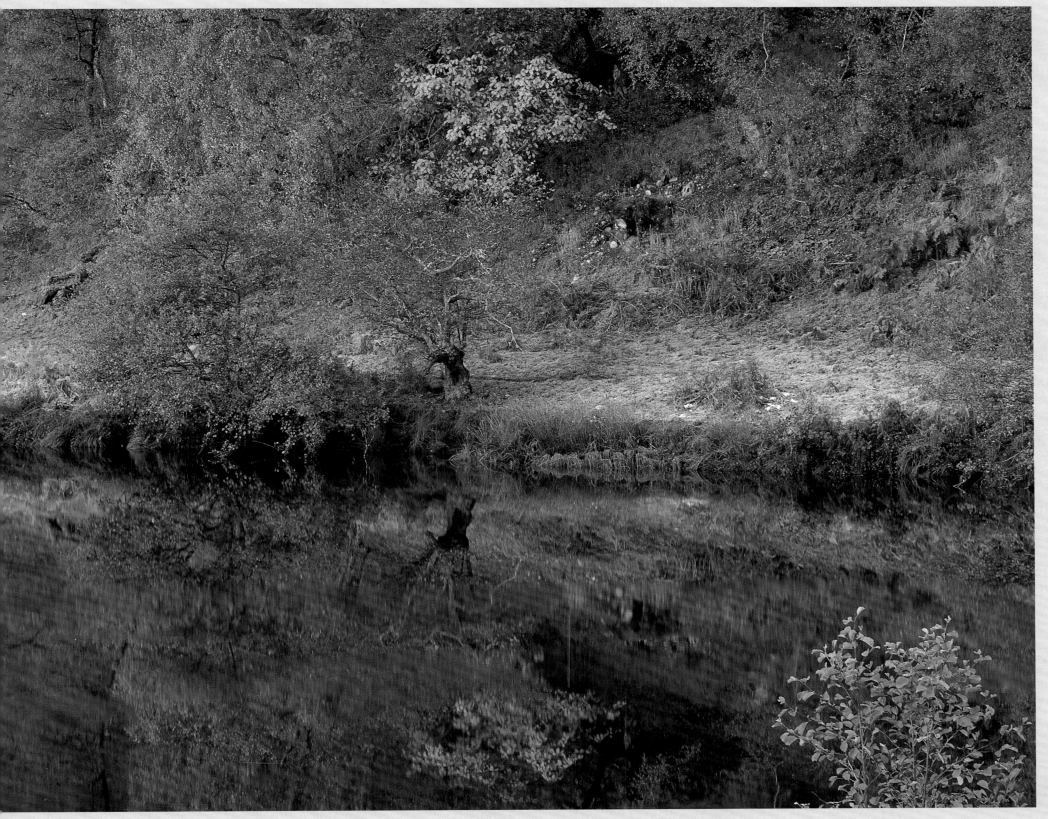

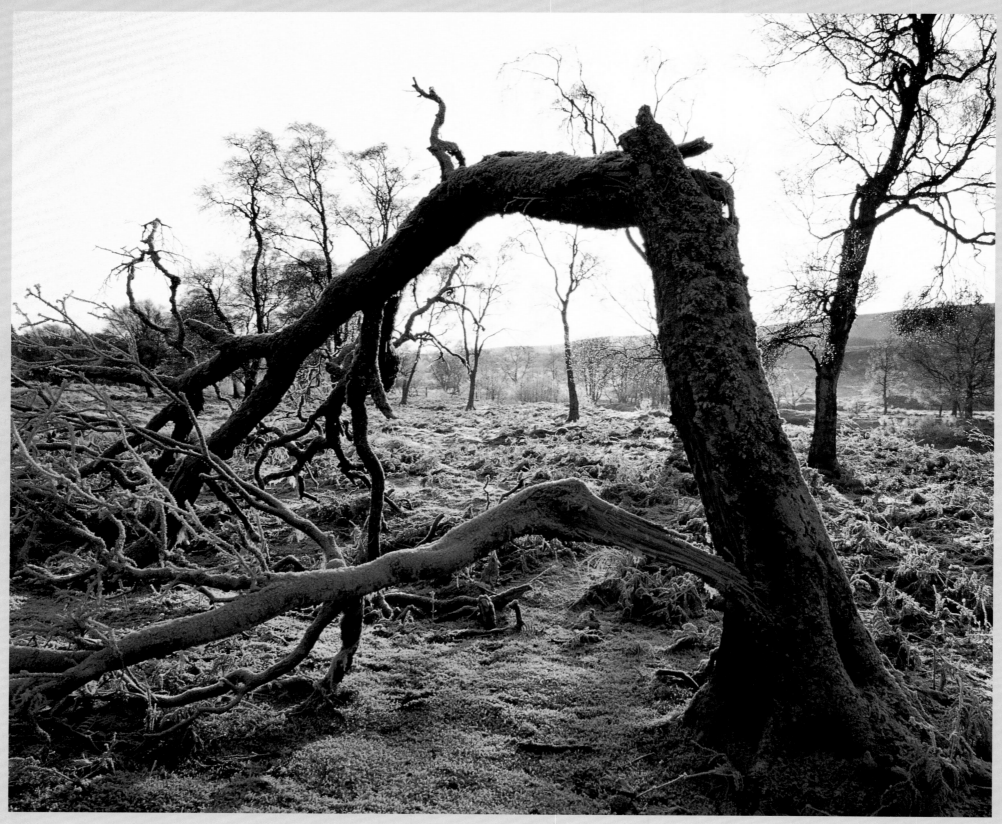

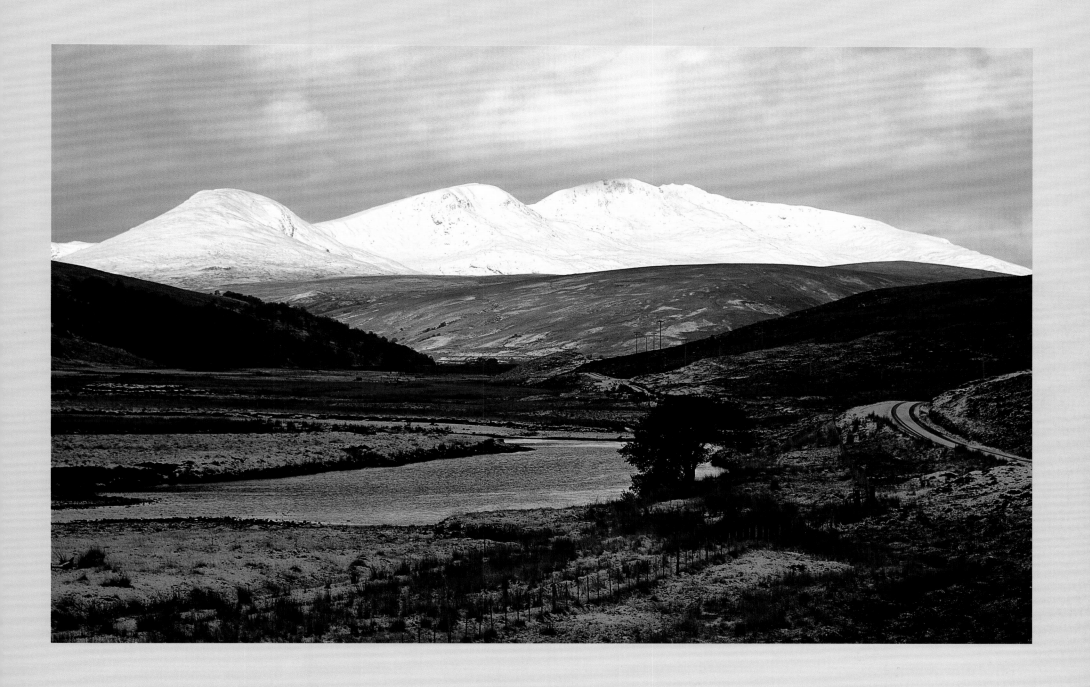

(left) Broken tree in Glen Cassley (above) Ben More Assynt (next page) Upper Cassley Falls

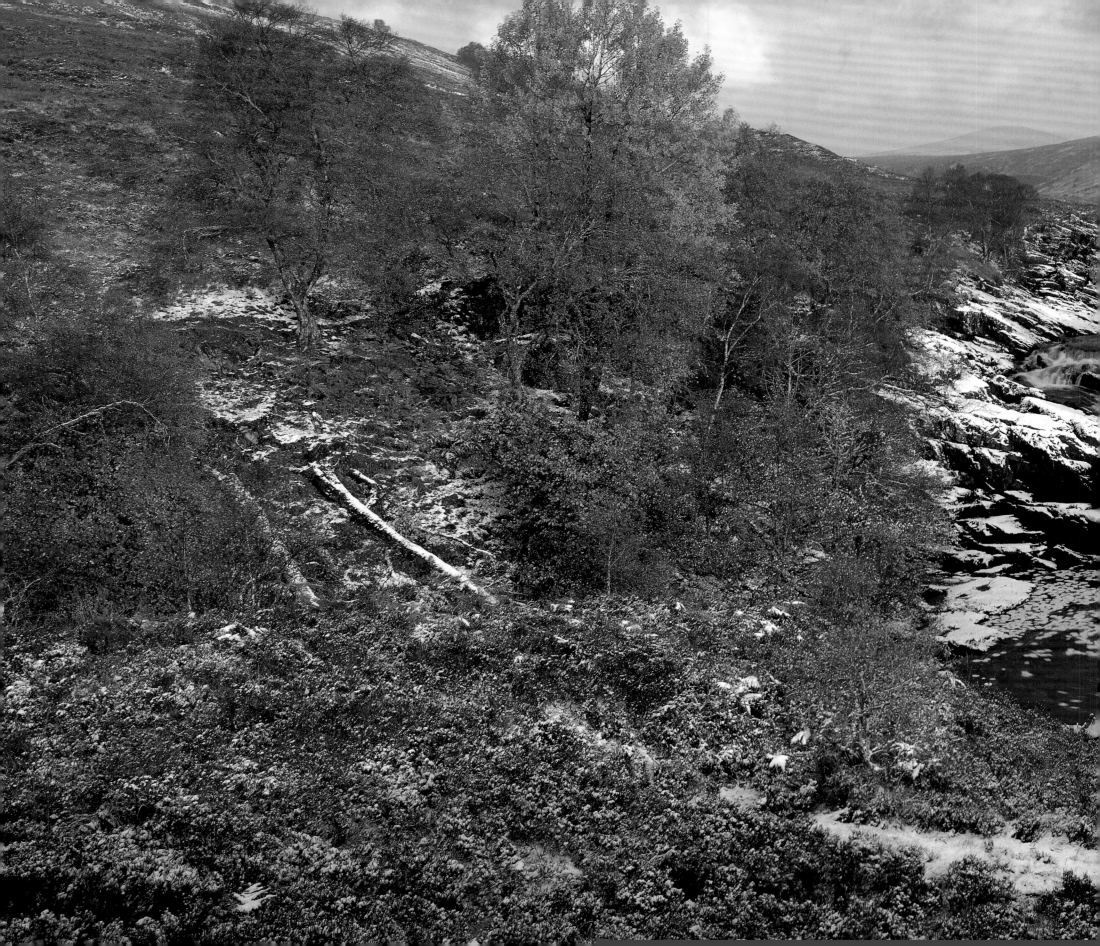

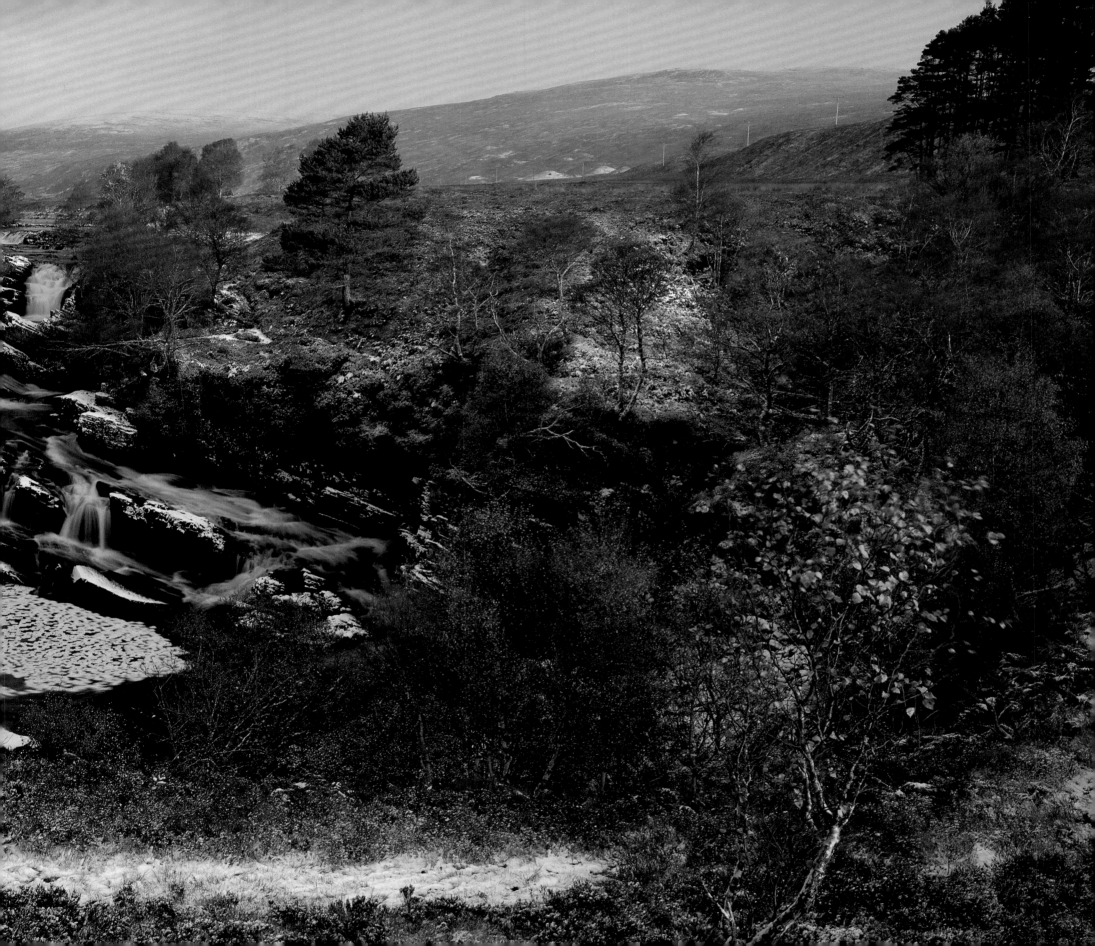

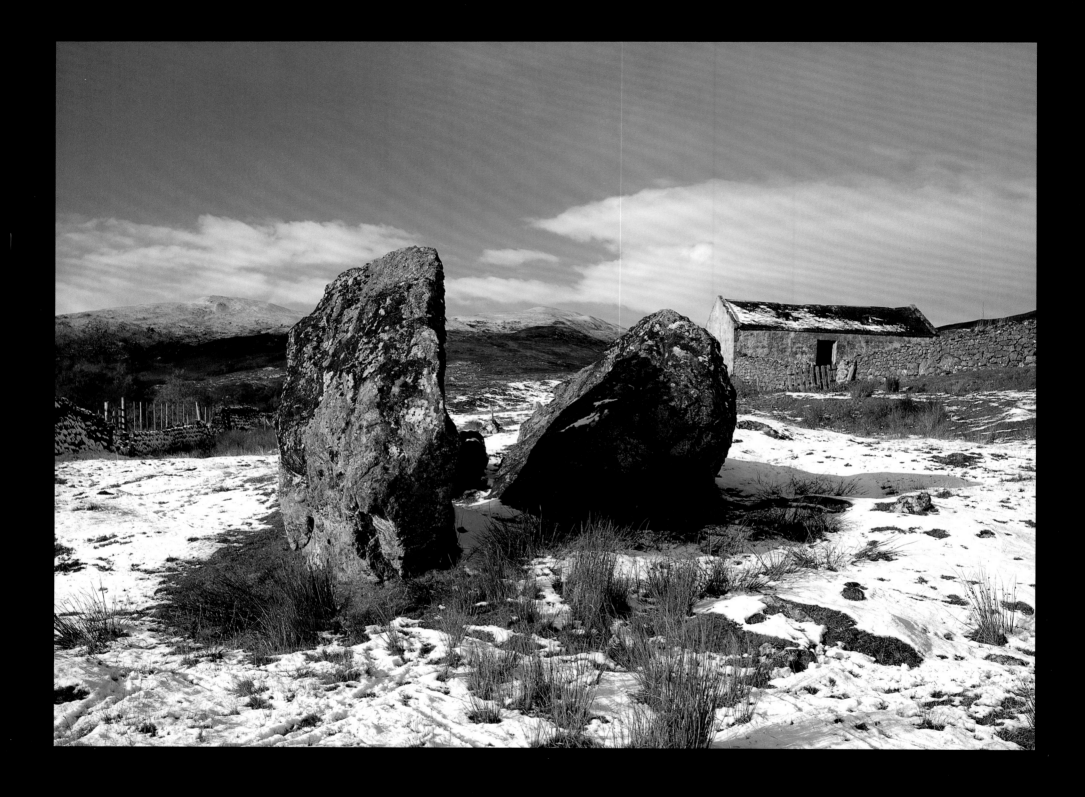

(next page) Ardvreck Castle, Loch Assynt (above) Strathcarron (right) Sheep pen

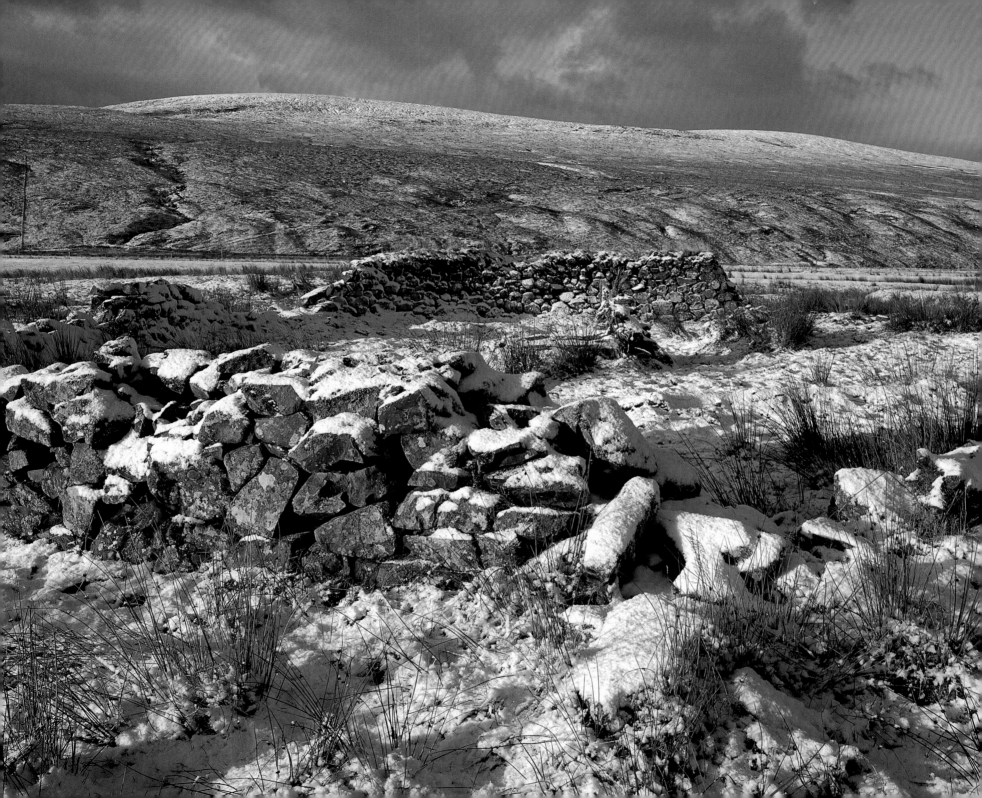

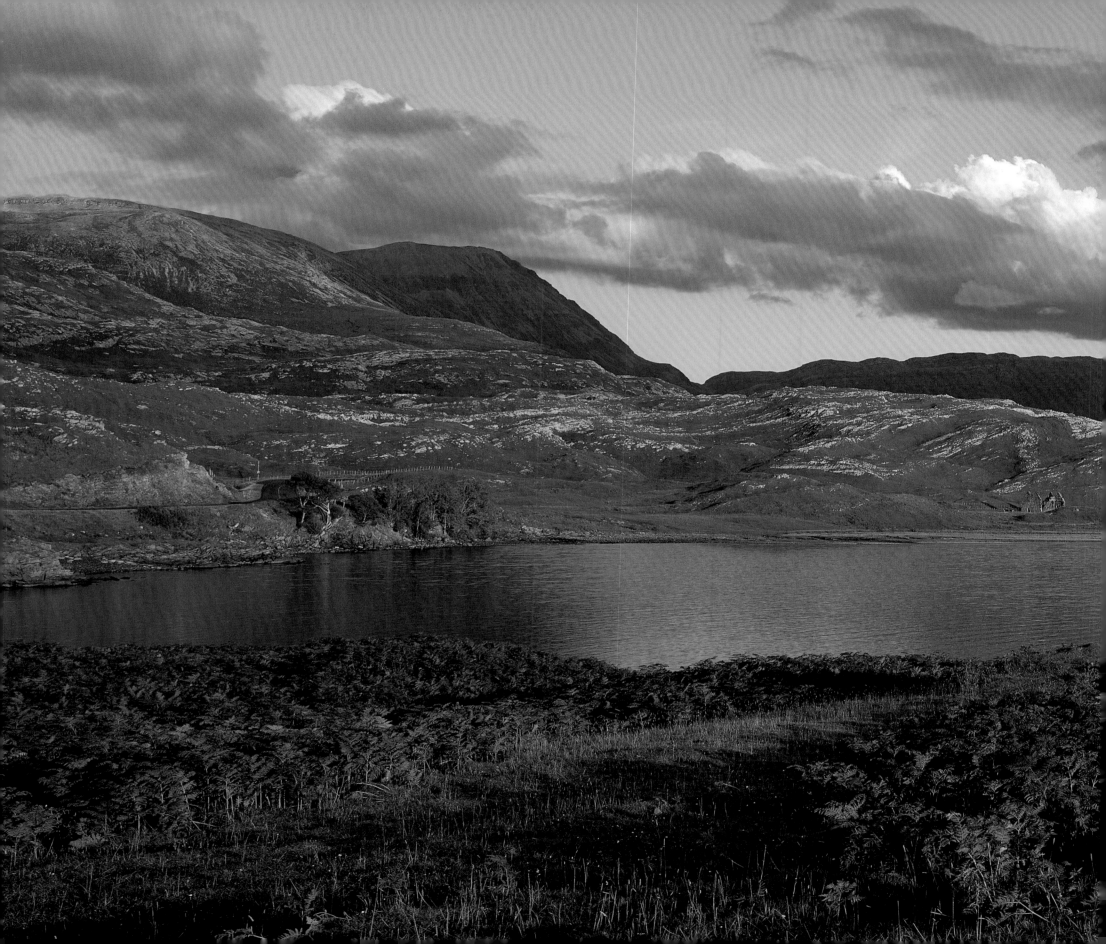

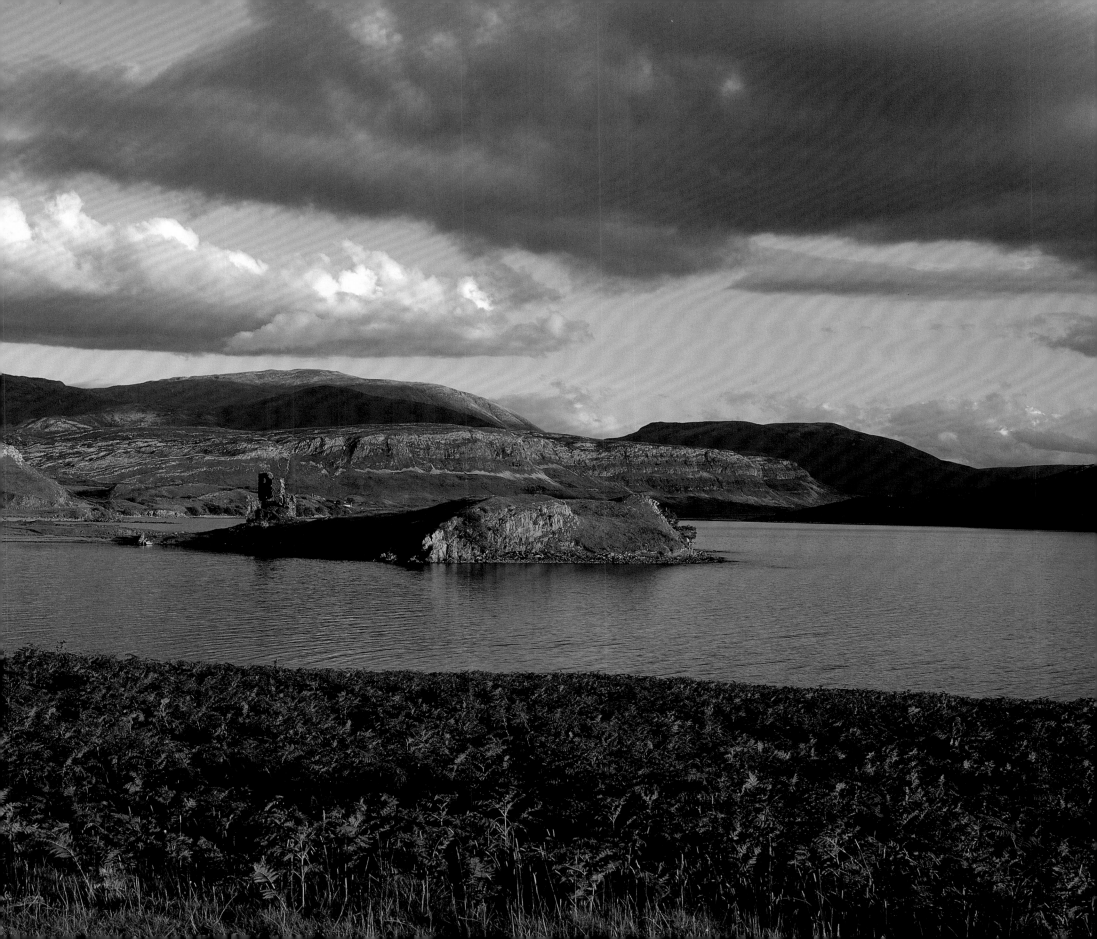

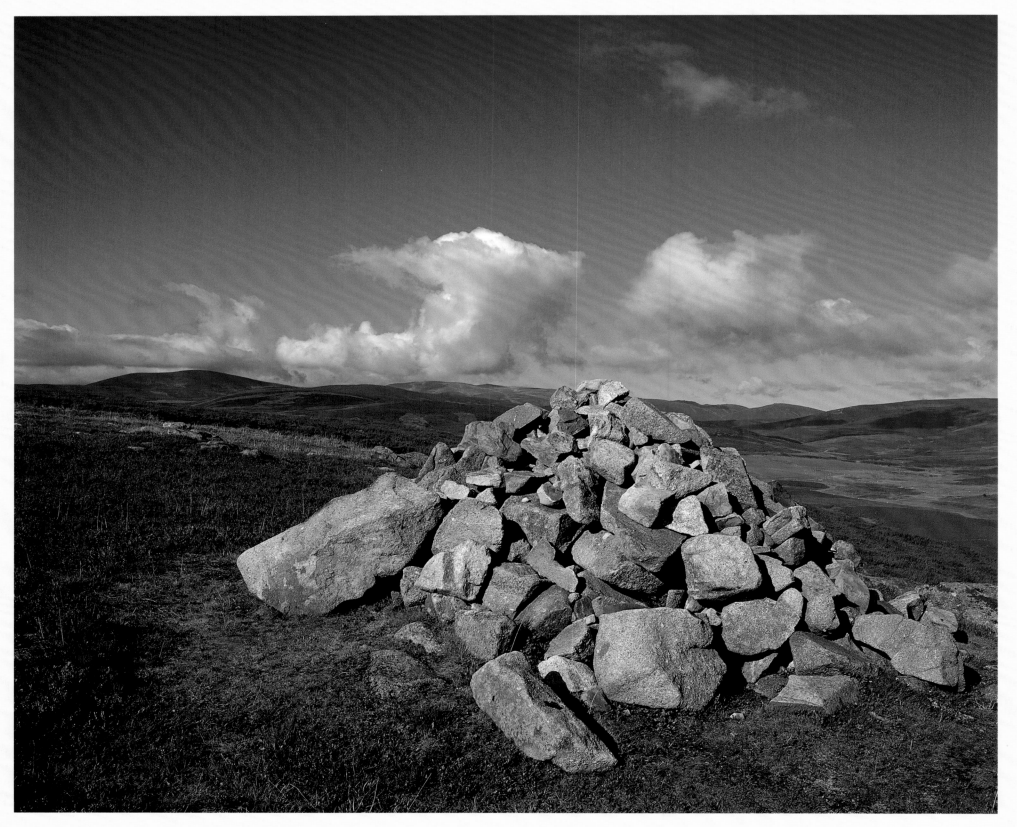

The Cairngorms, Strathspey and Badenoch

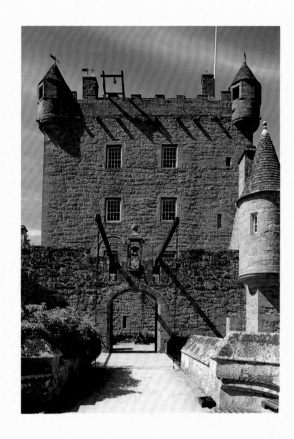

Cairngorm (which means the blue or green cairn) is the name of a mountain that is 1, 245 metres (4,084 feet) high. It has given its name to the range that has been described as "the largest and most important mountain system in the British Isles". The range was known to the Gaels as *Monadh Ruadh*, meaning the Red Mountain Range, due to its underlying red granite.

There is more land above 1,200 metres (*c.* 4,000 feet) in the Cairngorms than in any other part of the British Isles (four of Scotland's five highest mountains are in the range). The Cairngorms National Nature Reserve covers some 25,200 hectares (63,000 acres) of this high plateau which, with its dramatic deep corries and lochs, its arctic to sub-arctic climate and montane vegetation and fauna, has been described as a slab of the Arctic 1,600 kilometres (1,000 miles) too far south. The River Dee rises in the heart of the range at 1,309 metres (4,300 feet), the greatest fall from source to sea of any river in the British Isles. A large part of the Cairngorm massif lies within Badenoch and Strathspey. The influence of the River Spey, which rises

far back in Monadhliath, pervades this land of forest, wetland and loch. Stock farms are located in the clearings; as one penetrates to the higher ground of Badenoch, they give way to hill sheep farms and deer forests.

The heather moorlands of the Eastern Highlands have, for many people, come to symbolize Scotland. They are dominated by the ling (*Calluna vulgaris*), whose little purple flowers colour the hills. A number of associated species make up the plant community, including cross-leaved heath (*Erica tetralix*), bell heather (*Erica cinerea*), blaeberry (*Vaccinium myrtillus*), crowberry (*Vaccinium vitis-idaea*), and bearberry (*Arctostaphylos uva-ursi*). Several species of mosses and lichens are also important constituents of the moorland ecosystem.

Changes in land use in the eighteenth century favoured the spread of this moorland, and this in turn provided more habitat for red grouse. From this time the management of heather moorland for grouse shooting developed as a form of land use in the highlands.

(left) A cairn in Strathdon

(above) Cawdor Castle

In recent years, however, much heathland has disappeared as a result of over-grazing by sheep and red deer, conversion to forestry, and too much burning. But the heather moorlands of the British Isles are an important habitat for many birds, including not only grouse but also merlins, peregrine falcons, hen harriers, golden eagles, short-eared owls and a range of wading birds.

Whisky

Scotland is, of course, renowned for its whisky. Although *usquebaugh*, or the water of life, is distilled throughout Scotland, from the peat-free Glengoyne of the Trossachs to the smoky-tasting Laphroaig and Lagavullin from the Isle of Islay, Spey-side might justifiably lay claim to being the centre of whisky production. Some sixty or so distilleries are concentrated within an area of just over 15 square miles, in an area bounded by the rivers Findhorn, Livet and Deveron.

But although whisky was certainly drunk in the Highlands before the eighteenth century, it had not won the universal popularity that it now has. Up to that time, it seems that beer was the beverage of the ordinary folk, while the chiefs and gen-try drank wine, particularly claret, and brandy or rum for preference.

The great change in drinking preferences was due, in part, to the introduction of the potato in the 1750s. Its enormous productivity meant that ground could be released from growing barley for food and devoted to the production of malt, to make whisky. Whisky was valuable because it could be used instead of money as a cur-rency for paying rent; a currency, moreover, that did not spoil readily, and kept its value.

The impossibility of enforcing absurd laws about the licensing of stills and the taxation of barley and malt ensured a flourishing underground industry and much smuggling, particularly in the Lowlands, where the duty on whisky was heavier than in the Highlands. By the early nineteenth century, a great deal of whisky was being drunk throughout Scotland. In 1822 no less a personage than George IV was treat-ed to a gift of illicit Glenlivet whisky by Grant of Rothiemurchus. The connivance of so many, from the highest to the lowest in the land, made a mockery of the law and it was changed in 1824. The excise duty was lowered to a point where it made better sense for bigger producers to pay the tax than try avoiding it. However, it also had the effect of putting smaller distillers out of business and this contribut-ed to the misery of the emerging crofting community of the 1830s and 1840s. None the less, the legislation of 1824 set the foundations for the development of the Scot-tish whisky industry as we know it to this day.

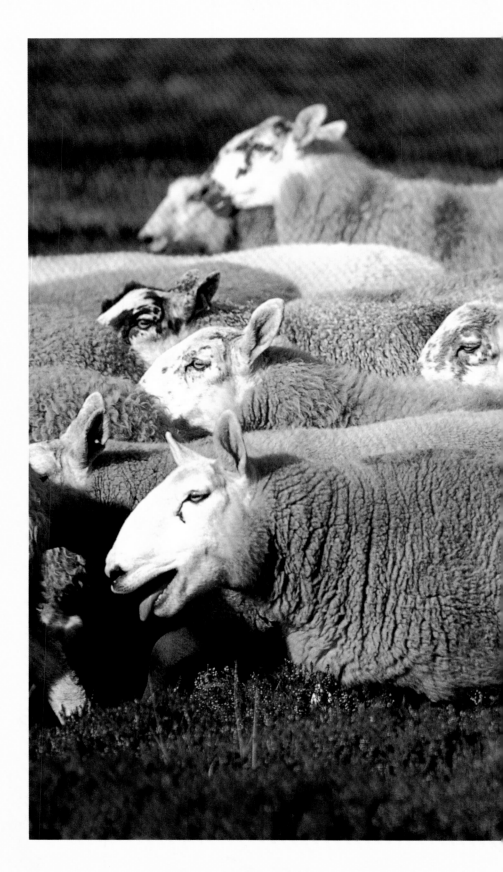

Sheep in Strathdon

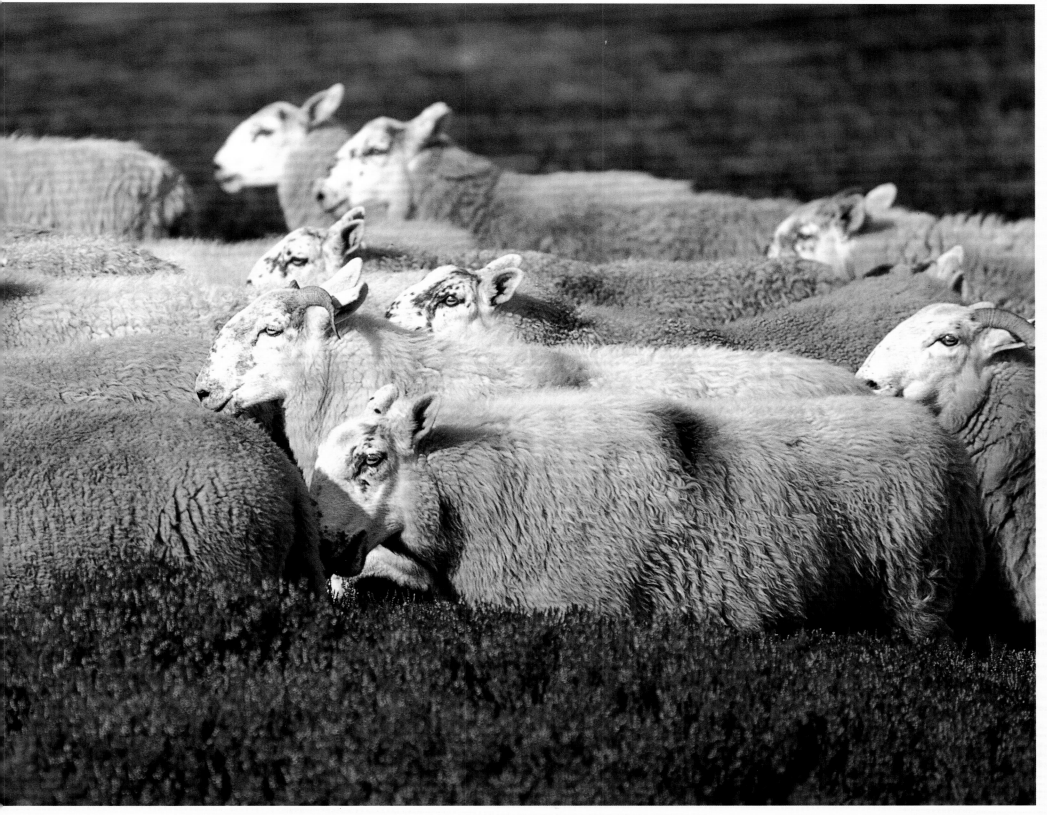

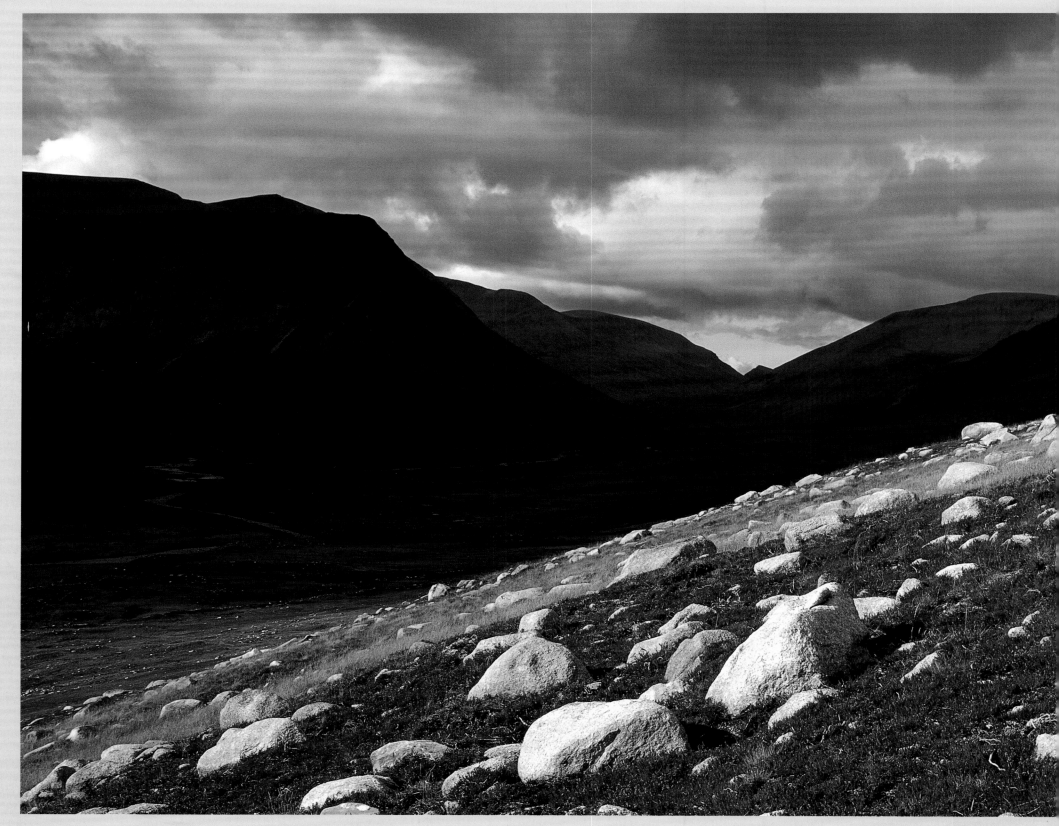

(left) The Lairig Ghru (next page) General Wade's Bridge

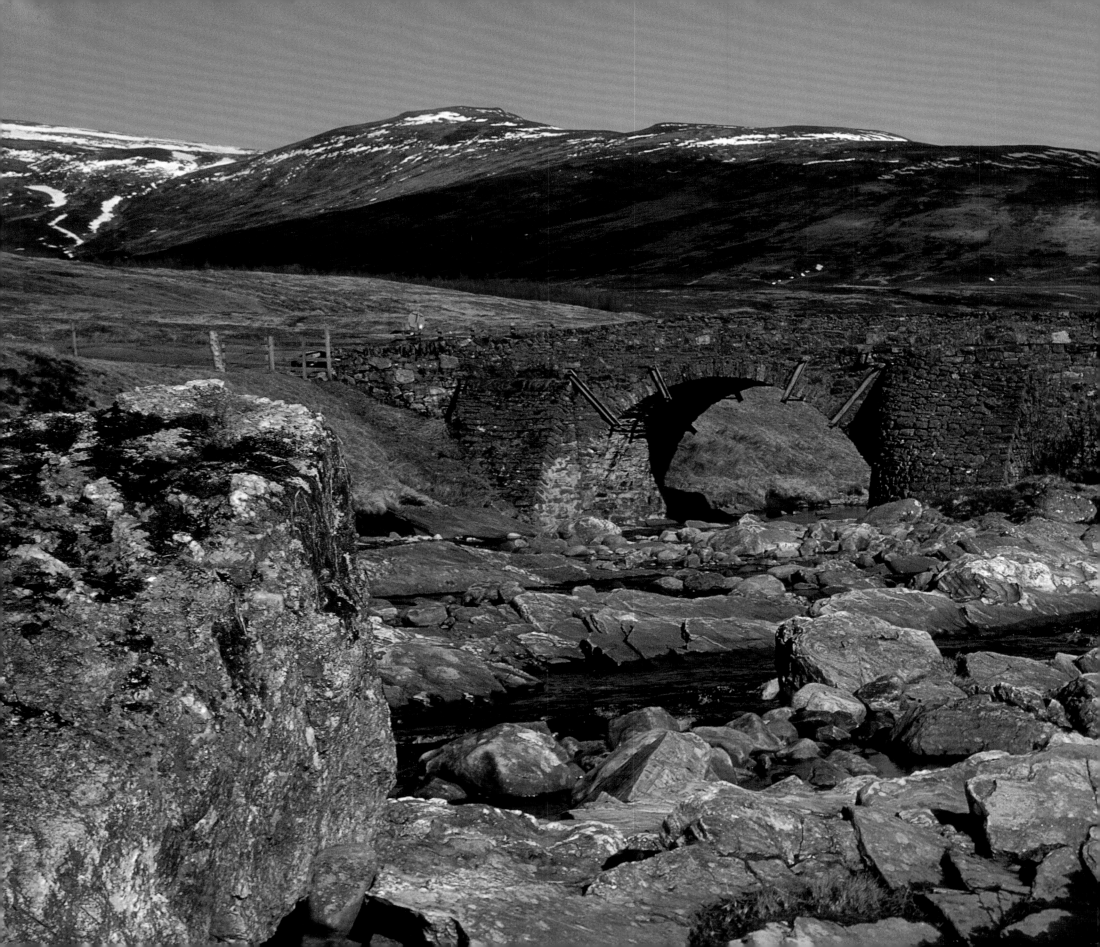

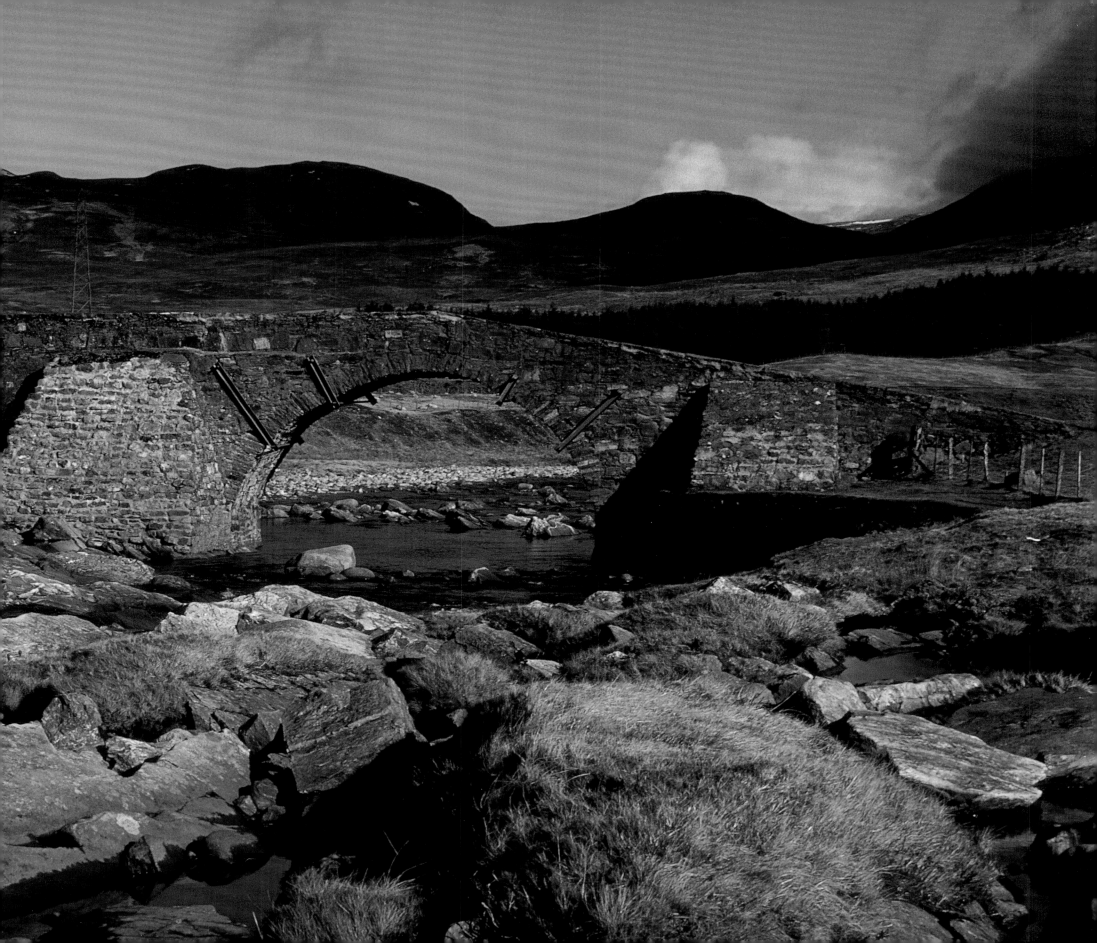

Loch Morlich

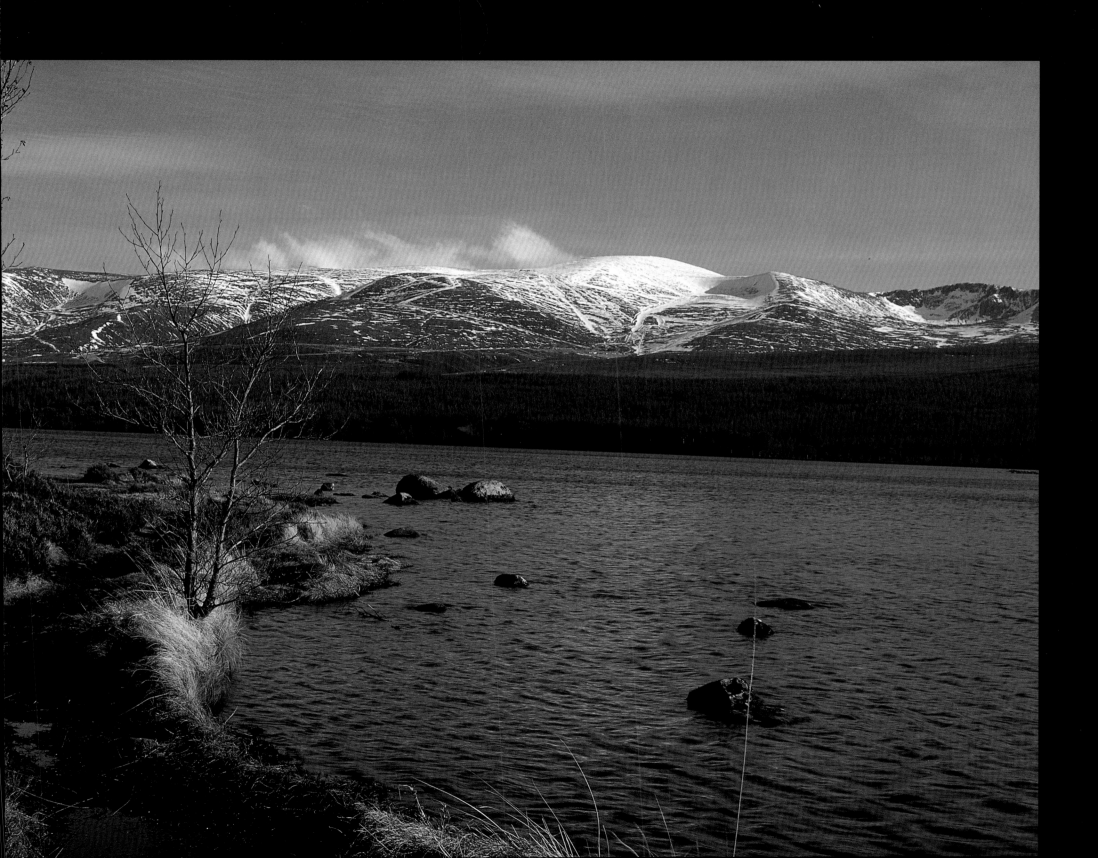

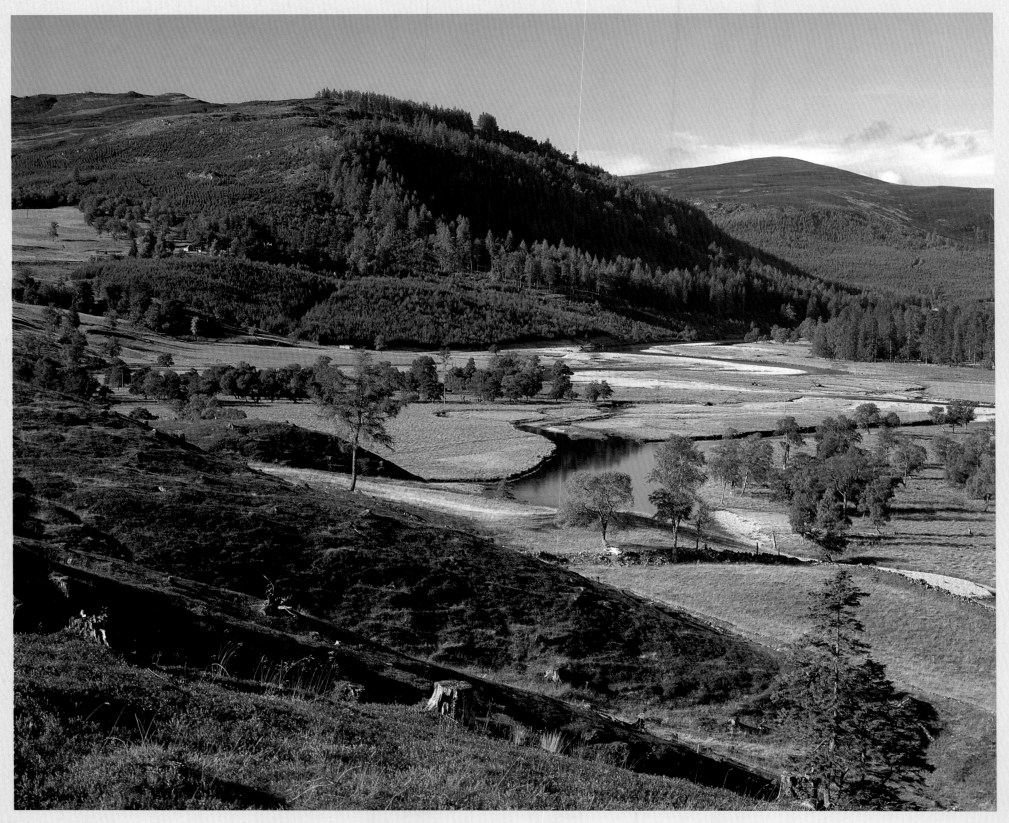

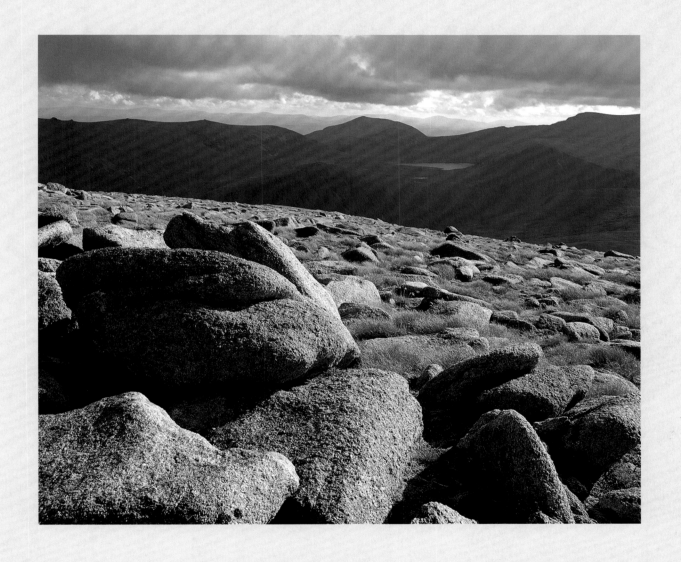

(left) Deeside

(above) **Summit of Cairngorm**

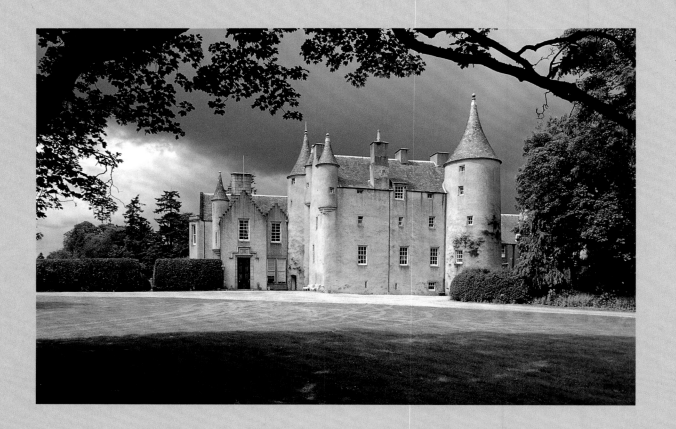

(above) Pitcaple Castle

(right) Sheep on Garvamore

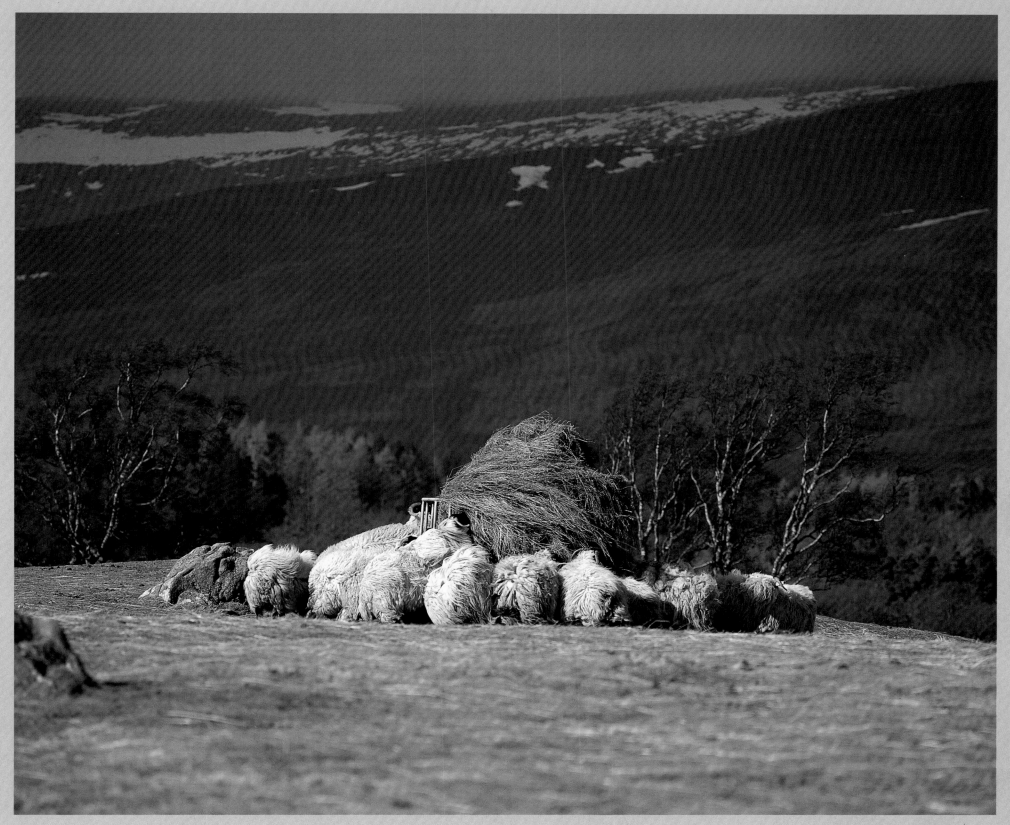

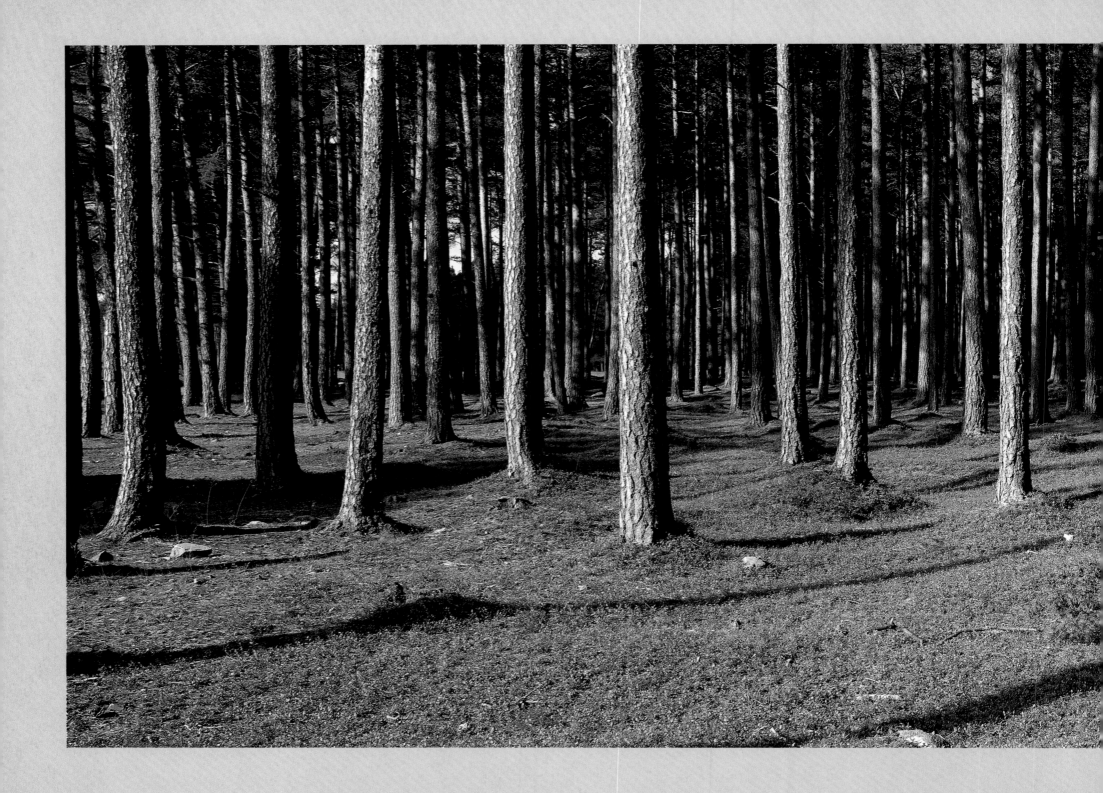

(above) Plantation of pines

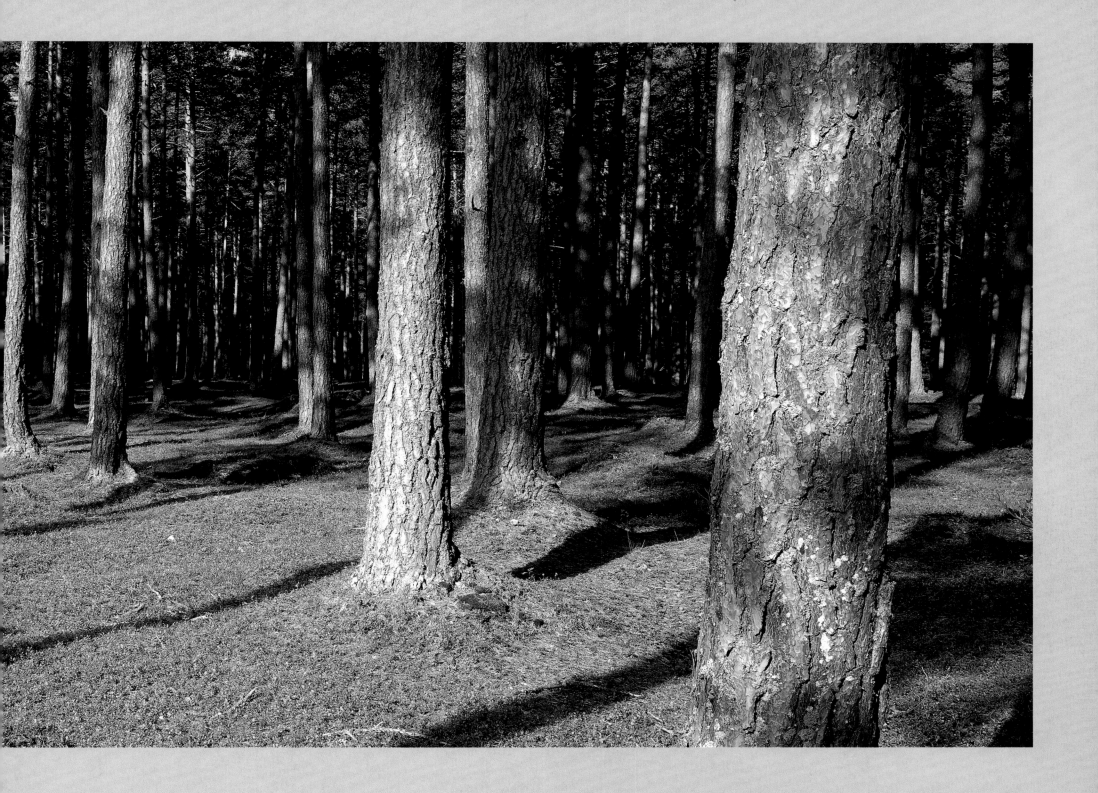

Photographer´s Note

Some thoughts on photography

In very general terms, one of the functions and skills of an artist is the ability to find an aesthetic means of expressing his or her feelings through images and share them with the world. For me, landscape photography is essentially about trying to recreate what it felt like to be in a particular place at a particular time.

Compared to the skills you need to draw and paint, photography is relatively easy – and just as satisfying artistically. Although technical understanding is an essential component in picture taking, I prefer to approach photography from a design point of view: in the same way that a painter deals with shapes, tones and textures on canvas, the photographer deals with shapes, tones and textures through the lens. The first priority is to consider how the design elements within a subject relate to one another. Line, shape, tone, space, pattern and texture: these are the components that make up a two-dimensional image. With experience, the ability to organize these relationships becomes intuitive. One useful tip in drawing and in picture taking is to look at the space between objects (negative shapes) as well as at the objects themselves (positive shapes). In two-dimensional terms, the negative shapes are just as important as the positive ones.

The second priority is technique, or knowing how you can achieve those aims in a picture with the tools at your disposal. As one's photographic experience increases and develops, one instinctively views the world through a variety of different lenses. Knowing which lens does what becomes second nature. The same applies to film stock, filters, and all the other paraphernalia of the trade: if you have to stop and think about the technicalities of what you're doing, the chances are that you'll lose the shot.

I love Greco-esque images where the sky is full of foreboding and the landscape itself is bathed in bright sunshine. However, you can't be that lucky all the time, and one thing that I have learned through experience is to always take a picture. Waiting around for "perfect" light is nonsensical, as you can take good images in almost all conditions. A good photographer reacts to the environment he or she is in, rather than trying to impose preconceived ideas on a situation.

But although the light may not always be what you would like, you do need to think about the direction of light and to understand how the quality of light varies at different times of the day and in different seasons. Luck is important, but you can create your own luck by careful planning – and so having a map and being able to work out where the sun will be at a particular time of day is essential. Photographs taken between 10 a.m. and 4 p.m. in summer on sunny days are usually disappointing: with the sun directly overhead, shadows are short (or non-existent) and the scene looks flat and uninteresting. Moreover, the colours are desaturated.

I prefer to shoot early in the morning – but only because I don't mind getting up. In fact, evening light can be better as particles in the atmosphere build up during the day and can provide a softer, less contrasty result. Shooting into the light often yields great results, but be careful to keep the direct sun off the front element of the lens.

I use filters as little as possible. Apart from uv filters for lens protection, most of the photographs in this book were taken without filters. This is a matter of personal preference. Filters have many uses: for example, they can overcome the limitations inherent in film emulsion by reducing contrast or warming up a cold scene. But they also increase the number of decisions that you have to make. Having less choice allows you to concentrate on producing the best result you can with the resources available.

The most important thing is to be open-minded at all times. Having a fixed idea of what you're going to achieve before you start can be detrimental. This flexible attitude, combined with an intuitive artistic approach and good technique, is the key to successful image making.

Sam Lloyd■

8	9	11	12/13	14/15	16	17	18
Hasselblad 500CM 150mm f/11, 1/125 sec. Fuji Velvia	Hasselblad 500CM 80mm f/8, 1/125 sec. Fuji Velvia	Minolta 9000 80–200mm f/5.6, 1/125 sec. Fuji Velvia	Linhof 6/17 90mm f/32, 1/4 sec. Fuji Velvia	Linhof 6/17 90mm f/32, 1/8 sec. Fuji Velvia	Hasselblad 500CM 50mm f/11, 1/15 sec. Fuji Velvia	Hasselblad 500CM 80mm f/8, 1 sec. Fuji Velvia	Sinar 210mm with 6/12 back f/11, 1/125 sec. Fuji Velvia

19	20/21	22	23	24/25	26	27	28/29
Hasselblad 500CM 80mm f/16, 1/2 sec. Fuji Velvia	Linhof 6/17 90mm f/32, 4 secs Fuji Velvia	Sinar 210mm with 6/12 back f/16, 1/125 sec. Kodak EPP	Hasselblad 500CM 120mm f/8, 1/60 sec. Fuji Velvia	Linhof 6/17 90mm f/32, 1 sec. Fuji Velvia	Hasselblad 500CM 120mm f/8, 1/60 sec. Fuji Velvia	Nikon FE 28mmPC f/11, 1/15 sec. Fuji Velvia	Minolta 9000 80–200mm f/8, 1/125 sec. Fuji Velvia

30/31	32	33	34	35	36	37	38
Nikon FE 28mm PC f/11, 1/15 sec. Fuji Velvia	Hasselblad 500CM 150mm f/8, 1/30 sec. Fuji Velvia	Linhof 6/17 90mm f/11, 1/2 sec. Fuji Velvia	Nikon FE 28mm PC f/11, 1/8 sec. Fuji Velvia	Minolta 9000 80–200mm f/5.6, 1/30 sec. Fuji Velvia	Minolta 9000 80–200mm f/8, 1/125 sec. Fuji Velvia	Hasselblad 500CM 60mm f/8, 1/60 sec. Fuji Velvia	Linhof 6/17 90mm f/32, 1 sec. Fuji Velvia

39	40/41	42	43	44/45	46	47	48/49
Linhof 6/17 90mm f/32, 2 secs Fuji Velvia	Minolta 9000 80–200mm f/11, 1/250 sec. Fuji Velvia	Sinar 90mm with 6/12 back f/8, 1/125 sec. Fuji Velvia	Hasselblad 500CM 80mm f/8, 1 sec. Fuji Velvia	Linhof 6/17 90mm f/32, 1 sec. Fuji Velvia	Hasselblad 500CM 80mm f/16, 2 secs Fuji Velvia	Hasselblad 500CM 80mm f/8, 1/60 sec. Fuji Velvia	Nikon FE 28mm PC f/11, 1/15 sec. Fuji Velvia

50/51	52/53	54	55	56	57	58/59	60/61
Nikon FE 28mm PC f/11, 1/60 sec. Fuji Velvia	Hasselblad 500CM 80mm f/11, 1/60 sec. Fuji Velvia	Hasselblad 500CM 50mm f/8, 1/2 sec. Fuji Velvia	Hasselblad 500CM 120mm f/8, 1/2 sec. Fuji Velvia	Minolta 9000 80–200mm f/5.6, 1/125 sec. Fuji Velvia	Hasselblad 500CM 50mm f/8, 1/60 sec. Fuji Velvia	Hasselblad 500CM 80mm f/8, 1/30 sec. Fuji Velvia	Hasselblad 500CM 80mm f/8, 1/60 sec. Fuji Velvia

62
Hasselblad 500CM
80mm
f/8, 1/125 sec.
Fuji Velvia

63
Nikon FE
28mm PC
f/11, 1/60 sec.
Fuji Velvia

64
Hasselblad 500CM
80mm
f/8, 1/30 sec.
Fuji Velvia

65
Nikon FE
28mm PC
f/11, 1/30 sec.
Fuji Velvia

66
Minolta 9000
80–200mm
f/5.6, 1/125 sec.
Fuji Velvia

67
Minolta 9000
80–200mm
f/5.6, 1/125 sec.
Fuji Velvia

68/69
Nikon FE
28mm PC
f/11, 1/4 sec.
Fuji Velvia

70/71
Nikon FE
28mm PC
f/8, 1/30 sec.
Fuji Velvia

72
Hasselblad 500CM
80mm
f/8, 1/60 sec.
Fuji Velvia

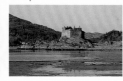
73
Hasselblad 500CM
80mm
f/8, 4 secs
Fuji Velvia

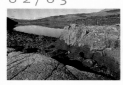
74
Nikon FE
28mm PC
f/8, 1/15 sec.
Fuji Velvia

74/75
Nikon FE
28mm PC
f/11, 1/60 sec.
Fuji Velvia

76/77
Hasselblad 500CM
80mm
f/8, 1/15 sec.
Fuji Velvia

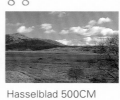
78
Hasselblad 500CM
80mm
f/11, 1/60 sec.
Fuji Velvia

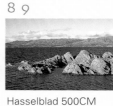
79
Nikon FE
28mm PC
f/11, 1/60 sec.
Fuji Velvia

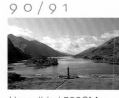
80/81
Nikon FE
28mm PC
f/11, 1/60 sec.
Fuji Velvia

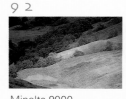
82/83
Nikon FE
28mm PC
f/11, 1/60 sec.
Fuji Velvia

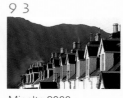
84
Hasselblad 500CM
80mm
f/11, 1/60 sec.
Fuji Velvia

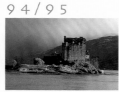
85
Minolta 9000
80-200mm
f/5.6, 1/125 sec.
Fuji Velvia

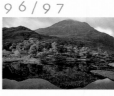
86
Hasselblad 500CM
80mm
f/8, 2 secs
Fuji Velvia

87
Nikon FE
28mm PC
f/11, 1/8 sec.
Fuji Velvia

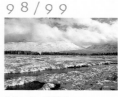
88
Hasselblad 500CM
80mm
f/11, 1/60 sec.
Fuji Velvia

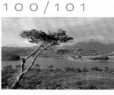
89
Hasselblad 500CM
80mm
f/11, 1/60 sec.
Fuji Velvia

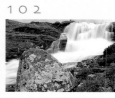
90/91
Hasselblad 500CM
80mm
f/11, 1/60 sec.
Fuji Velvia

92
Minolta 9000
80–200mm
/f5.6, 1/125 sec.
Fuji Velvia

93
Minolta 9000
80–200mm
f/5.6, 1/125 sec.
Fuji Velvia

94/95
Minolta 9000
80–200mm
f/5.6, 1/125 sec.
Fuji Velvia

96/97
Minolta 9000
80–200mm
f/5.6, 1/60 sec.
Fuji Velvia

97
Hasselblad 500CM
80mm
f/11, 1/60 sec.
Fuji Velvia

98/99
Minolta 9000
80–200mm
f/5.6, 1/125 sec.
Fuji Velvia

100/101
Linhof 6/17
90mm
f/32, 1/15 sec.
Fuji Velvia

102
Hasselblad 500CM
80mm
f/22, 2 secs
Fuji Velvia

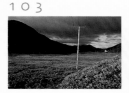
103
Nikon FE
28mm PC
f/11, 1/60 sec.
Fuji Velvia

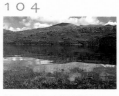
104
Hasselblad 500CM
120mm
f/11, 1/60 sec.
Fuji Velvia

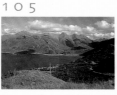
105
Hasselblad 500CM
120mm
f/11, 1/60 sec.
Fuji Velvia

106/107
Minolta 9000
80–200mm
f/5.6, 1/250 sec.
Fuji Velvia

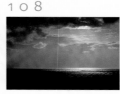
108
Hasselblad 500CM
80mm
f/8, 1/60 sec.
Fuji Velvia

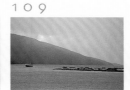
109
Hasselblad 500CM
80mm
f/4, 1/60 sec.
Fuji Velvia

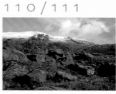
110/111
Linhof 6/17
90mm
f/32, 1/8 sec.
Fuji Velvia

112
Nikon FE
28mmPC
f/11, 1/60 sec.
Fuji Velvia

113
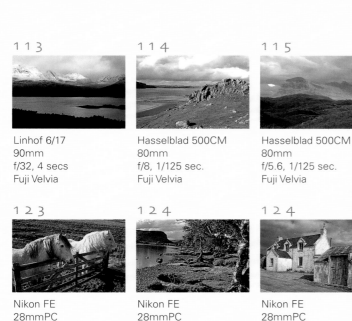
Linhof 6/17
90mm
f/32, 4 secs
Fuji Velvia

114
Hasselblad 500CM
80mm
f/8, 1/125 sec.
Fuji Velvia

115
Hasselblad 500CM
80mm
f/5.6, 1/125 sec.
Fuji Velvia

116
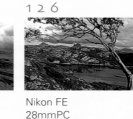
Nikon FE
28mmPC
f/11, 1/60 sec.
Fuji Velvia

118/119
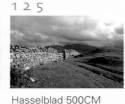
Minolta 9000
28mm
f/11, 1/30 sec.
Fuji Velvia

119
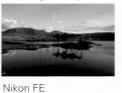
Minolta 9000
80–200mm
f/5.6, 1/125 sec.
Fuji Velvia

120/121
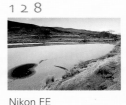
Minolta 9000
80–200mm
f/5.6, 1/125 sec.
Fuji Velvia

122

Nikon FE
28mmPC
f/11, 1/60 sec.
Fuji Velvia

123

Nikon FE
28mmPC
f/11, 1/30 sec.
Fuji Velvia

124

Nikon FE
28mmPC
f/8, 1/125 sec.
Fuji Velvia

124

Nikon FE
28mmPC
f/11, 1/30 sec.
Fuji Velvia

125
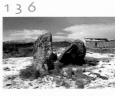
Hasselblad 500CM
80mm
f/11, 1/60 sec.
Fuji Velvia

126

Nikon FE
28mmPC
f/11, 1/60 sec.
Fuji Velvia

126/127
Nikon FE
28mmPC
f/11, 1/60 sec.
Fuji Velvia

128
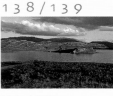
Nikon FE
28mmPC
f/11, 1/60 sec.
Fuji Velvia

129
Minolta 9000
28mm
f/3.5, 1/250 sec.
Fuji Velvia

130
Hasselblad 500CM
80mm
f/8, 1/60 sec.
Fuji Velvia

131
Hasselblad 500CM
80mm
f/8, 1/30 sec.
Fuji Velvia

132
Minolta 9000
28mm
f/11, 1/125 sec.
Fuji Velvia

133
Minolta 9000
35–70mm
f/4, 1/125 sec.
Fuji Velvia

134/135
Linhof 6/17
90mm
f/32, 1 sec.
Fuji Velvia

136
Hasselblad 500CM
80mm
f/8, 1/60 sec.
Fuji Velvia

137
Hasselblad 500CM
80mm
f/8, 1/60 sec.
Fuji Velvia

138/139
Linhof 6/17
90mm
f/32, 1/8 sec.
Fuji Velvia

140
Hasselblad 500CM
80mm
f/8, 1/60 sec.
Fuji Velvia

141
Nikon FE
28mmPC
f/11, 1/60 sec.
Fuji Velvia

142/143
Minolta 9000
80–200mm
f/5.6, 1/125 sec.
Fuji Velvia

144/145
Hasselblad 500CM
80mm
f/11, 1/60 sec.
Fuji Velvia

146/147
Hasselblad 500CM
80mm
f/11, 1/60 sec.
Fuji Velvia

148/149
Hasselblad 500CM
80mm
f/11, 1/60 sec.
Fuji Velvia

150
Hasselblad 500CM
80mm
f/11, 1/60 sec.
Fuji Velvia

151
Hasselblad 500CM
80mm
f/11, 1/60 sec.
Fuji Velvia

152
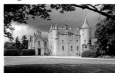
Nikon FE
28mmPC
f/11, 1/30 sec.
Fuji Velvia

153
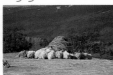
Minolta 9000
80–200mm
f/5.6, 1/125 sec.
Fuji Velvia

154/155

Linhof 6/17
90mm
f/8, 1/15 sec.
Fuji Velvia

Page

camera
focal length
aperture, exposure time
film stock

Acknowledgements

I would like to thank all those involved in the production of this book: Sarah Hoggett and Stefan Nekuda for all their editorial and design work and especially Cameron Brown for giving me such a marvellous opportunity to publish photographs that might never have seen the light of day.

I would also like to dedicate this book to my Mum, to my wife Jenny, to my daughters Katy and Amy, and to very, very happy memories of my father and of Glencassley.

Sam Lloyd